THE ART AND MAKING OF THE MOVIE

RUMBLE
THE ART AND MAKING OF THE MOVIE

ISBN: 9781789095128

Published by Titan Books
A division of Titan Publishing Group Ltd.
144 Southwark St.
London
SE1 0UP

FIRST EDITION: MAY 2021
1 3 5 7 9 10 8 6 4 2

DID YOU ENJOY THIS BOOK?
We love to hear from our readers. Please e-mail us at: readerfeedback@
titanemail.com or write to Reader Feedback at the above address.

To receive advance information, news, competitions, and exclusive
offers online, please sign up for the Titan newsletter on our website:
www.titanbooks.com

A CIP catalogue record for this title is available from the British Library.

Printed and bound in China.

THE ART AND MAKING OF THE MOVIE

NOELA HUESO

TITAN BOOKS

CONTENTS

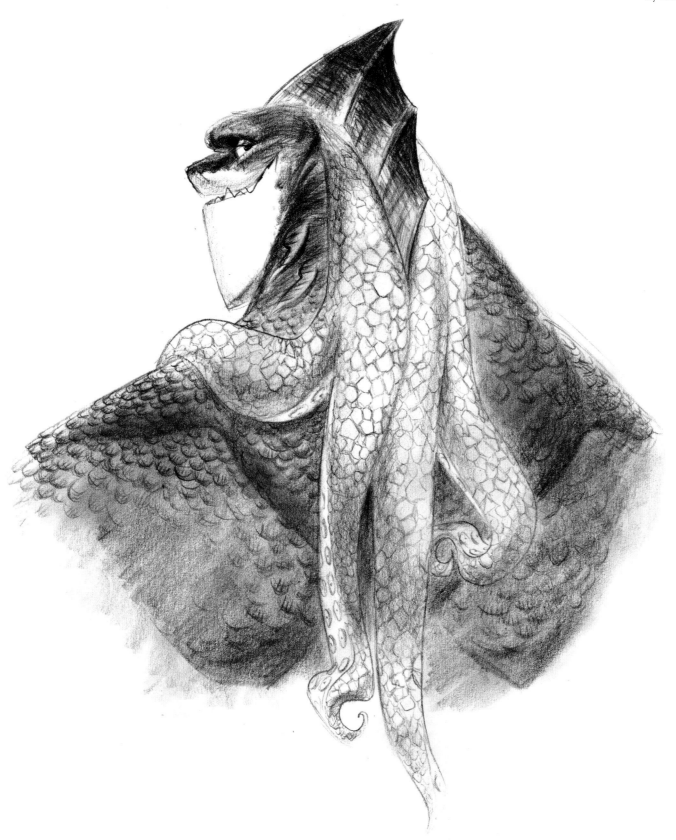

LEFT/ Early character sketch by David Colman.

FOREWORD

When I moved to Los Angeles in 1997, I thought I was going to be an animator. I had just retired from the NFL and had long dreamed of using my art for the movies. On six teams in seven years, I had developed the reputation of the 'artistic' football player. I painted the players, their families, the teams' yearbooks, the game programs, I even did fun caricatures of kids at Super Bowl events. My whole NFL career, I knew my artistic talent would some day lead me to my dream… working in Hollywood.

I hit the ground running as soon as I hit town. My portfolio was everywhere, from Hanna Barbera to DreamWorks to Disney. I had a dream of going to work drawing and creating all day, every day and actually getting paid to do so. I polished up my craft with night classes at Associates in Art, where they would show you how to be and in-betweener and how to paint backdrops. I learned to be open to everything, from illustrating movie posters to sketching storyboards: anything that would allow you to pay the bills and stay in the game. But the one thing I never counted on was that the animation world as I knew it was going to go through a seismic shift that would change the way everything was done forever: computer animation.

After the success of *Toy Story*, hand-drawn animation was on its way out. Sure, studios needed creative people, but just not so many of them. Many great artists were out on the street and the computer generation had begun. My portfolio submissions went weeks without an interview and then dried up completely as no one was even interviewing anymore. Desperate, I tried something else entirely: acting.

My friend invited me on an audition, and as chance would have it, the first thing I auditioned for I got. A show called *Battledome*, which was a cross between wrestling and *American Gladiators*. I never looked back and have been acting for over twenty years. Which now brings me to *Rumble*.

No one ever thinks they are the villain. There have been many times when I went to sleep the hero, only to wake up and discover I was a villain. I was shouting when I should have been listening. I was tough when I should have been caring. I was fighting when I should have been building. I can't speak for everyone, so I won't even try. I just know that there is a very thin line between self-actualized as opposed to self-righteous. Between allowing your pain and suffering to bring about empathy or its polar opposite, moral superiority. Between using your superpowers as a force for good, or evil. I loved doing *Rumble*. In playing Tentacular all the complexities of the above were explored in detail. The dynamics of winning versus losing. The power of creativity versus the frustration of competition. Sports is often seen as a metaphor for life, but as a former professional athlete myself, it took me years to discover that what often considered successful in sport, does not transfer into success in real life. In my experience, competition has been the exact opposite of creativity. Creativity sets a stage where there are no more winners or losers: just champions.

To see how far that creativity in animation has come has been nothing short of amazing. The art in *Rumble* is realistic, yet still captures a hand-drawn feel of traditional animation. Scope and scale are handled with amazing detail as these giant creatures battle each other for the affections of their prospective cities, with the flash and bravado of old-school wrestlers with a mix of NFL hype to keep things interesting. The world of sports and animation meet and create a beautiful scenario of heroes and villains. A world I am proud to be a part of because I know both so well.

Terry Crews
June 2020

INTRODUCTION

Can a teenage girl and an overweight monster save a town that is in danger of losing the one thing that keeps it going?

That's the premise of Paramount Pictures' *Rumble*, a true underdog story that takes place in a world where humans and monsters live side-by-side in harmony, and where there's nothing bigger, literally and figuratively, than monster wrestling.

Spunky sixteen-year-old Winnie Coyle has lived her entire life in Stoker, a picturesque little burg with an East Coast college town vibe. It's the kind of place where stores close on game day as everyone convenes on their beloved Stoker Stadium, the town's centerpiece attraction. For many years, the stadium was the home of Winnie's dad, Coach Jimbo Coyle and Rayburn, his champion wrestler monster. Before they were tragically lost at sea nine years ago, they were the G.O.A.T. – an unstoppable duo who won eight consecutive World Monster Wrestling championships; Stoker Stadium is the house they built. So, when the egotistical current hometown hero Tentacular announces – right after beating King Gorge, the reigning champion – that he's leaving town for something "Much. Much. Better," locals are stunned, hurt, and disappointed. Yup, Tentacular is off to Slitherpoole, the cavernous and imposing metropolis that has a state-of-the-art stadium owned by trust funder Jimothy Brett-Chadley III. Adding insult to injury is the fact that Tentacular is taking his coach Siggy with him, another local who used to be Jimbo's assistant.

THIS SPREAD/ Storybeat paintings by Julia Blattman (Bottom Left) Cathleen McAllister (Bottom Right) and Paige Woodward (Far Right).

NEXT SPREAD/ Storybeat painting by Cathleen McAllister.

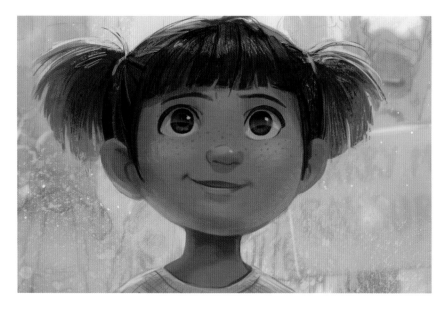

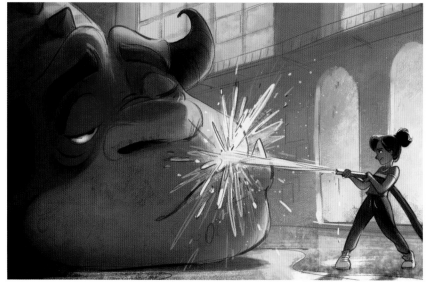

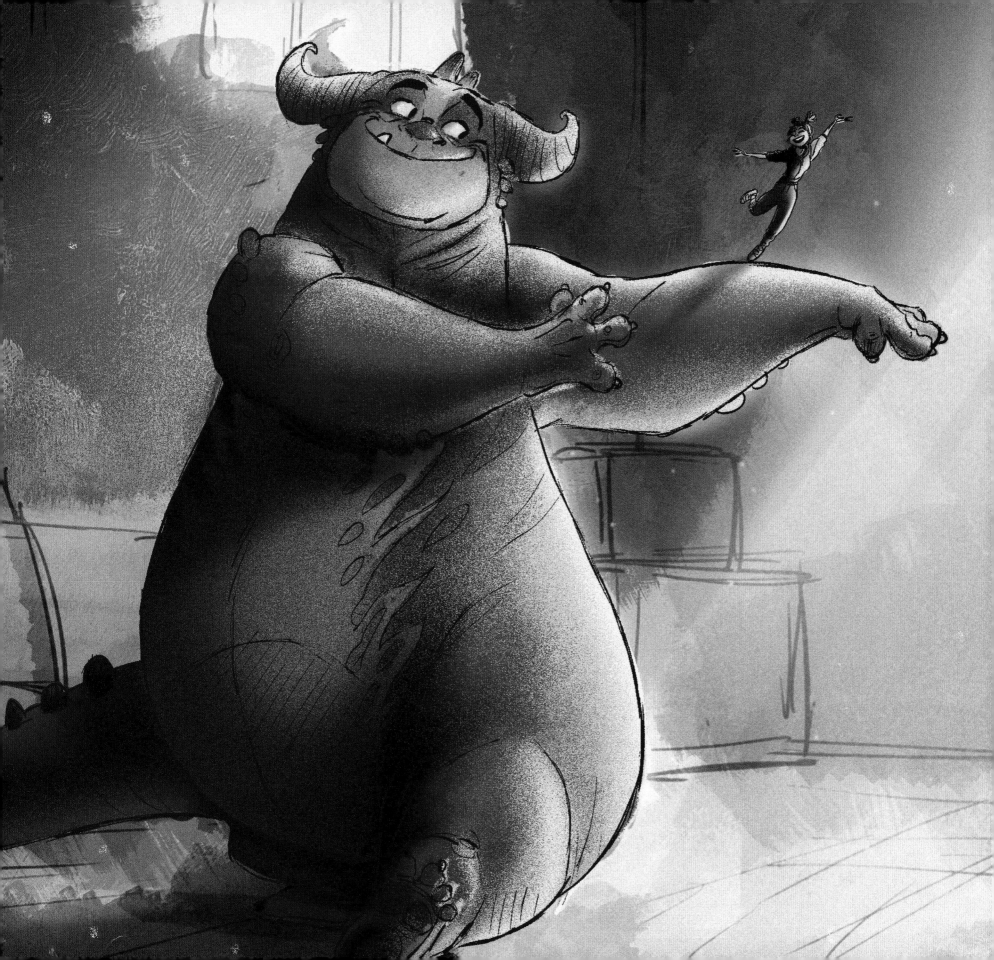

No one is more upset at this news than Winnie, and, as she and the town learn on that fateful day, there's an even bigger problem: Stoker is in financial straits. With only ninety days to turn things around before the town goes bankrupt, Winnie sets out to find another monster that she can train, using every trick in the book – her father's playbook, that is – to save the day. But who wants to be trained by a 16-year-old girl? Certainly not the motley crew of monsters she finds at a shady underground fight club. Just when Winnie thinks her plan is on the ropes, though, she sees a vaguely familiar face in the ring. Steve the

Stupendous is overweight and slow and doing his best not to win. Even so, this pudgy beast is more than he seems: Winnie recognizes him as Rayburn Jr., the son of the legendary fighter from Stoker! "Steve" wants nothing to do with Winnie or her proposal to return to his old stomping ground, however. But when he's suddenly hit with a large debt, he reluctantly agrees… he's in it for the money, though, nothing more. What happens next is a journey of epic proportions as both Rayburn and Winnie, with hilarity and heart, come to terms with their lineages (can Winnie ever be as good a coach as her father?), forge their own identities

(can Rayburn be a champion fighter in his own unique way?) and, ultimately, fight gargantuan odds to save Stoker.

According to Rumble director Hamish Grieve, the overriding theme of *Rumble* is about legacy: "It's about how you figure out where you come from and how that relates to where you're going," he says, adding that it's an understandable one. "We're all trying to figure out if we want to be like our parents or not be like our parents. If we came from a bad childhood, do we overcome it, or do we succumb to it? There's a million ways this applies to everyone's life."

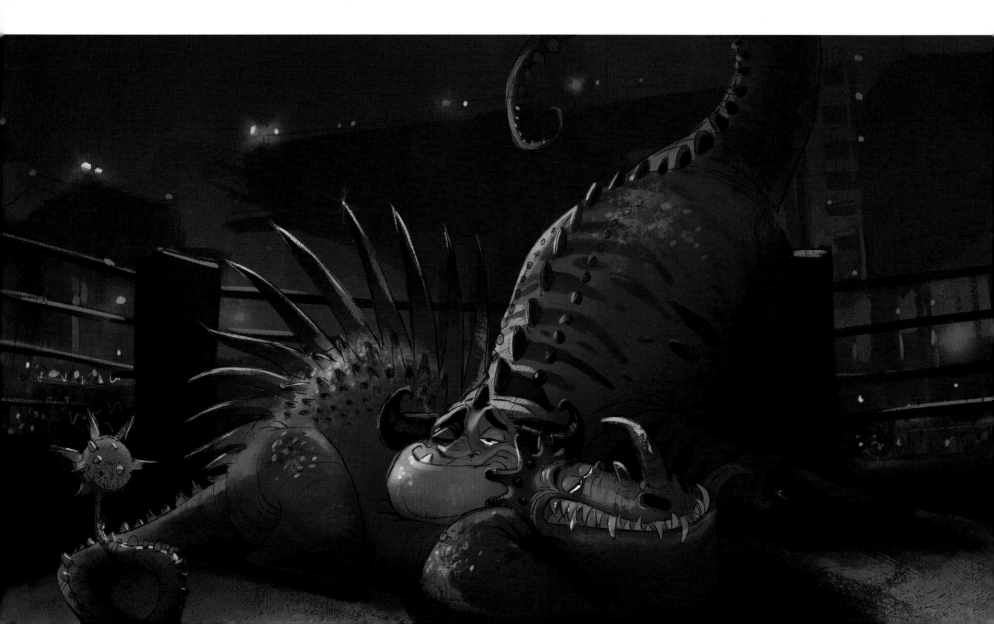

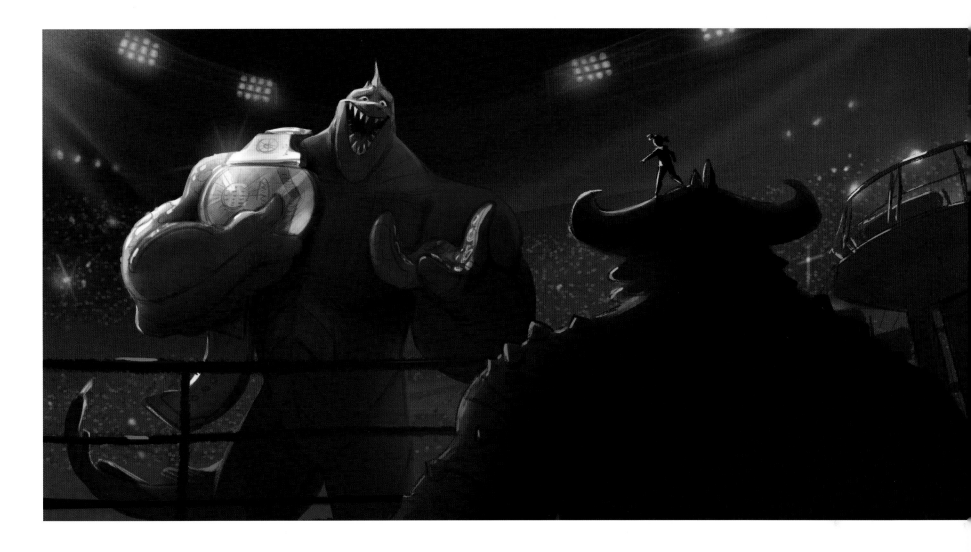

The story is also about some really big, colorful monsters and some monumental smackdowns. "We thought it would be fun to make a film about giant wrestling monsters that actually felt like a sports movie," Grieve says. "We referenced a lot of the classics: *Rocky, Creed, Rudy*; you have a pretty good idea where you're going to end up in terms of story arc, but you can have a lot of fun with it along the way."

The filmmakers say that getting the behemoths' dimensions just right in relation to their human counterparts was crucial in telling an effective, plausible tale. "The biggest cinematic challenge has been to sell the scale of this movie, to make the monsters feel ginormous and amazing and huge but also for them to be characters that can talk and have personality," says Grieve. Agrees cinematographer Kent Seki: "The monsters in *Rumble* have the same level of emotional development and expression as our humans. Connecting characters of vastly different scale presented challenges both in terms of shot selection as well as lensing." Lighting supervisor Liz Hemme says that making the monster characters feel as if they were part of their environments was another imperative – and unusual in an animated feature.

"So often we're directed to have characters 'pop' from their backgrounds," she remarks. "By keeping ours set within their world, it makes them more believable and relatable."

With explosive fights, monstrous situations, and massive spunk, *Rumble* is a feel-good sports movie on steroids. This is revealed in the pages of *Rumble: The Art and Making of the Movie* through over 450 pieces of original art, showcasing, on a grand scale, the visual voyage taken by the talented international team of artists and filmmakers at Paramount into the creation of enormous monsters, tiny humans, and the singular world they inhabit together.

BIG FIGHT!

COME SEE THE BIGGEST AND THE BADDEST

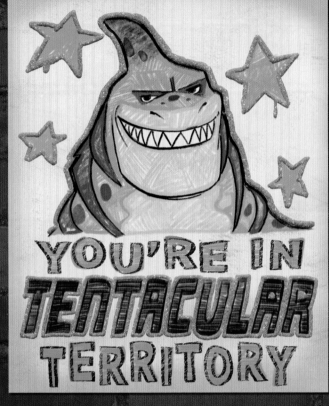

ENTER AT YOUR OWN RISK

YOU'RE IN TENTACULAR TERRITORY

SOMEDAY ALMOST WHAT IF IF ONLY

POST NO BILLS

AMBER'S REVENGE

Stoke

CREATING THE CHARACTERS

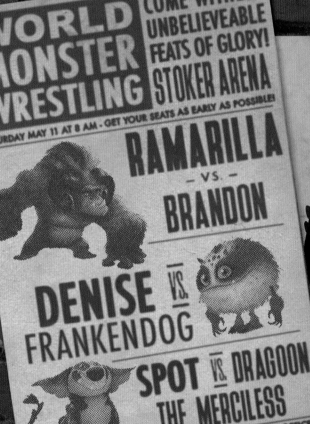

WORLD MONSTER WRESTLING

COME WITNESS UNBELIEVEABLE FEATS OF GLORY! STOKER ARENA

ATURDAY MAY 11 AT 8 AM · GET YOUR SEATS AS EARLY AS POSSIBLE!

RAMARILLA
— VS. —
BRANDON

DENISE VS. **FRANKENDOG**

SPOT VS **DRAGOON THE MERCILESS**

TICKETS ARE AVAILABLE FOR PURCHASE FOR $7 AT THE BOX OFFICE

AYBURN MBO COYLE

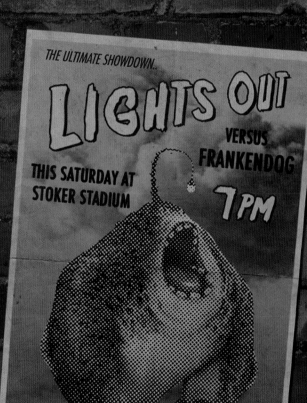

THE ULTIMATE SHOWDOWN...

LIGHTS OUT

VERSUS **FRANKENDOG**

THIS SATURDAY AT STOKER STADIUM

7PM

GET TICKETS EARLY AT THE BOX OFFICE. THIS EVENT WILL SELL OUT!

WRESTLING TRYOUTS:

Do you have what it takes to be the next international sensation?

Are you around 50 feet tall?

Have you ever eaten a car?

This Saturday at the Stoker Arena

MONSTER XING

CREATING THE CHARACTERS

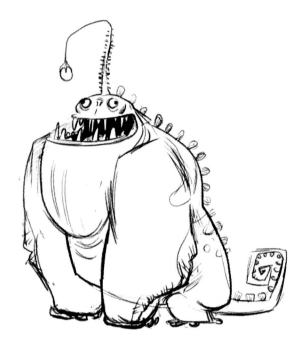

Beyond the dynamic action and laugh-out-loud comedy, at its core, *Rumble* is a heartfelt, character-based story with colorful and distinct personalities at every turn, particularly the film's two leads, Winnie and Rayburn. "We wanted to do a classic odd-couple relationship," director Hamish Grieve says, "and there's nothing odder than a teenage girl and a flabby, fifty-foot monster!" Their interactions needed to be authentic, which proved challenging at times, considering their disparity of size.

"Our two main characters have a forty foot height difference," says head of story Lawrence Gong. "Standard shots like closeups, over the shoulder, wide shots, they all took on a different context. We had to make sure Winnie and Rayburn connected, and that meant being clever with the way we used the camera and the way they interacted physically. Luckily, with a comedy we could have a lot of fun with that stuff."

From a story perspective, "For each shot in the film, we had to ask ourselves, is this selling the scale but also allowing us to milk the comedy and see the

THIS PAGE/ Early sketch by David Colman (Above). Storybeat painting by Paige Woodward (Below).

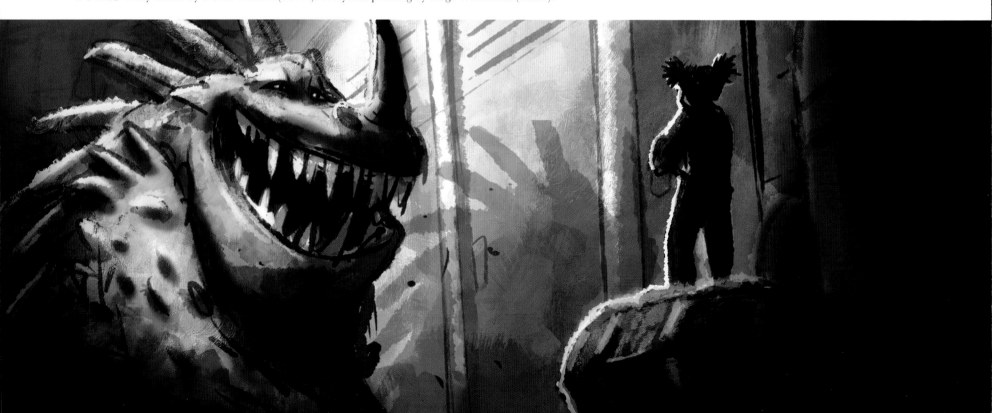

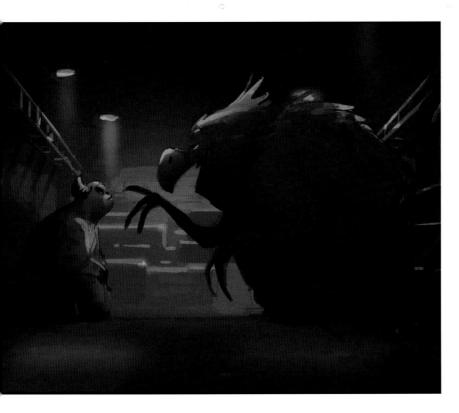

THIS PAGE/ Storybeat paintings by Naveen Selvanathan (Above). Early character sketches by Annette Marnat (Below).

emotion?" Grieve says. "You want it to look amazing and for everything to be top-notch quality in terms of technology, but really, it always comes down to the story. Is it something that will grab peoples' attention and hold their interest all the way through? It's a cliché that 'story is king' but it's true: You can have all the bells and whistles in the world but if you don't have a good story, it's not going to matter."

The filmmakers relied on two people to craft a design style for the characters: production designer Christophe Lautrette, who created sketches for each one, and character designer Max Narciso. "Christophe's production design drove the style of the movie," says art director Fred Warter, "while Max, whose work is akin to Disney artist Milt Kahl in the 1960s and 70s, took Christophe's sketches and realized them into something that is very unique and appealing. The idea was to always have all the characters – humans or monsters – feel like they're part of the same world. Max was our guarantee that things would all be cohesive from a design standpoint."

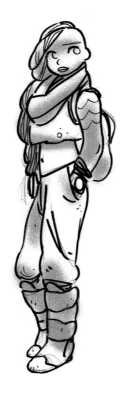
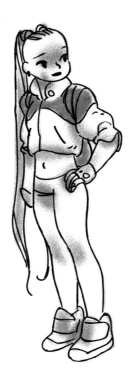

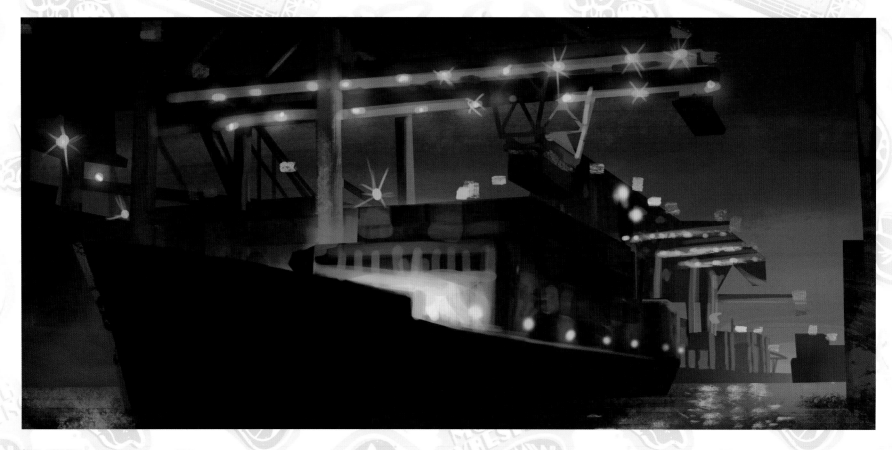

THIS SPREAD/ Color keys by Julia Blattman.

 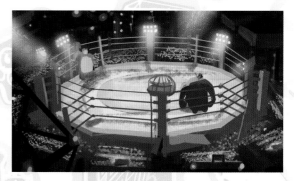

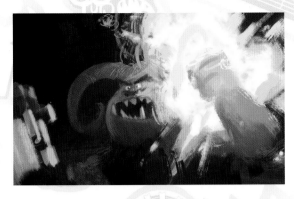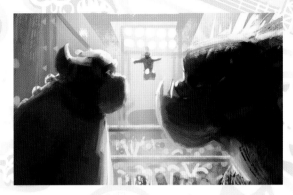

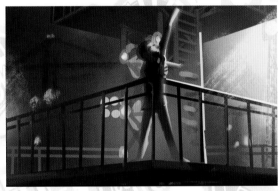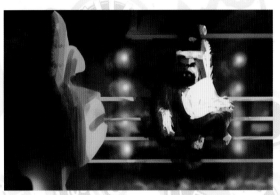

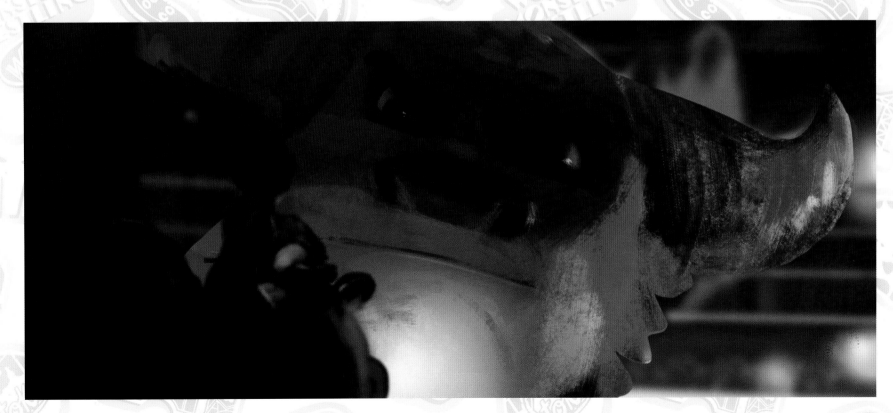

MONSTERS

When you're creating a movie about incredible behemoths, the No. 1 imperative is to make sure that they're believable – that they look like they live in the world around them and that they can convincingly interact with their human counterparts. The greatest hurdle the *Rumble* filmmakers had to overcome was, by far, establishing a realistic sense of scale between the beasts and their smaller friends. Thankfully, director Hamish Grieve had a few tricks up his sleeve. More than a decade ago, he was a story artist on DreamWorks Animation's *Monsters vs. Aliens*, a film that featured a fifty-foot woman as its lead character; Grieve used a lot of the same storyboarding techniques on *Rumble* that he used on that film, such as having the big guys disappear out of frame and incorporating atmospheric perspective.

"With atmospheric perspective, as these giant monsters go up toward the horizon, they become more and more obscured," says art director Fred Warter. "It gives a sense that they're part of the world instead of being in sharp focus in the foreground."

Just as important was the ability to sell the monsters' bearing as a whole. "If we were being technically accurate," says animator Omar El Hindi, "the monsters would feel like they would be moving in slow motion compared to our humans, their speech would be significantly slower, and overall, the fight scenes would be less dynamic.

We decided to opt for a hybrid, trying to keep the weight of the monsters significant – especially in scenes with human characters in them. Then, when it was a monster vs. monster situation, we had a bit more freedom to let loose."

"We have pretty realistic shots, but also crazy Looney Tunes squash-and-stretch moments," Grieve elaborates. "The film was always a tightrope walk between believability and fun – Tentacular can do stuff no real wrestler can do, for instance. We hired some amazing fight choreographers early on to use as reference, and to figure out how we could incorporate the monsters' physical characteristics with actual wrestling and fighting moves."

Folks in the lighting department were charged with accentuating the monsters' features and animation – it was a fun exercise, says lighting supervisor Liz Hemme. "Our huge colorful monsters have been a blast to light. They all have a unique form which gives us a challenge to accentuate their features and animation. We often use haze, saturation and light attention to sell their massive scale."

In researching oversized characters from the past, the *Rumble* team referenced such classic monster movies as *King Kong, Godzilla*, and *The Iron Giant*. "What we noticed in those movies is that the monsters don't talk," Grieve says. "We have these giant creatures who are funny, fully-represented personalities."

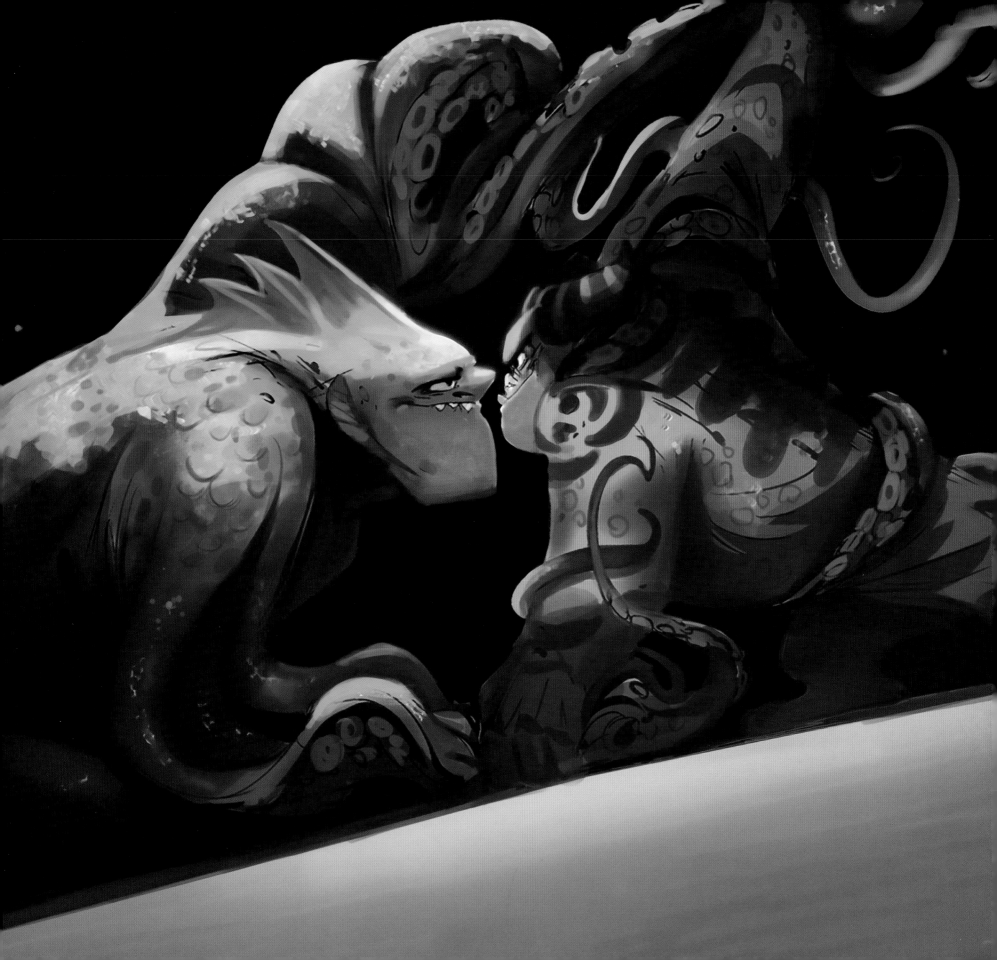

RAYBURN JR.

"THIS MOVE ISN'T IN ANY PLAYBOOK"

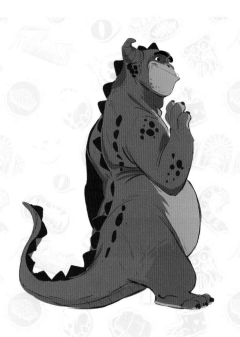

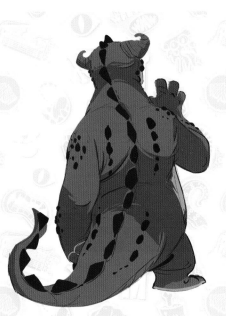

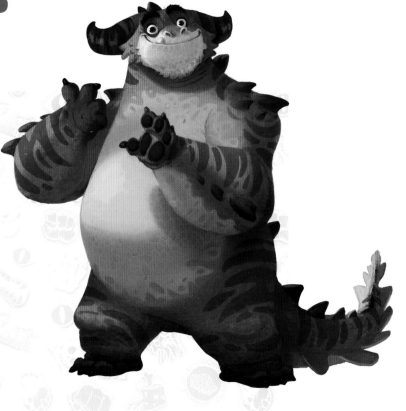

The reluctant hero of *Rumble* is, of course, Rayburn Jr. He's a self-described loser and he's perfectly OK with that. He thinks he has some very big pawprints to fill, and he'd just rather not. Instead, he's built a comfortable existence for himself away from his father's shadow in the bowels of Pittsmore, as 'Steve,' the schlubby wrestler who has never won a fight. Outside of the ring, Rayburn's favorite pastimes are eating, sleeping, and generally doing nothing. When Winnie comes along, though, she motivates him to be better and taps into his hidden love for salsa dancing. "My absolute favorite moment in the film is when Winnie realizes her training matches simply don't seem to work," says animation consultant Simon Otto. "She finally gives up and resets by asking Rayburn about his passions. His response – saying nothing at first, but then letting the word salsa slip out, is hilarious. I love the way he instantly regrets having divulged that." It's a funny moment but it's also a turning point: with Winnie's guidance, and despite his protestations, salsa becomes Rayburn's secret weapon in winning matches. "Winnie is the irresistible force and Rayburn is the immovable object," says director Hamish Grieve, "and their

ABOVE/ Full color character concepts by Max Narciso (Left). Painterly character illustration by Julia Blattman (Right).

NEXT PAGE/ Facial expression study by Max Narciso (Top). Sketches by Christophe Lautrette (Middle and Top).

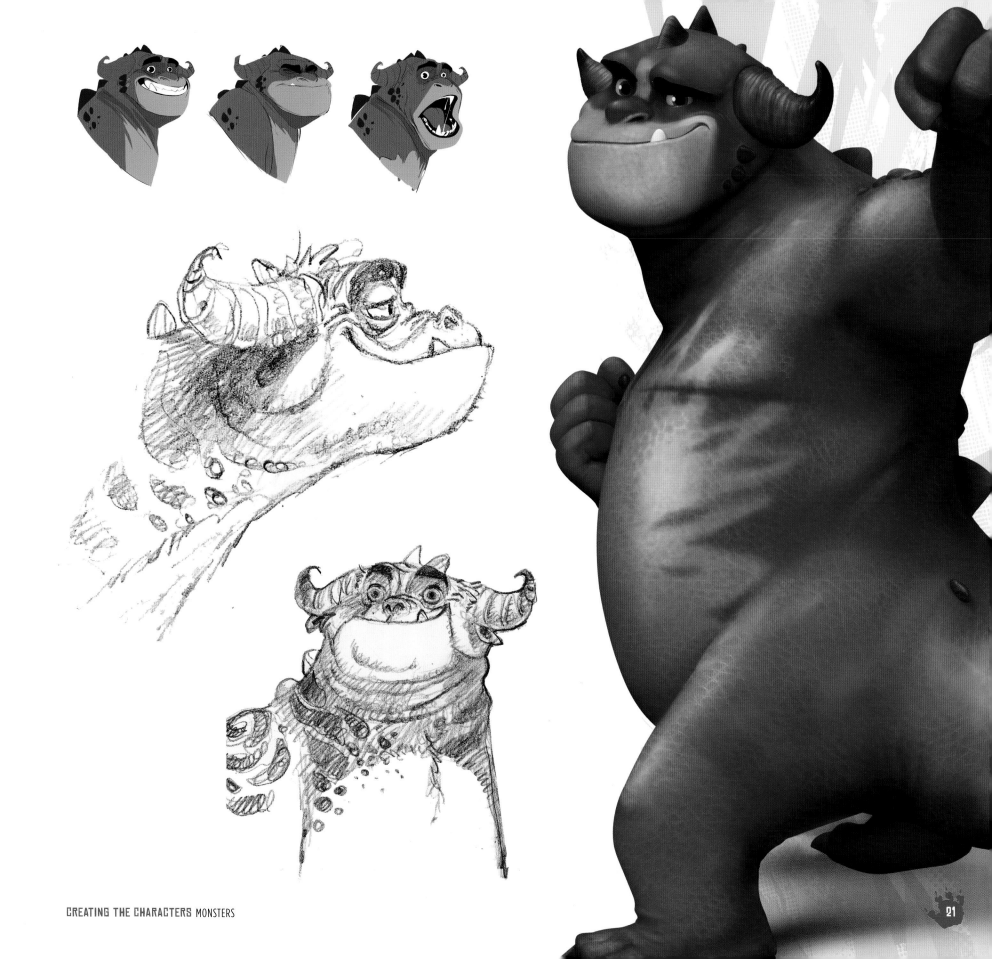

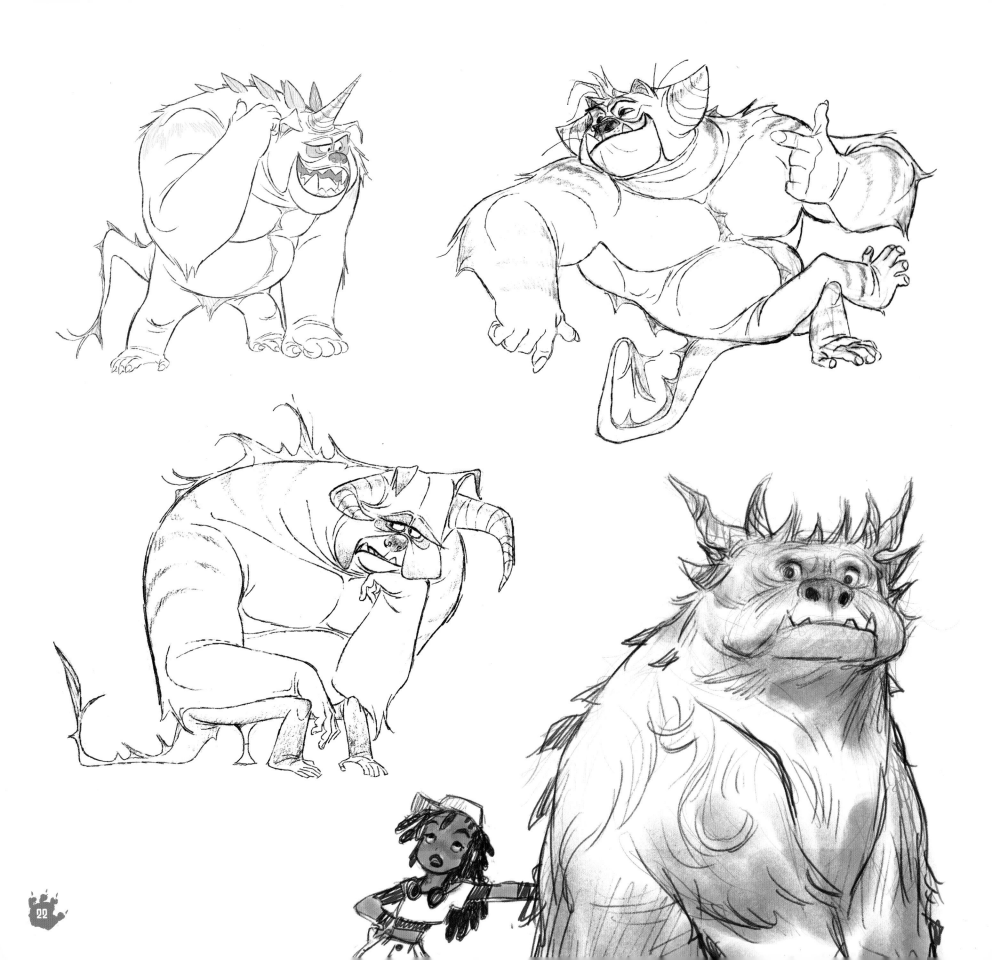

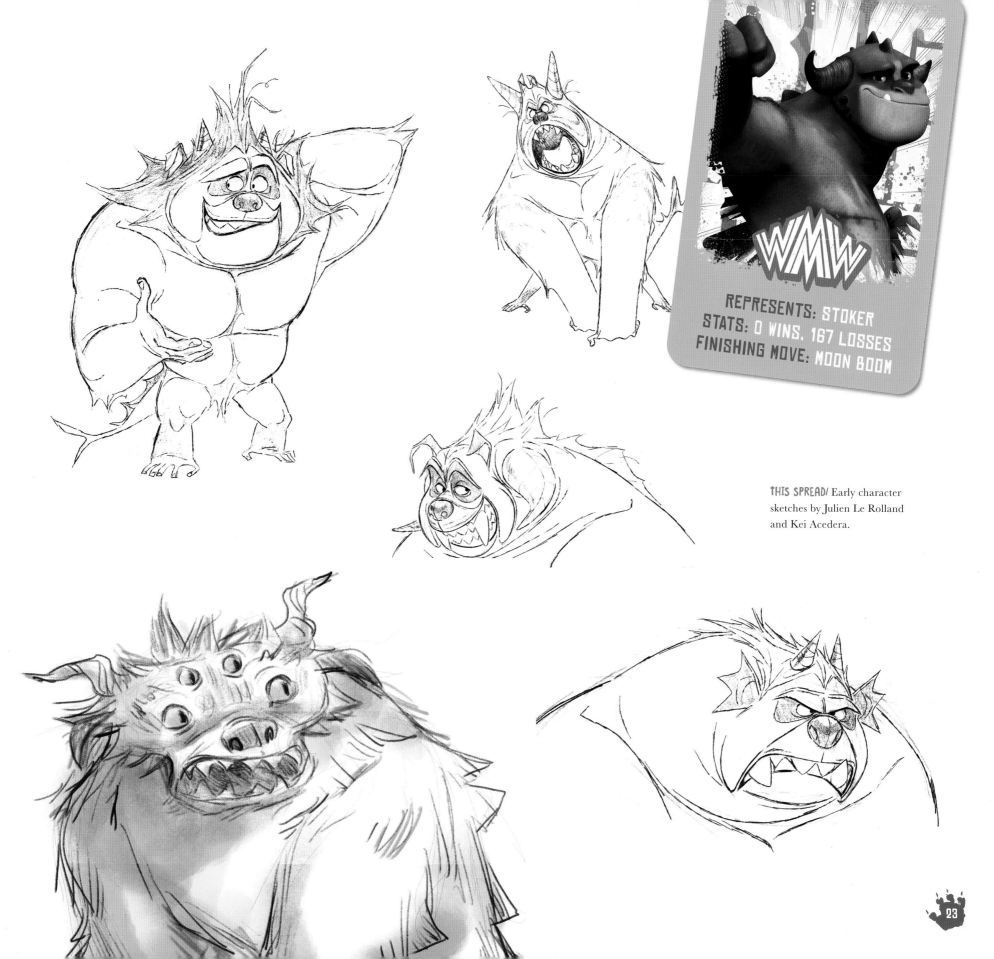

REPRESENTS: STOKER
STATS: 0 WINS, 167 LOSSES
FINISHING MOVE: MOON BOOM

THIS SPREAD/ Early character sketches by Julien Le Rolland and Kei Acedera.

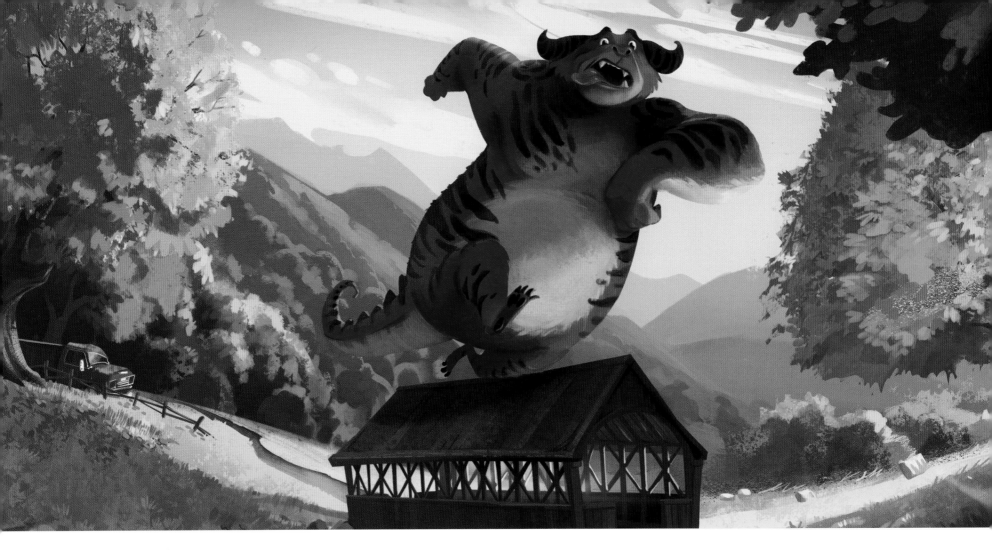

THIS PAGE/ Cathleen McAllister (Above), Max Narciso (Below), and Christophe Lautrette (Far Right).

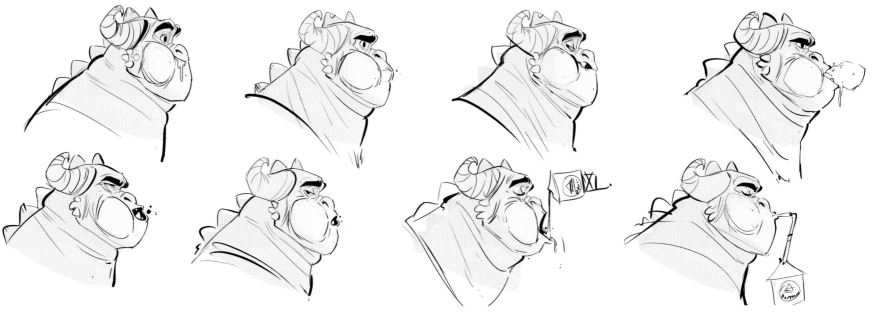

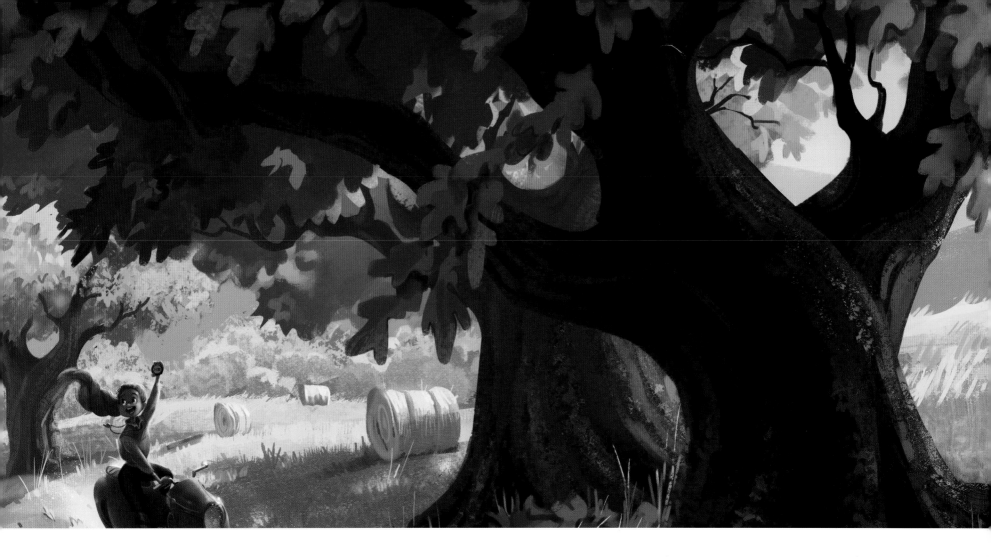

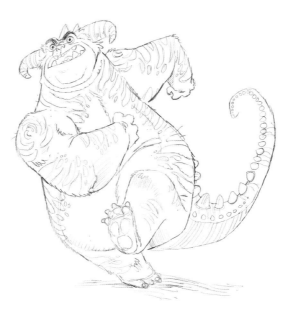

"Winnie is the irresistible force and Rayburn is the immovable object."

HAMISH GRIEVE – DIRECTOR

THIS PAGE/ Color concepts by Wouter Tulp (Top). Storybeat paintings by Cathleen McAllister (Bottom Left) and Julia Blattman (Bottom Right).

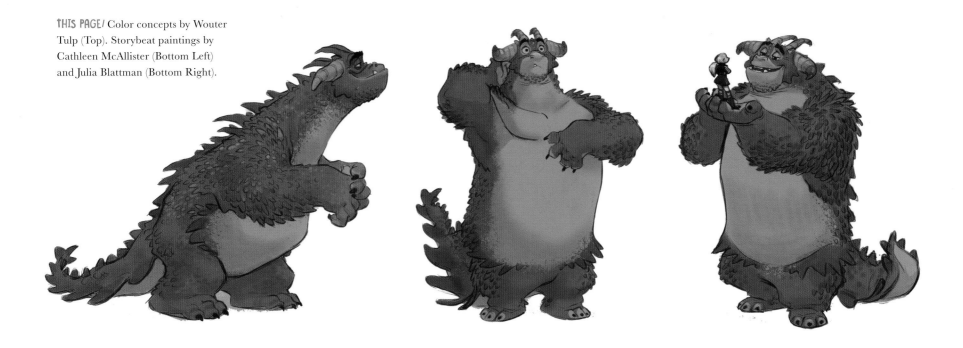

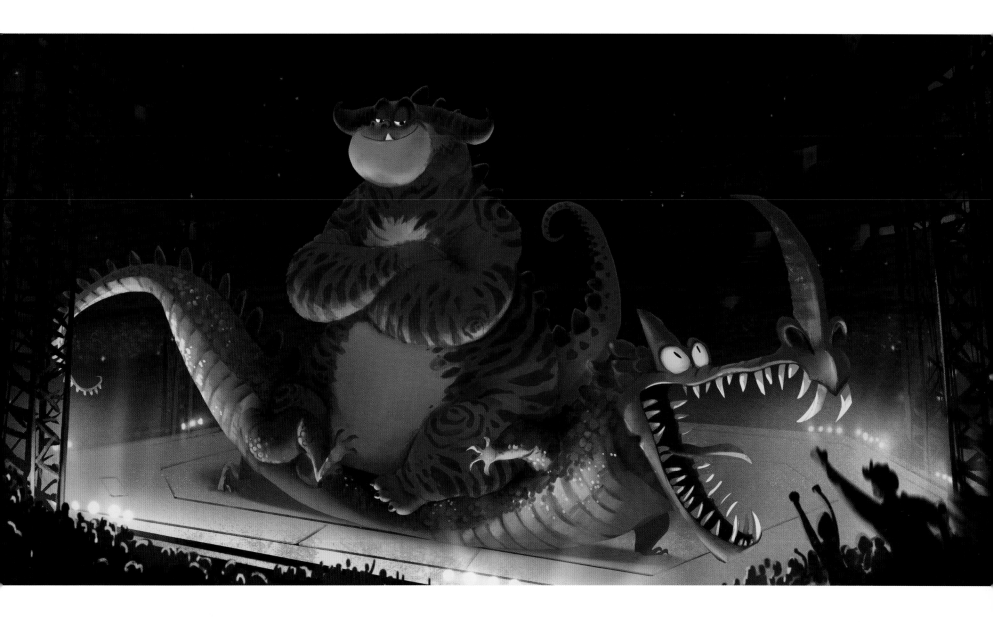

relationship is all about that collision. He comes to realize that he's more than just a loser but he's not just his dad, either. He doesn't just become a winner, he becomes a better version of himself."

Weighing in at twenty-two tons of flabby fun, he's forty-three-feet tall. Not the biggest monster in *Rumble*, but not the smallest, either. His skin is a warm brown. Bony plates on his spine give him the appearance of a dragon, while the horns on his head suggest some type of bovine. He's

anthropomorphic and when he strides down the street, people can feel him coming! "Rayburn went through a lot of changes," says art director Fred Warter. "A lot of artists had their hand at drawing him. Production designer Christophe Lautrette came the closest. He brought in a little bit of bulldog and a little bit of dragon and somehow, he started to come together." He's also got a big, friendly smile. "I root for Rayburn," Warter says. "He's a very relatable character."

ABOVE/ Storybeat painting by Wouter Tulp.

NEXT PAGE/ Rayburn Sr. illustration by Christophe Lautrette (Left). Moment painting by Paige Woodward (Right).

RAYBURN SR.

Rayburn's dad, the legendary Rayburn Sr., was larger than life in more ways than one. He was the undisputed champion and the greatest monster wrestler the world had ever seen. Standing a towering sixty-five-feet tall, he was also huge!

Early on, Rayburn Sr. was a buffed-out version of his corpulent son, just a little bigger and more mature – and with the confidence his son initially lacks. They shared the same earthy skin tone with tiger stripes and there was no mistaking that they were related. For the sake of the story, though, it was decided

that Rayburn Sr. had to have a different appearance. "It needed to be less obvious that he was Rayburn's dad," art director Fred Warter says. "We got to a point where we felt that he could be, but at the same time it was still questionable whether he was or wasn't. That's where we needed to be." But because his new color palette was red and black, Paramount executives made the comment that he resembled a demon, which was not what they wanted. The designers went in a different direction and Rayburn Sr. emerged as yellow and green. He's got the same type of bovine-inspired horns as his son, only larger and more impressive.

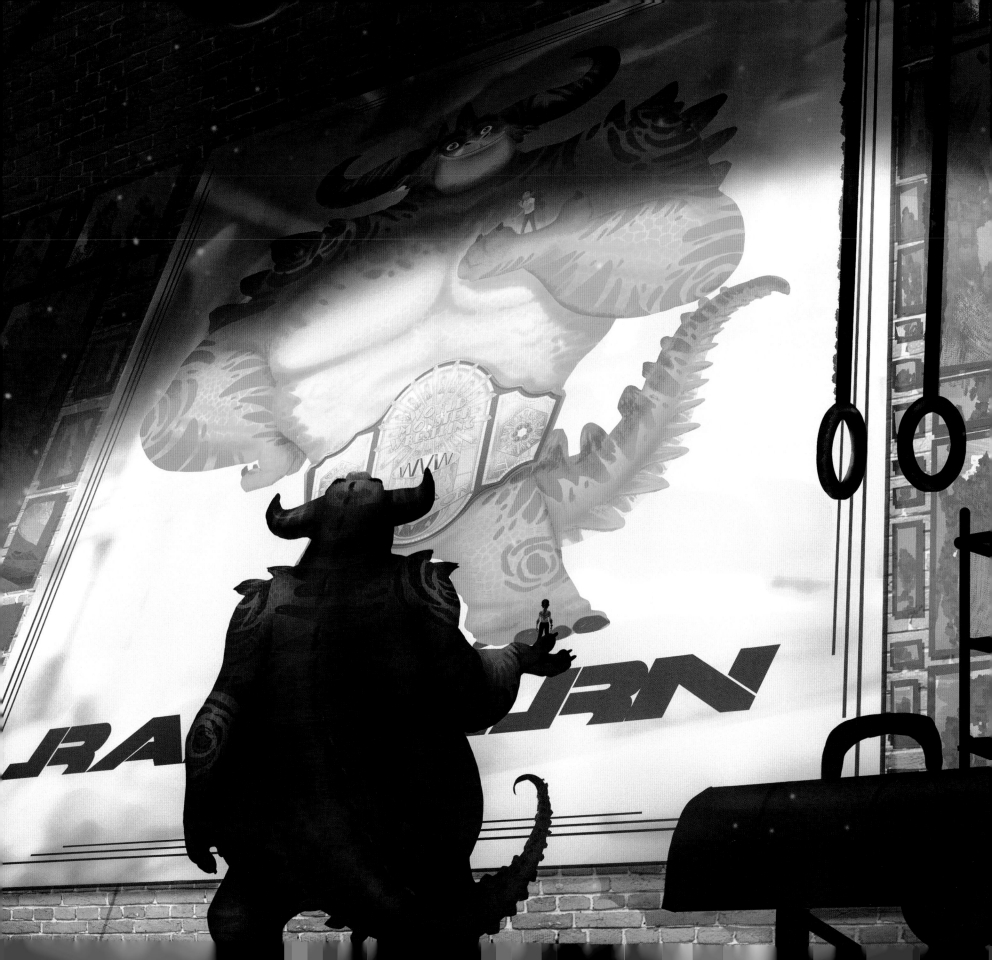

TENTACULAR

"I'M ABOUT TO MAKE HISTORY, MY OWN HISTORY"

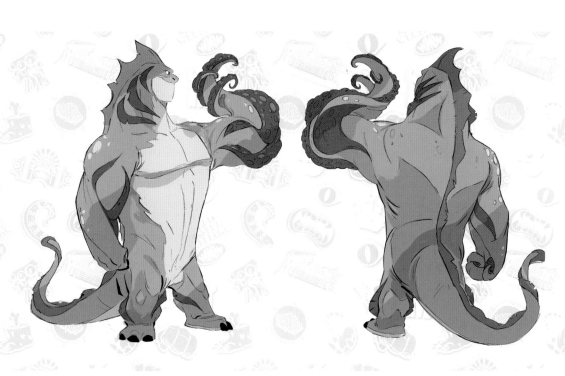

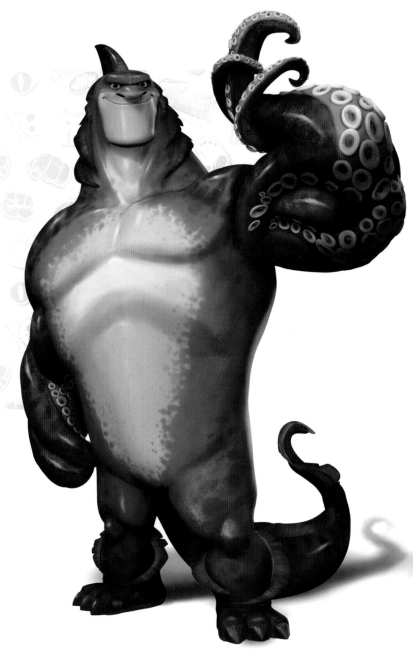

Is there a stadium big enough for Tentacular's incredible ego? He's sixty feet-tall and twenty-four tons of pure glow-in-the-dark muscle, which makes him unbeatable in the ring – and he knows it. A flexing, flaunting fighting machine with the face of a shark and three tentacles on each arm, wrestling Tentacular is like taking on three monsters at once. "I thought it would be cool if he had some tentacles that we don't see all the time," says production designer Christophe Lautrette, who designed the brute.

ABOVE/ Color character sketches by Max Narciso.

NEXT PAGE/ Sketches by Max Narciso (Top), David Colman (Middle), and Wouter Tulp (Bottom).

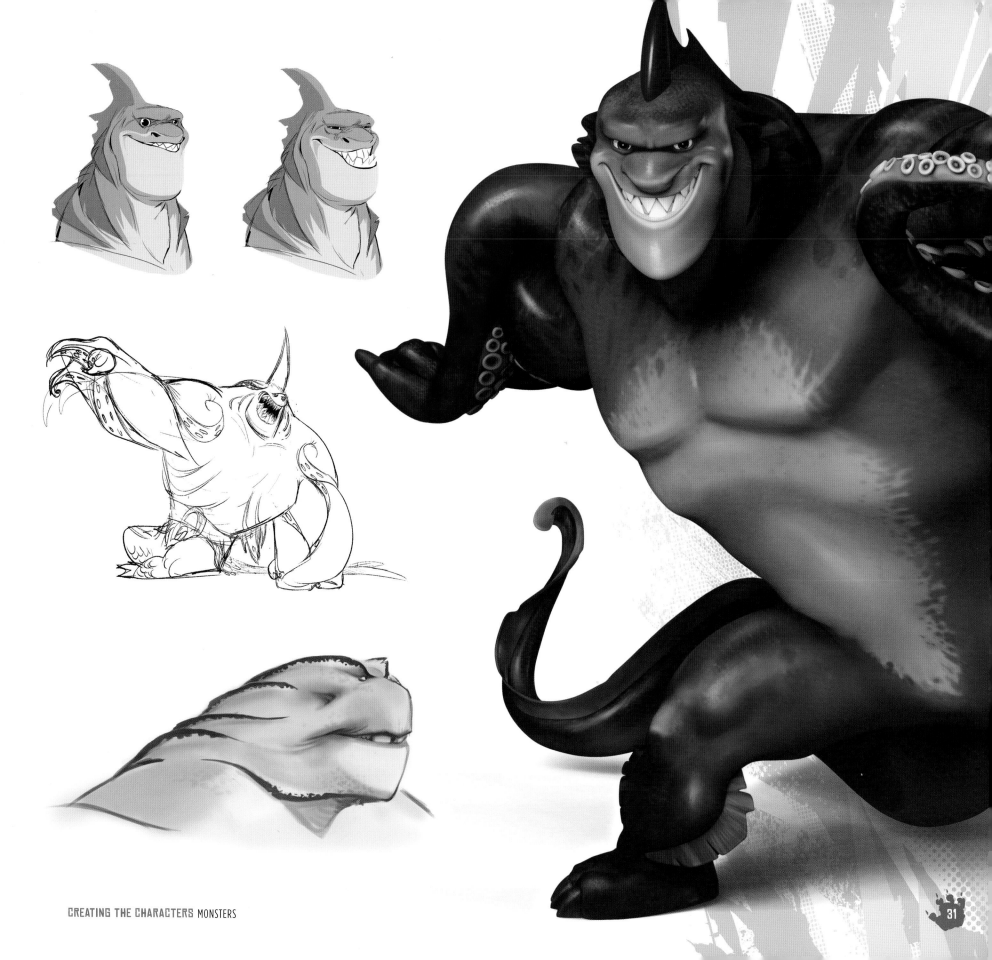

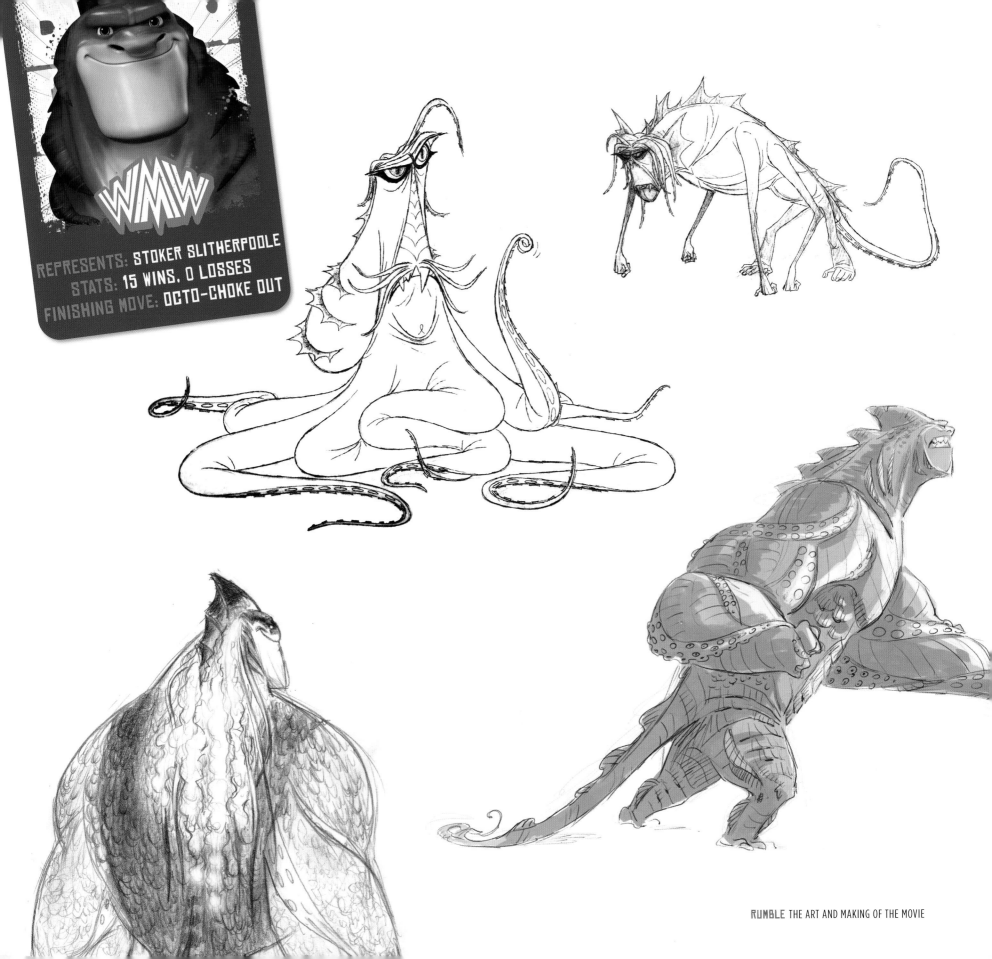

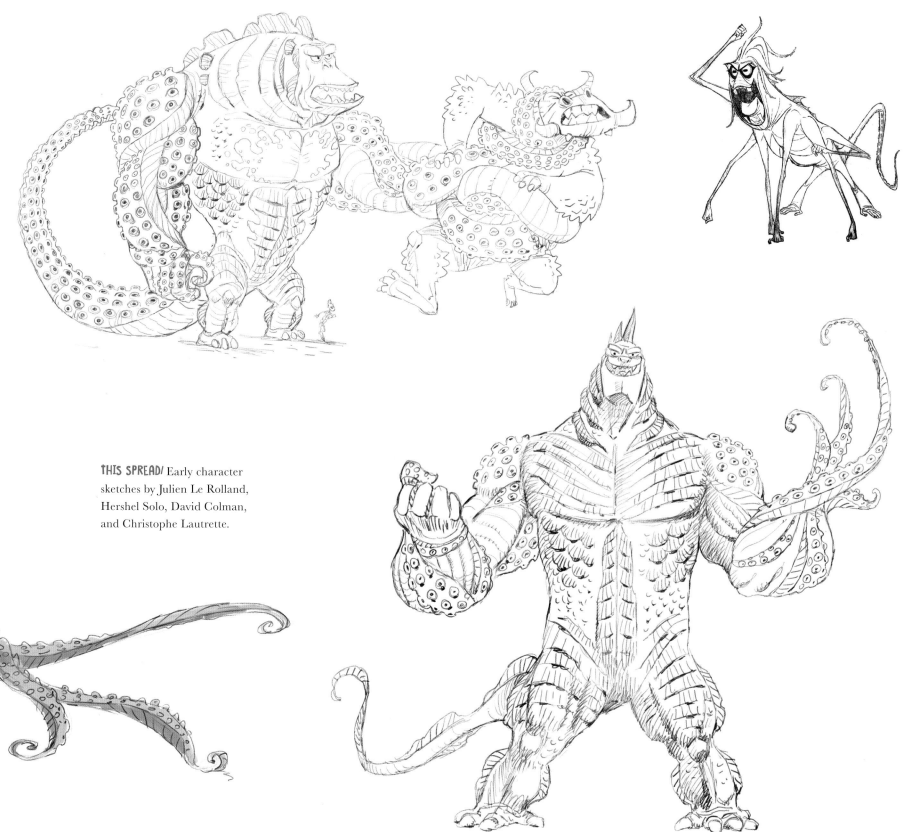

THIS SPREAD/ Early character sketches by Julien Le Rolland, Hershel Solo, David Colman, and Christophe Lautrette.

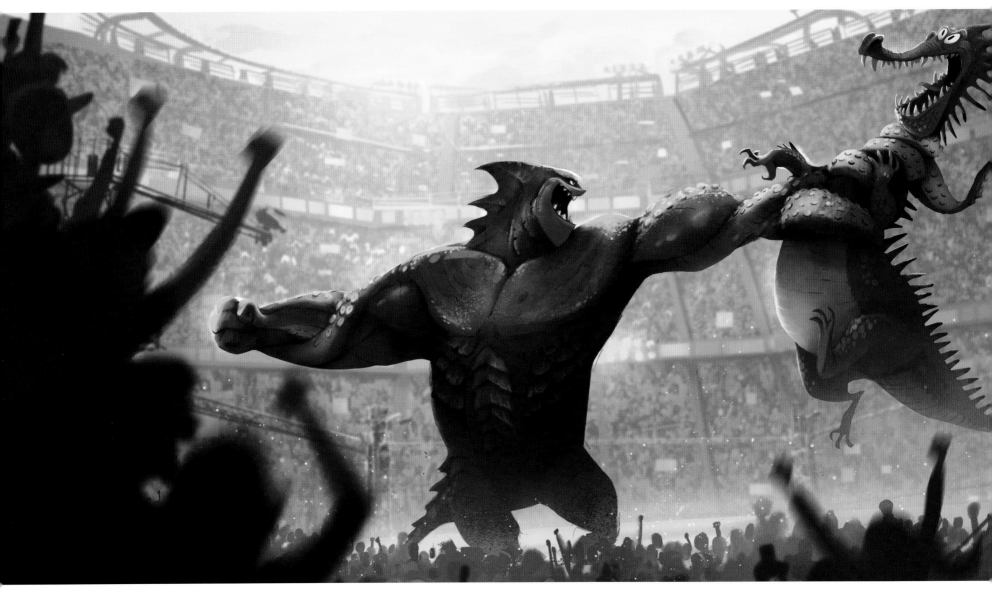

THIS PAGE/ Storybeat painting by Cathleen McAllister (Above). Early character sketch by Christophe Lautrette (Far Right). Facial expression and tentacle studies by Max Narciso (Below and Top Right).

"Then, when he's on the battlefield, he unleashes his secret weapon. This make him really powerful because you never know when it's going to happen."

Tentacular wasn't always an egomaniac. At one point, he "was more of the dumb jock type who was being controlled and manipulated," head of story Lawrence Gong says. And though everyone is shocked when he announces that he's leaving Stoker, director Hamish Grieve suggests he was never a native son to begin with. "There used to be a line in the script that says that after Rayburn Sr. dies, Siggy finds this young hungry monster 'in the minnow leagues,' and brings him back to Stoker."

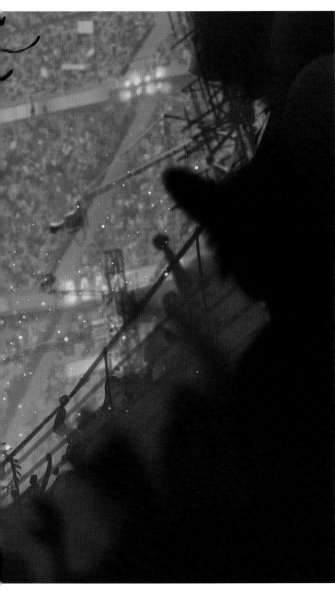

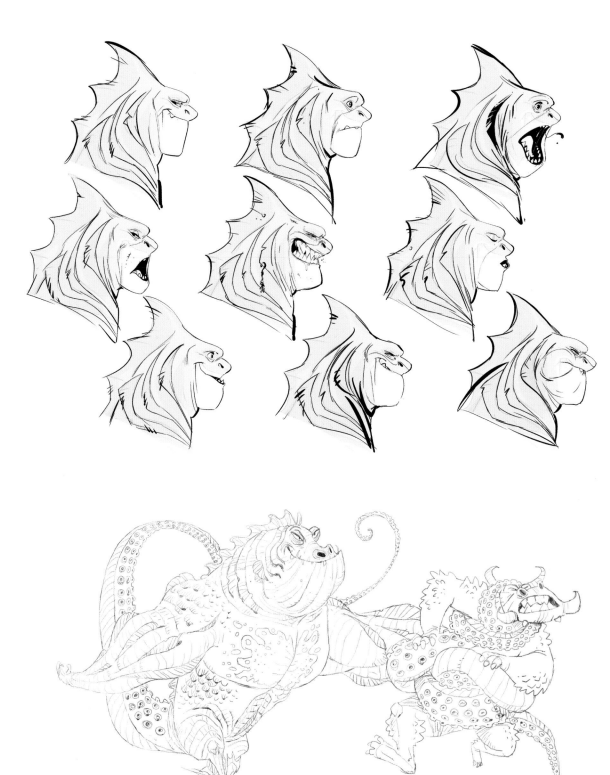

"Then, when he's on the battlefield, he unleashes his secret weapon. This make him really powerful because you never know when it's going to happen."

CHRISTOPHE LAUTRETTE –
PRODUCTION DESIGNER

THIS PAGE/ Storybeat painting by Fred Warter (Right), concept by Christophe Lautrette (Top Left), and color key by David Colman (Bottom Left).

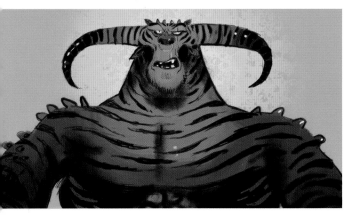

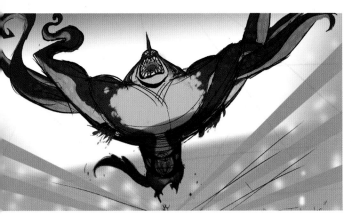

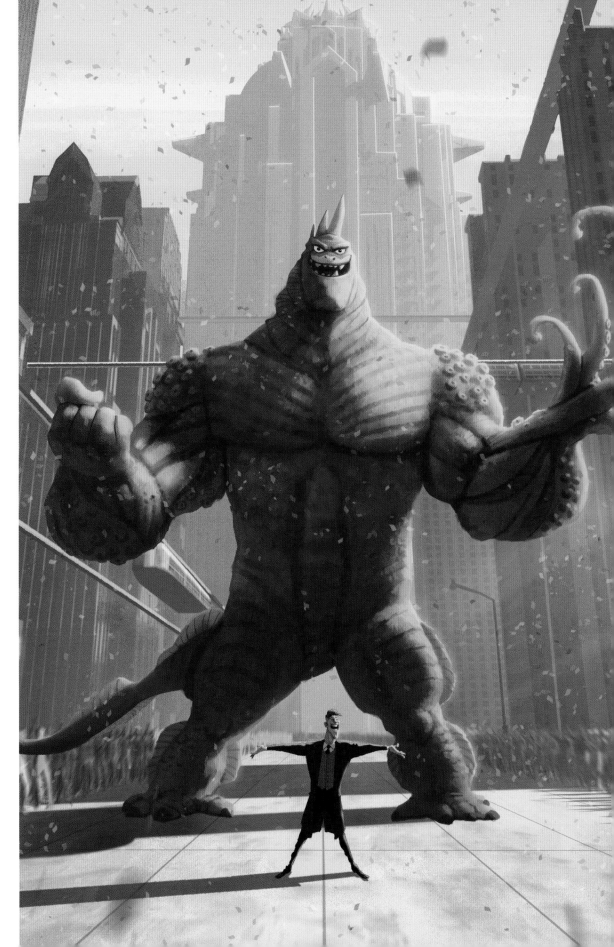

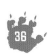

THIS PAGE/ Color character painting by Christophe Lautrette (Right) and color sketches by Max Narciso (Left).

LIGHTS OUT MCGINTY

"THAT IS A HIGH DEGREE OF DIFFICULTY RIGHT THERE"

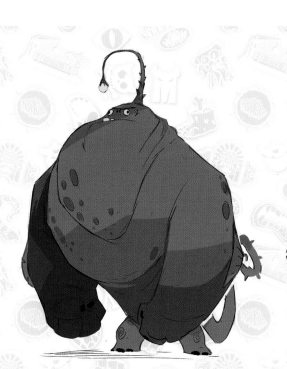

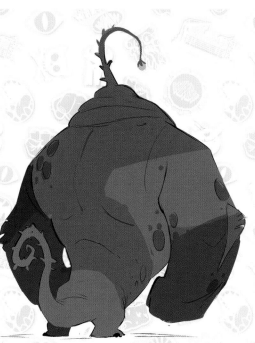

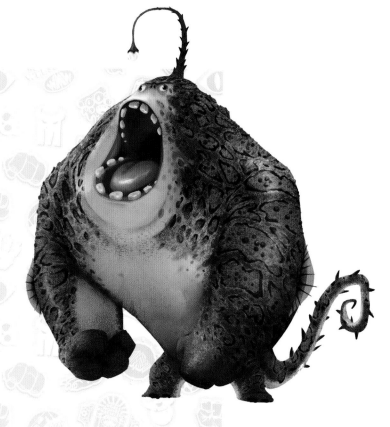

Lights Out McGinty is a former wrestler-turned-sportscaster who co-hosts The Mac & Marc Show with his human counterpart Marc Remy.

Resembling a genetically mutated frog, he's nineteen tons and thirty-three-feet tall; he has a huge upper body, which tapers to smaller lower half, small legs, and enormous hands. He's easily distracted by the anglerfish-style light dangling over his head that, as an added genetic bonus, turns off when it's clapped at.

Even though he's a former athlete, Lights Out isn't all jock. He has a soft spot for dancing, too, and surprises Marc Remy with his knowledge about the pursuit. As the movie progresses, his sensitive side emerges front and center to comical effect.

Says director Hamish Grieve: "In earlier versions of the script, Marc Remy and Lights Out McGinty were very much side characters, but now, as played by Stephen A. Smith and Jimmy Tatro, they steal the show. I don't think anyone thought they would be the double act in the movie that they definitely are."

ABOVE/ Character sketch by Max Narciso (Left). Color concept by Cathleen McAllister (Right).

NEXT PAGE/ Color concept by Max Narciso (Top). Character sketch by David Colman (Bottom).

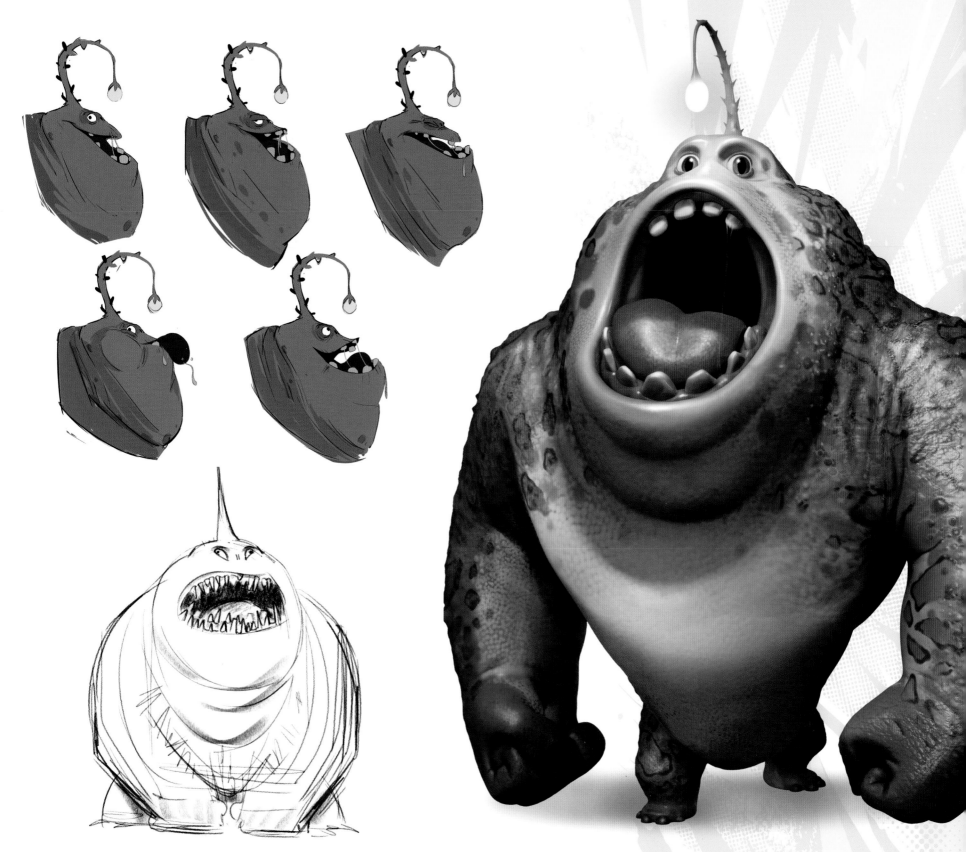

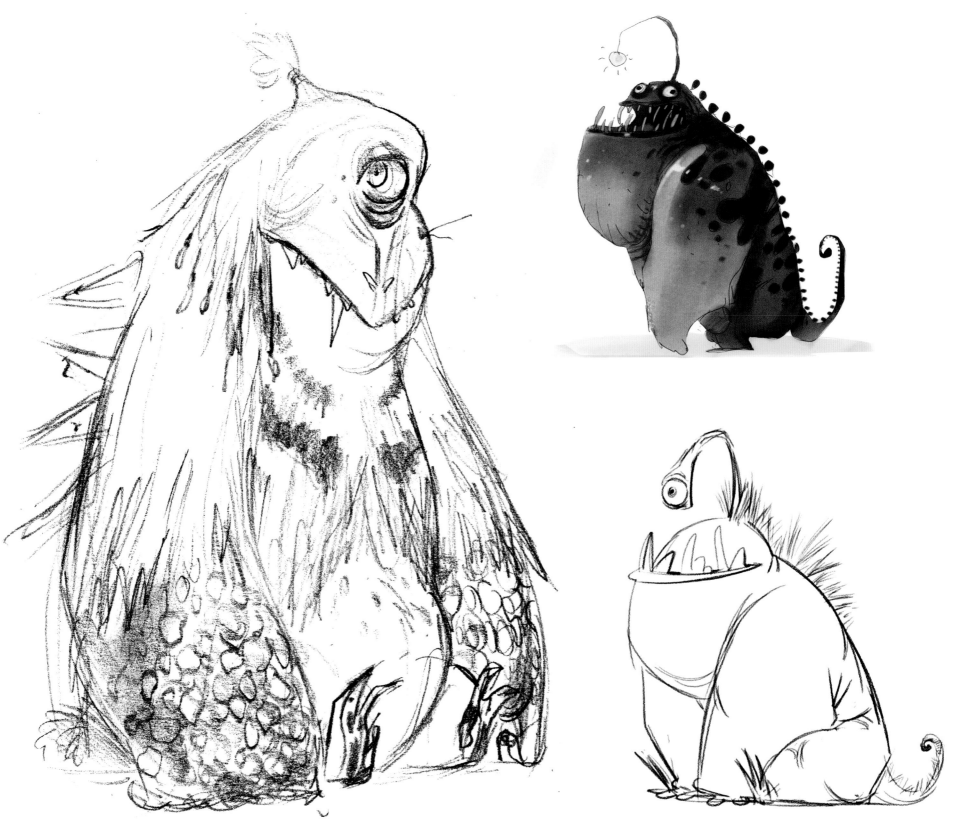

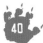

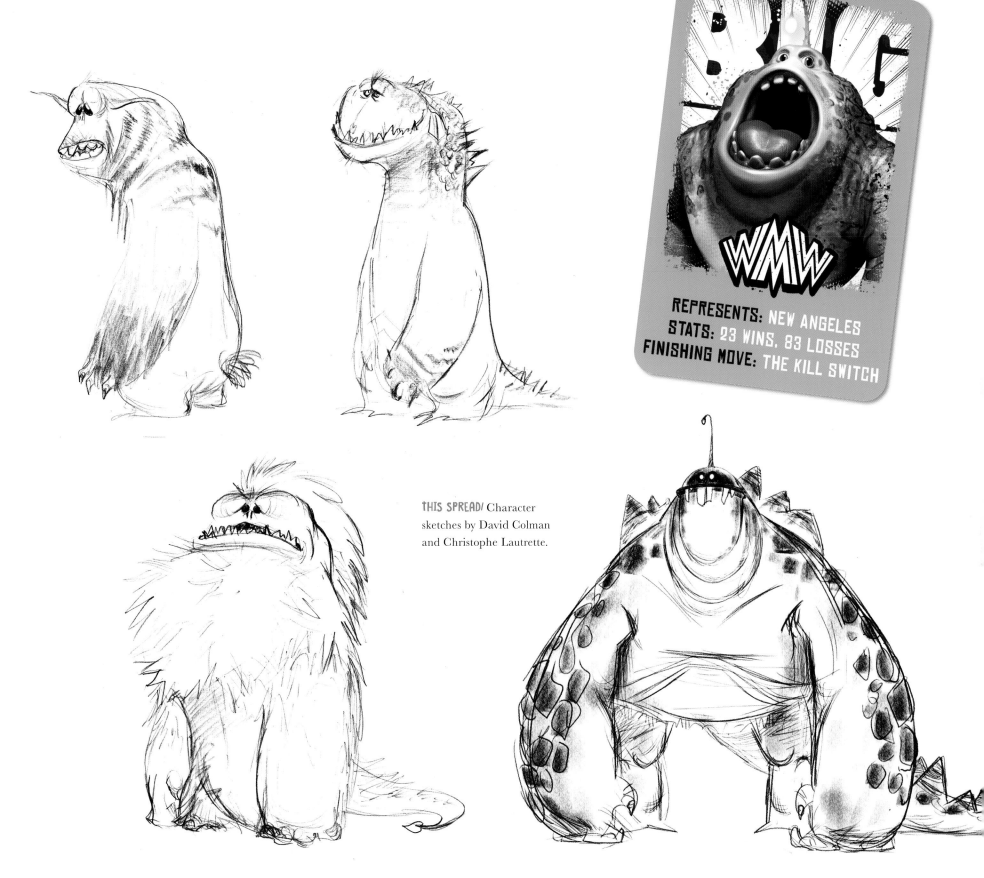

REPRESENTS: NEW ANGELES
STATS: 23 WINS, 83 LOSSES
FINISHING MOVE: THE KILL SWITCH

THIS SPREAD/ Character sketches by David Colman and Christophe Lautrette.

KING GORGE
"BOW TO YOUR KING"

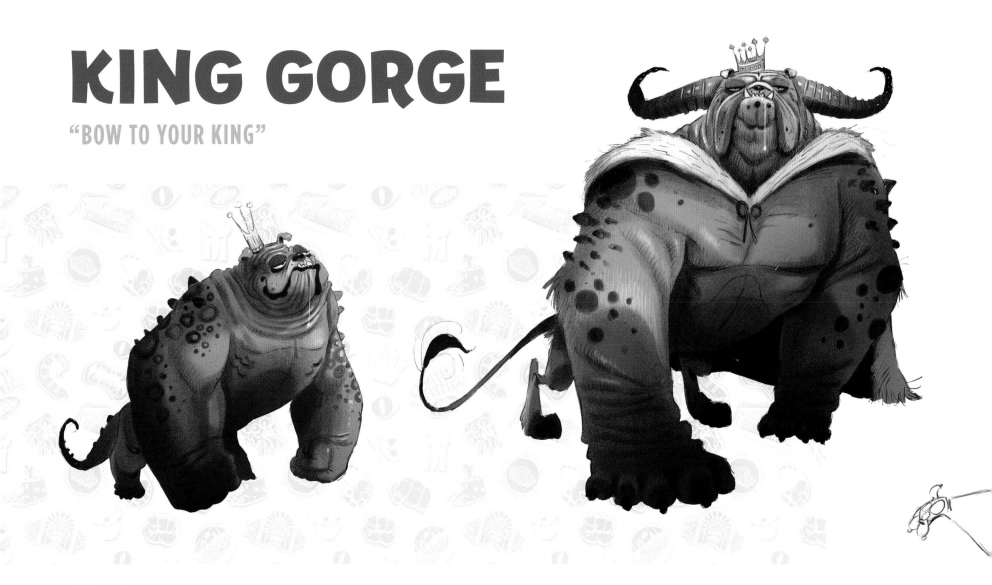

ABOVE/ Full ink character concepts by Christophe Lautrette.

He's not King George – he's King *Gorge*! At the start of *Rumble*, before he's spectacularly dethroned by Tentacular, King Gorge is the reigning wrestling champ, the holder of the Big Belt. Straight from the United Kingdom, he's the no-bull British Bulldog, the Slimy Limey, the one everyone in Stoker loves to hate. Someone who doesn't hate him at all is director Hamish Grieve, who came up with the idea for King Gorge. "He's my baby. I said to myself, 'If I'm going to do a monster movie, the ten-year-old boy in me is going to make sure that one of those monsters is mine,'" he chuckles. "My scratchy scrawls were taken and made amazing by a real artist."

King Gorge is a particularly fun character in *Rumble*. He's got a whole British royalty schtick going on. Trumpets announce his arrival. He holds a scepter and wears a crown; a Union Jack cape is draped over his canine back. Prior to entering the ring, he drinks from a teacup and commands the crowd to "bow down to your king!"

Dubbed the "British Brawler," with his long, spiked reptilian tail, he's fifty-five-feet tall and twenty-seven tons of pure pain and slobber. He may look proper, but he plays dirty. Those who are paying attention will notice his tell in the ring: he licks his nose before he hooks left with his horn.

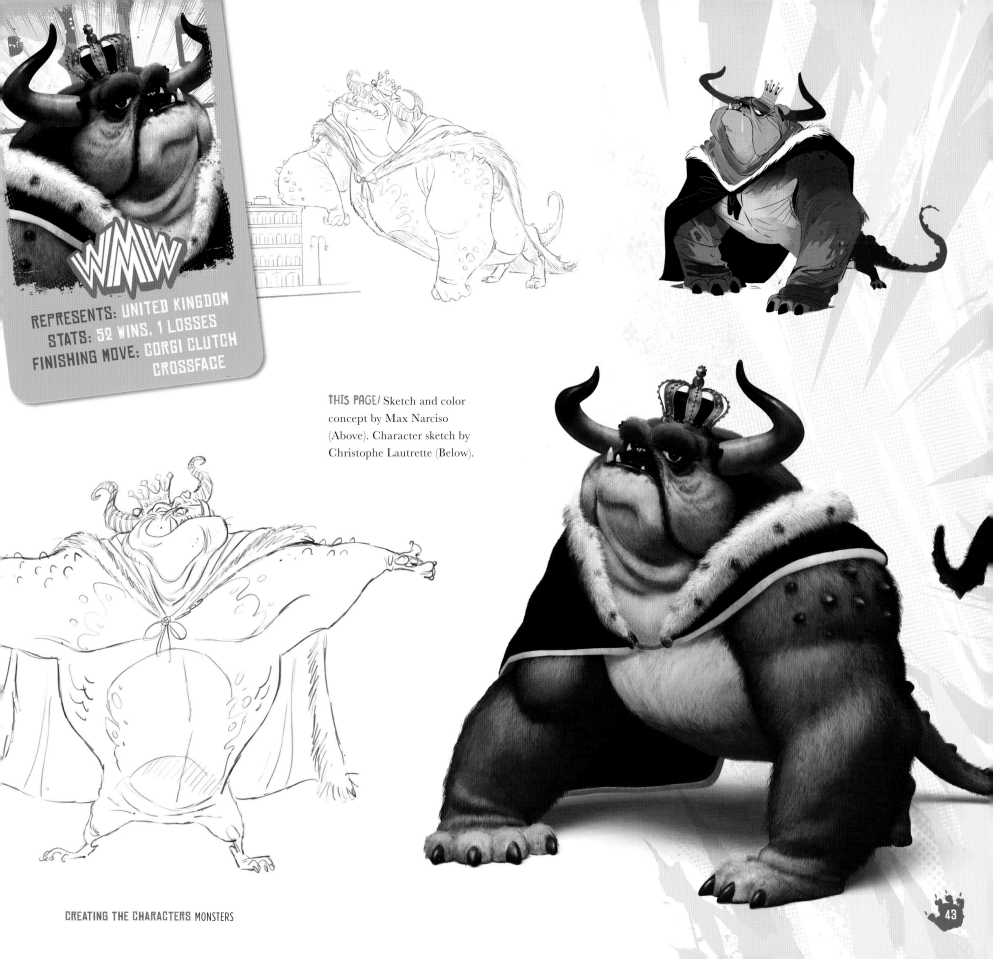

REPRESENTS: UNITED KINGDOM
STATS: 52 WINS, 1 LOSSES
FINISHING MOVE: CORGI CLUTCH CROSSFACE

THIS PAGE/ Sketch and color concept by Max Narciso (Above). Character sketch by Christophe Lautrette (Below).

LADY MAYHEN

"DO YOU KNOW WHAT HAPPENS TO THOSE WHO BETRAY LADY MAYHEN?"

WMW
REPRESENTS: PITTSMORE
STATS: 89 WINS, 2 LOSSES
FINISHING MOVE: MANI-PEDI POWERDROP

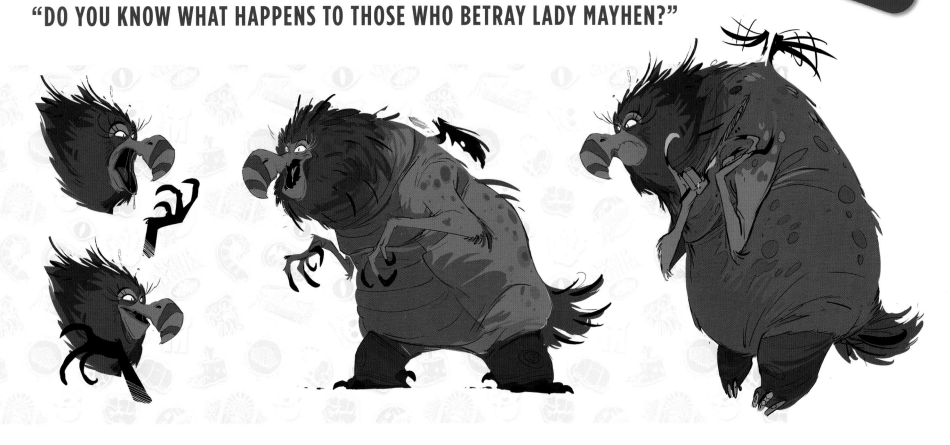

If there's one monster you don't want to mess with, it's Lady Mayhen, the manager of the underground fight club in Pittsmore. Sinister and intimidating, she's seventy-eight-feet tall and a whopping fifty-six tons. She is, by far, the largest, scariest monster in *Rumble*. An obese, bird-like creature, she has tiny wings that flutter ferociously to lift her corpulent frame a few feet off the ground. The sharp bedazzled toe talons she's constantly filing can inflict some serious damage (in her wrestling days, she was known for her finishing move, the Mani-Pedi Powerdrop), and there's no telling what her large, hooked beak can do. No one could ever call her pretty, but she does have lots of jewel-toned feathers covering her back with another set running down her spine, mimicking the spiked bony plates found on other monsters.

"She was so much fun that her part grew quite a lot," director Hamish Grieve says, to the point that later in the story, her attitude changes into a fan girl supporter when her star 'loser' turns out to be champion.

ABOVE/ Color character designs by Max Narciso.

NEXT PAGE/ Ink concept sketches by Christophe Lautrette.

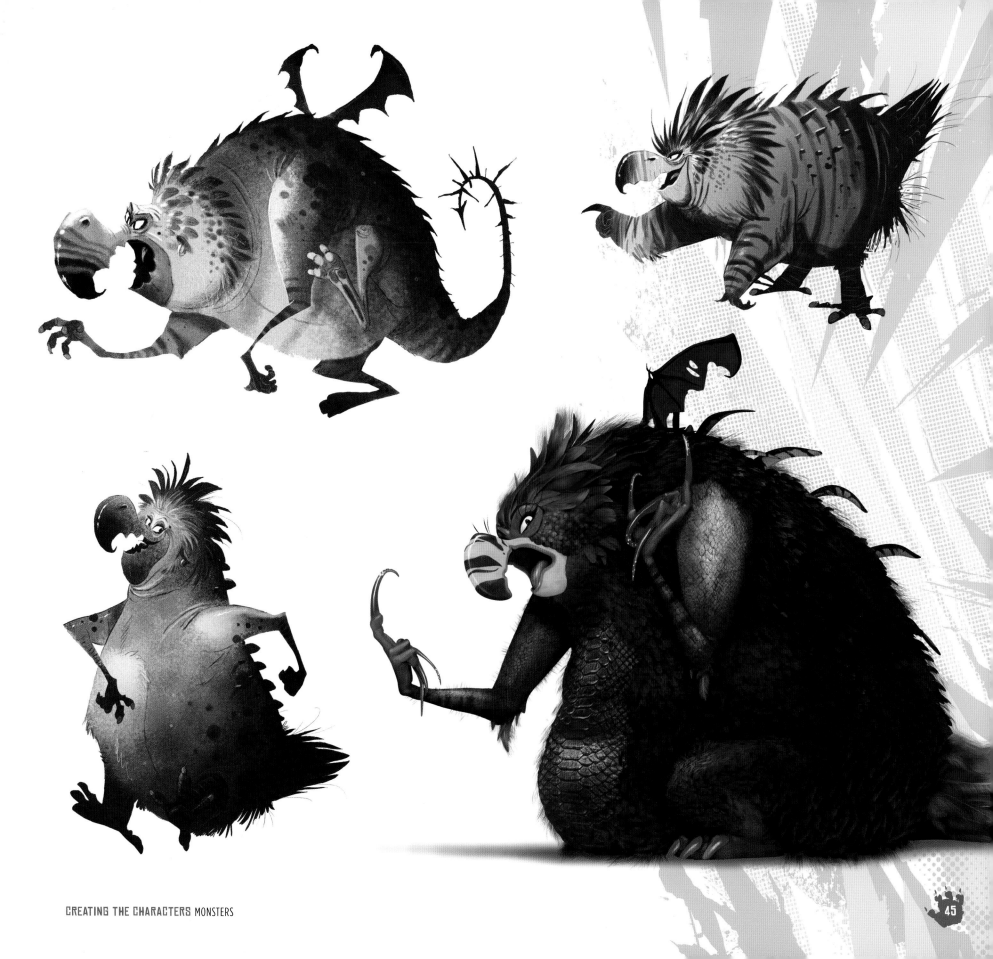

BACKGROUND MONSTERS
RAMARILLA

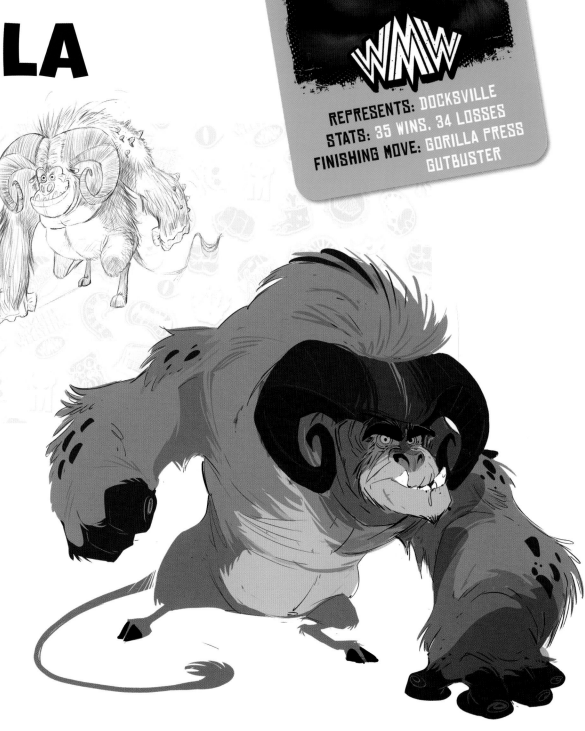

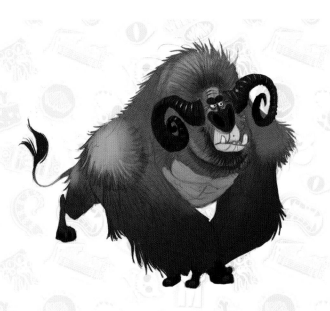

Ramarilla 'Killa' Jackson has two ram horns and one serious anger problem. Nicknamed Wham-Bam Ramarilla, he's been known to smash oil tankers on his head and throw shipping containers around like they're discarded banana peels. His signature move is pounding his chest like King Kong, which isn't surprising: After all, this eighteen-ton, forty-nine-foot monster is part ram and part gorilla! Ramarilla is the first monster Rayburn fights after Winnie becomes his coach, and while he may be strong, he does have a weakness: he tires easily. In their shipyard battle, Rayburn is less exhausted than Ramarilla… and comes out victorious!

AXEHAMMER

WMW

REPRESENTS: IRELAND
STATS: 45 WINS, 18 LOSSES
FINISHING MOVE: THE DEFENESTRATOR

Huge, scary, and mean, Axehammer is a crowd favorite at the underground fight club in Pittsmore. She's a fierce, intimidating competitor, even by monster standards – a pile-driving powerhouse who flexes, dabs, and takes no prisoners. Her first signature move is tossing her opponents long distances. Her second one is batting her long eyelashes at Rayburn. At thirty-five-feet tall and twenty-one tons, she's akin to a gigantic, jewel-toned stegosaurus. Watch out for her spiked mace tail, razor-sharp talons, and jagged, predatory teeth!

PREVIOUS PAGE/ Ink character design and sketch by Christophe Lautrette (top). Ink concept design by Max Narciso (bottom).

THIS PAGE/ Concept sketch by Max Narciso.

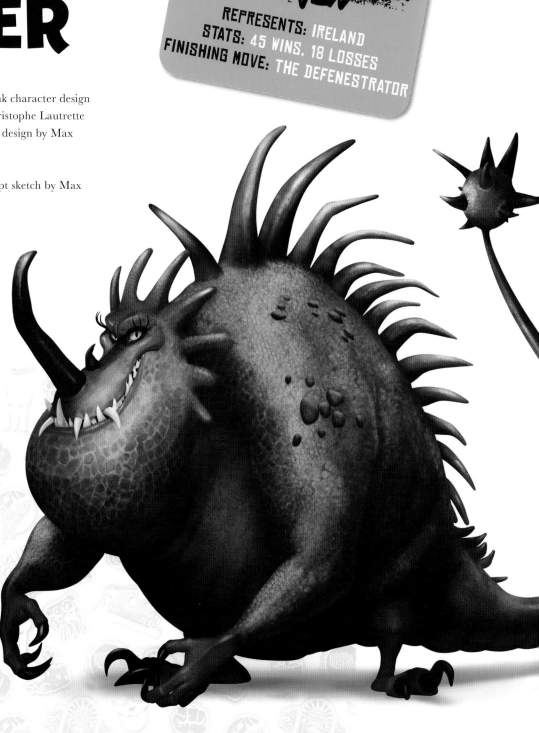

DENISE

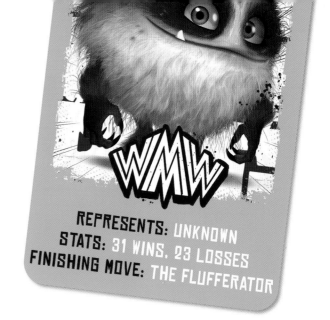

At first glance, Denise, another monster at the underground fight club, is just an adorable, fluffy ball of fur perched atop two furry sets of talons. Their big, friendly eyes suggest that they could be your pal… but be forewarned: there's a savage beast behind that cute smile. They've got teeth for days; one bite from them is gonna hurt! There's a reason why Lady Mayhen depends on little Denise, all fifteen feet of them, to crack down on any monster that doesn't follow her rules.

THIS PAGE/ Illustration of the final character design by Naveen Selvanathan (Left). Two color concepts by Max Narciso (Top). Two ink sketches by Christophe Lautrette (Bottom).

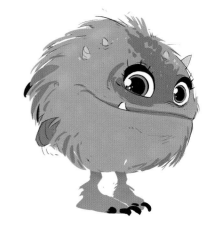

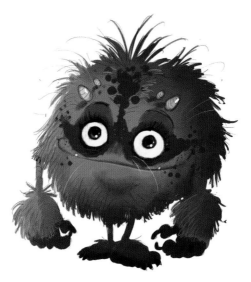

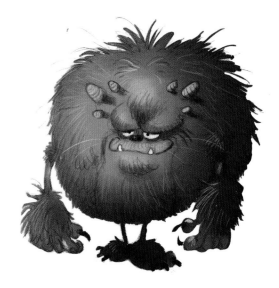

GARGANTULON

Gargantulon is a monster who dared to take on Rayburn Sr. back in the day, much to his detriment. If he were up against any other opponent, they'd have reason to be afraid: despite his excessive belly, he's fifty-eight feet of raw power, and while he may look like an overgrown turtle – and then some – he's anything but slow. Dangly bits hang from his head and he has distinct patterns on his green and brown hide. Spiked, bony plates all over his back add to his fierce appearance.

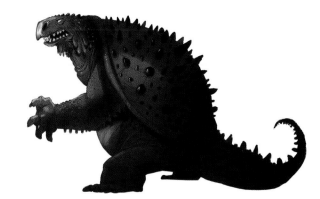

THIS PAGE/ Ink sketches by Christophe Lautrette (Top), Max Narciso (Bottom Left), and Paige Woodward (Bottom Right).

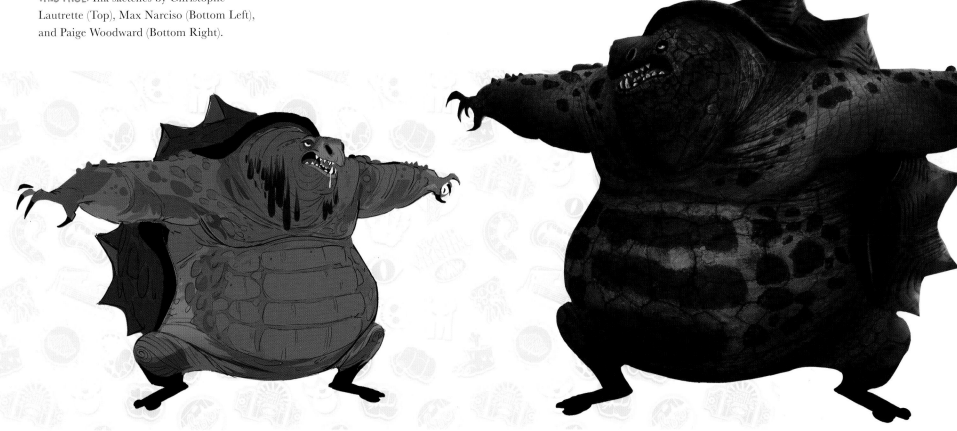

KLONK

Decked out in a purple mohawk that won't quit, Klonk is a sarcastic forty-five-foot boar who wrestles in the underground fight club. Audiences first see him when he's KO'd (incredibly) by 'Steve.' He's got two sets of tusks (why not?), sharp teeth (of course), and yes, spiked, bony plates running down his back. He's got a number of signature moves, including the Piledrive, the Elbow Drop, the Brainbuster, and everyone's favorite, the Chicken Wing Over-the-Shoulder Crossface.

THIS PAGE/ Color concept by Max Narciso (Top Left), sketches by Christophe Lautrette (Top Right and Bottom).

REPRESENTS: PORKSMOUTH
STATS: 6 WINS, 54 LOSSES
FINISHING MOVE: LIL PIGGY SQUEALER

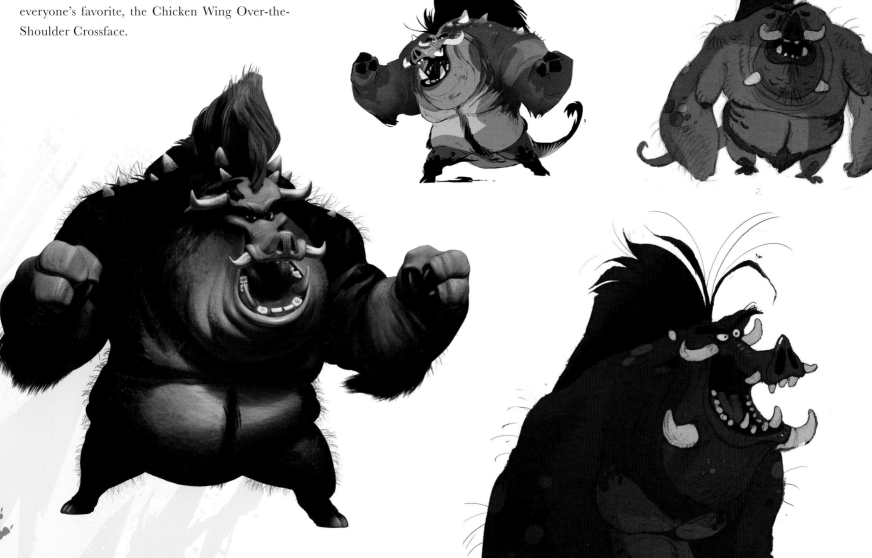

LUCHO LUCHON

REPRESENTS: MEXICO
STATS: 43 WINS, 34 LOSSES
FINISHING MOVE: TOP ROPE TRIPLE DROP

Hailing from central Mexico, the forty-foot tall Lucho Luchon is a colorful, four-legged dragon-monkey hybrid who fights Rayburn south of the border. He's got dazzling red peacock feathers on his back and flaunts a striking blue, teal, and fuchsia headdress. Like all good luchadores (and the bad ones, too), he's identified by his decorative blue and gold mask – except it's his face. He's not just a pretty boy, though. His high-flying maneuvers are second to none and he's the fastest monster wrestler in the biz. He slithers past any punch and surprises his competition with his signature move, the Chilaquiles-Chop. Even so, he's no match for Rayburn's moves.

THIS PAGE/ Color concepts by Christophe Lautrette (Bottom Left) and Max Narciso (Bottom Right).

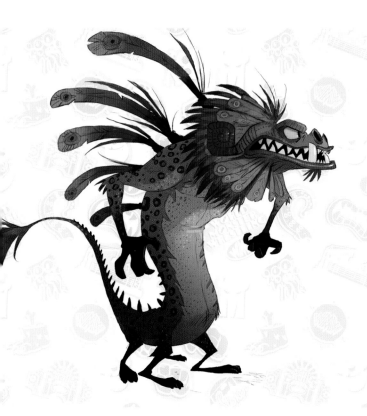

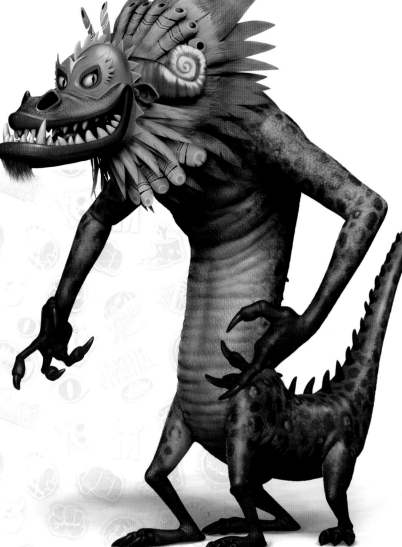

MR. YOKOZUNER

Mr. Yokozuner is the Japanese sumo monster to beat. Standing sixty-five-feet tall and weighing in at forty-six tons and six oz., he's got tiger markings on his mammoth red, black, and white frame, and wields a scary set of talons. He suits up in a mawashi loincloth and wears a traditional Japanese topknot. He may look intimidating but he's no match for Rayburn! When they meet in Japan, Rayburn chops him up like sushi.

THIS PAGE/ Ink concepts by Christophe Lautrette.

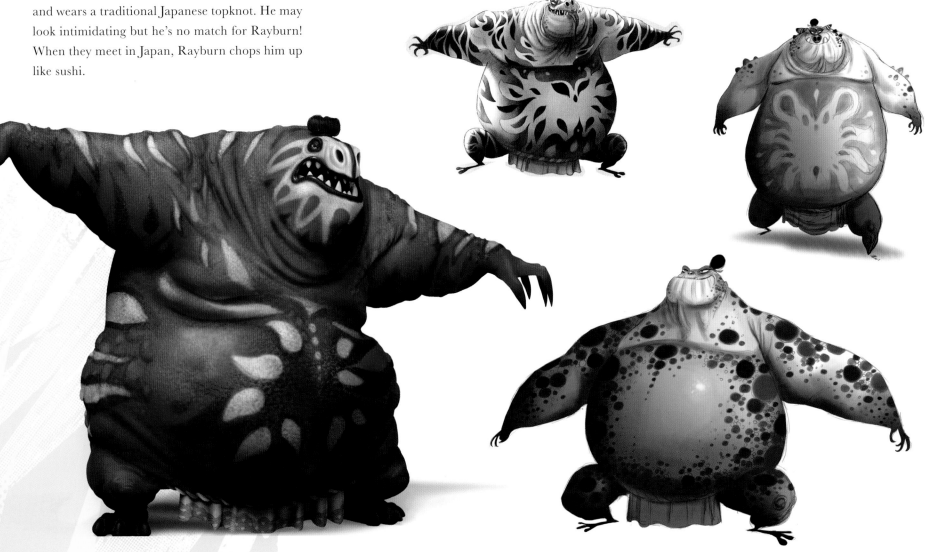

NERDLE

REPRESENTS: COLUMBIA
STATS: 3 WINS, 52 LOSSES
FINISHING MOVE: TICKLER TAIL

Nerdle is a four-eyed, furry monkey-like monster who fights and loses to Axehammer. He weighs twelve tons, stands forty-four-feet tall and has a forty-one-foot long tail. He wears contact lenses, which have the effect of giving him eight eyes. Anything to help win a fight!

THIS PAGE/ Color concepts by Max Narciso (Top). A darker variant on the final design by Julia Blattman (Bottom Left). Early sketch by David Colman (Bottom Right).

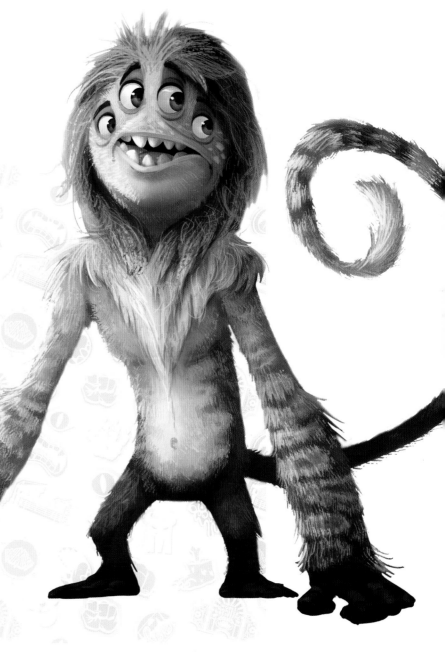

THE TWINS

The fast and mischievous Ting Tang Twins are a tiny (relatively speaking) but dynamic duo that fights as one. Standing twenty-feet tall and weighing in at four tons each, these former Two-Story League Tag Team champions sport six sturdy legs, scaly tails, and capacious, bat-like ears. They have the attitude of a ferocious dog and the knife-like teeth to match. They also have a mysterious brother, Tong, whose whereabouts is unknown.

THIS PAGE/ Color concepts by Max Narciso.

NEXT PAGE/ Early concepts by Max Narciso (Above) and sketches by David Colman (Below).

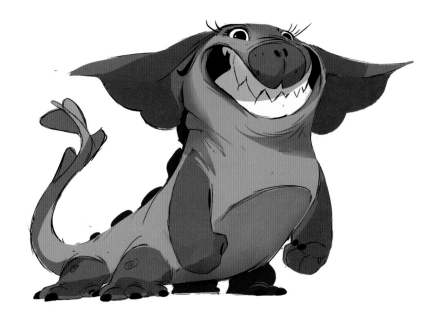

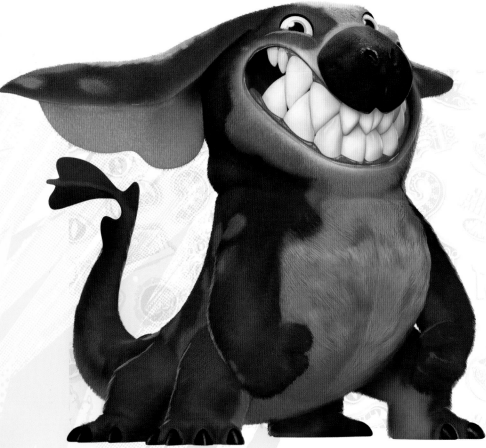

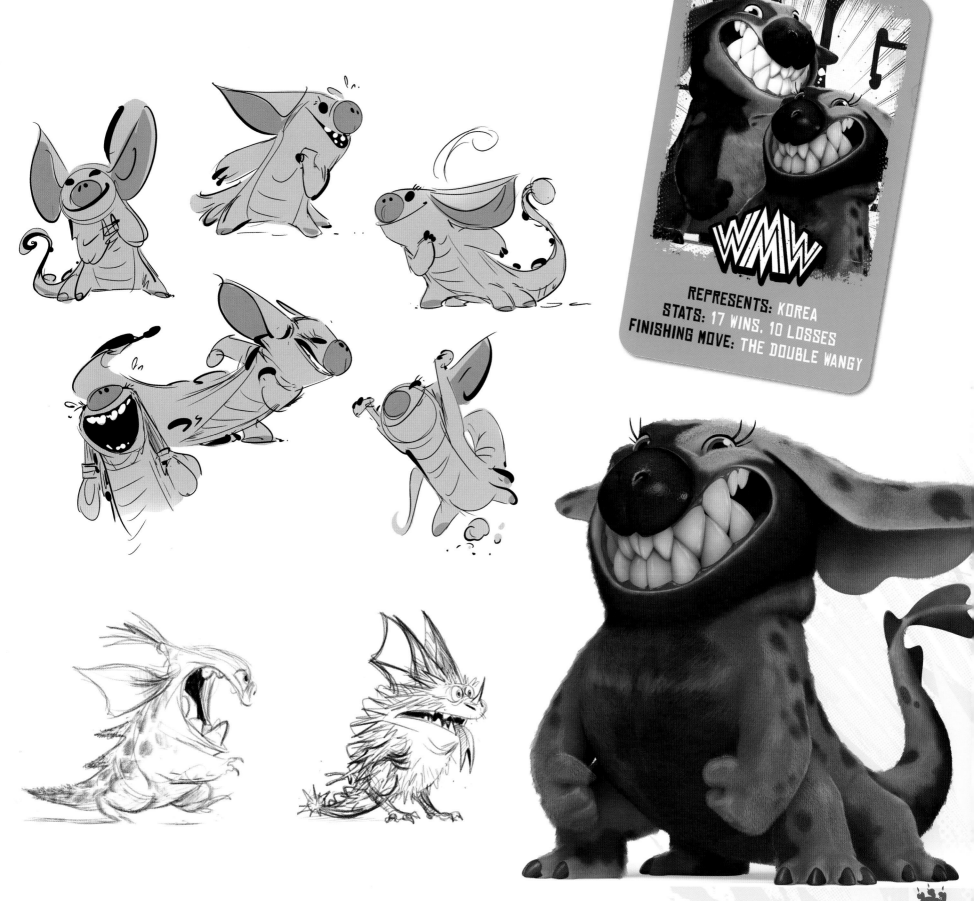

REPRESENTS: KOREA
STATS: 17 WINS, 10 LOSSES
FINISHING MOVE: THE DOUBLE WANGY

UNUSED MONSTERS

When they were in monster creation mode, the *Rumble* character designers let their imaginations run wild.

A fierce, six-legged polar bear with a horn? Sure! A hairy, half-ram, half-gorilla monstrosity that throws around shipping containers just for kicks? Why not? Other departments joined in the fun when Grieve asked everyone on the production come up with a monster design.

"There were some amazing ones I wish I could have put in the film," Grieve says of the twenty-five distinct creatures that emerged from the exercise. "At one point, all the walls in our war room were covered in different monsters. Then we whittled them down to our favorites."

But because the team regarded the monsters holistically – the intent was balance; they needed to look good together in terms of species, textures, and color palette – there were a lot of creatures that didn't make the *Rumble* cut. "At one point we had a blob-type monster," Grieve says. "Monsters that we didn't end up using just didn't feel like they fit within the palette."

THIS PAGE/ Early monster concepts by Maxime Mary.

NEXT PAGE/ Monster concepts by Christophe Lautrette.

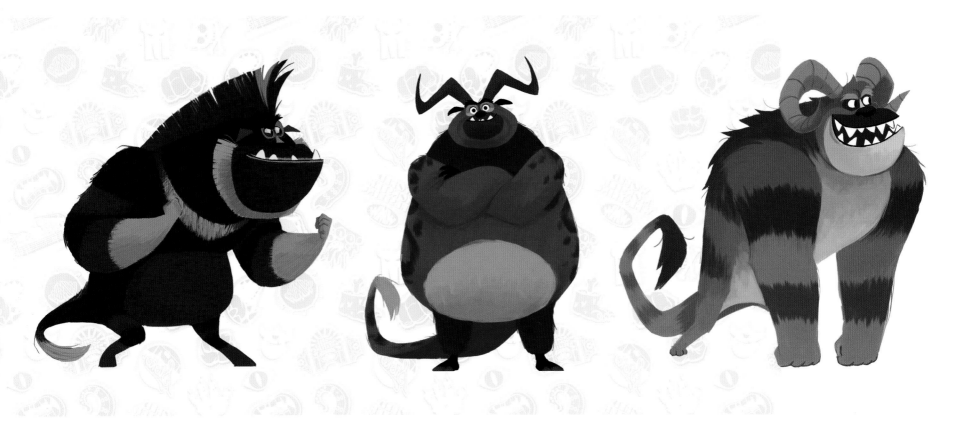

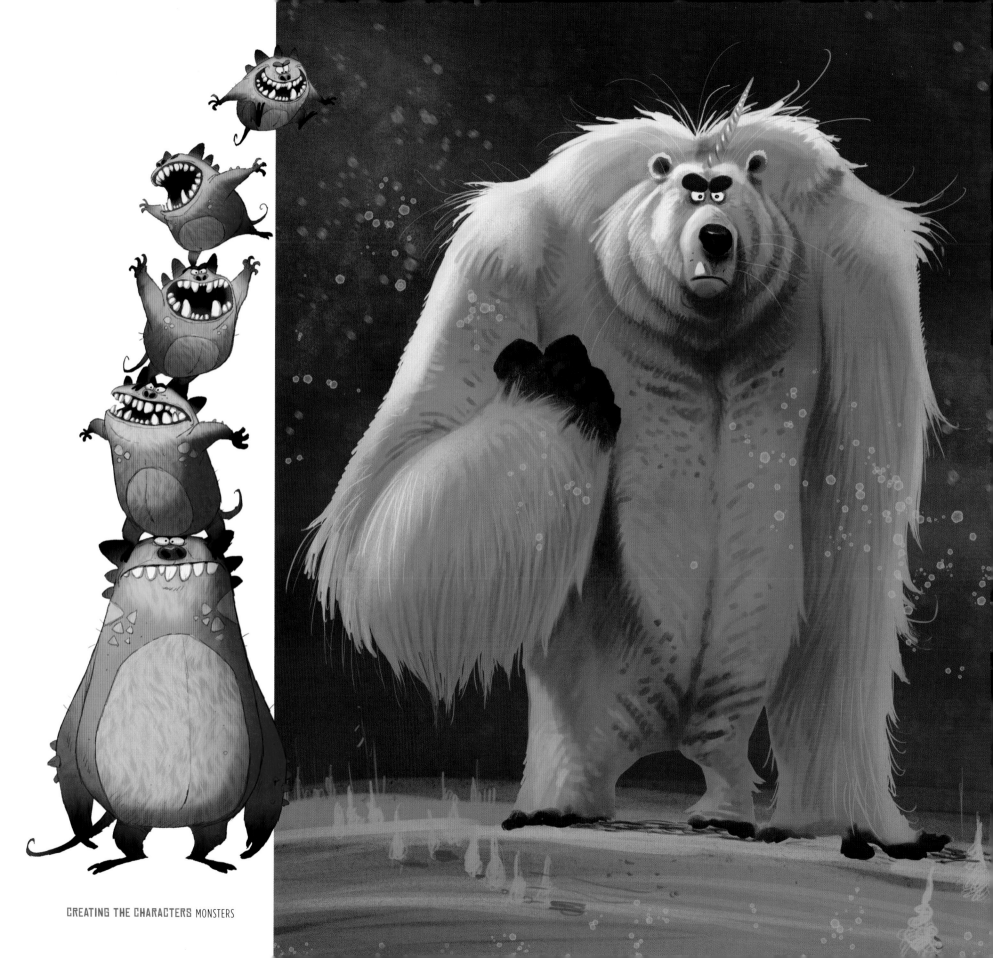

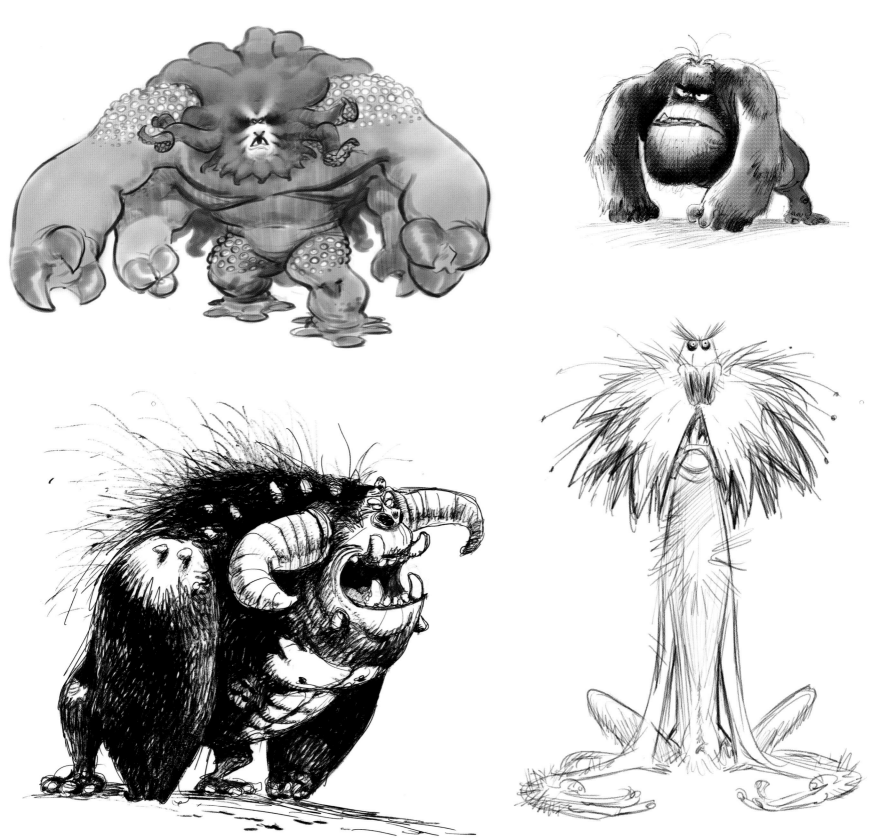

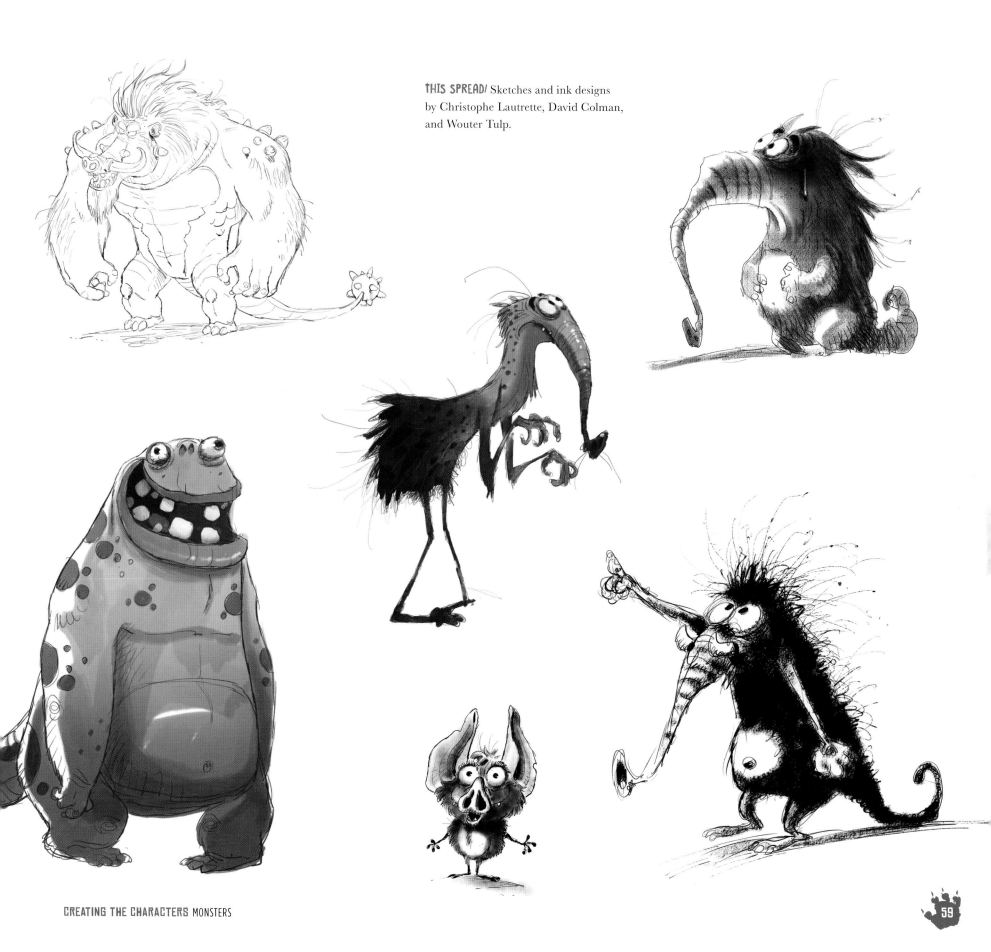

THIS SPREAD! Sketches and ink designs by Christophe Lautrette, David Colman, and Wouter Tulp.

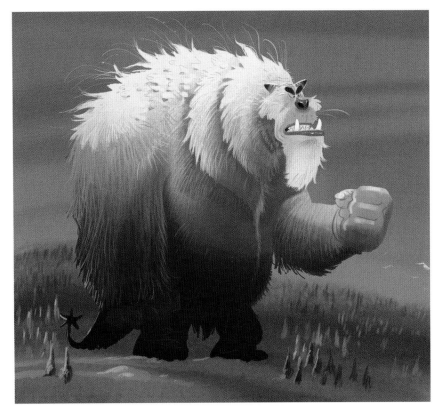

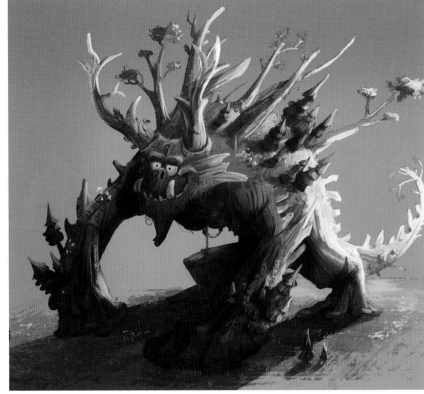

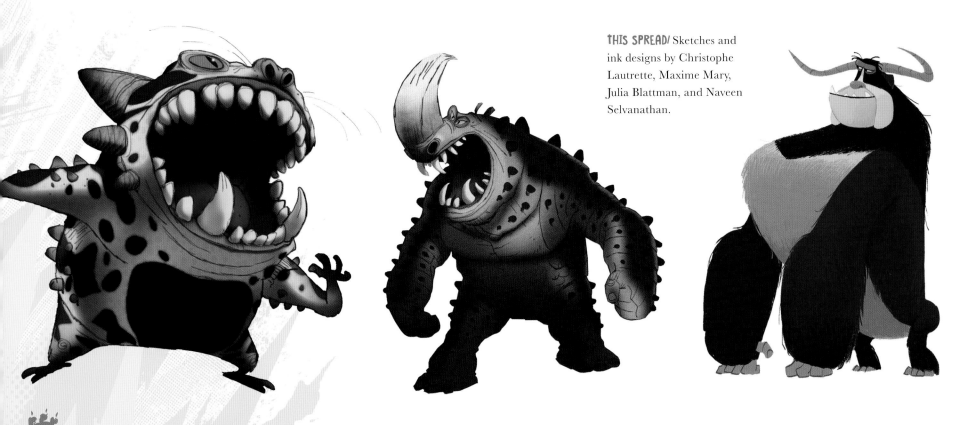

THIS SPREAD/ Sketches and ink designs by Christophe Lautrette, Maxime Mary, Julia Blattman, and Naveen Selvanathan.

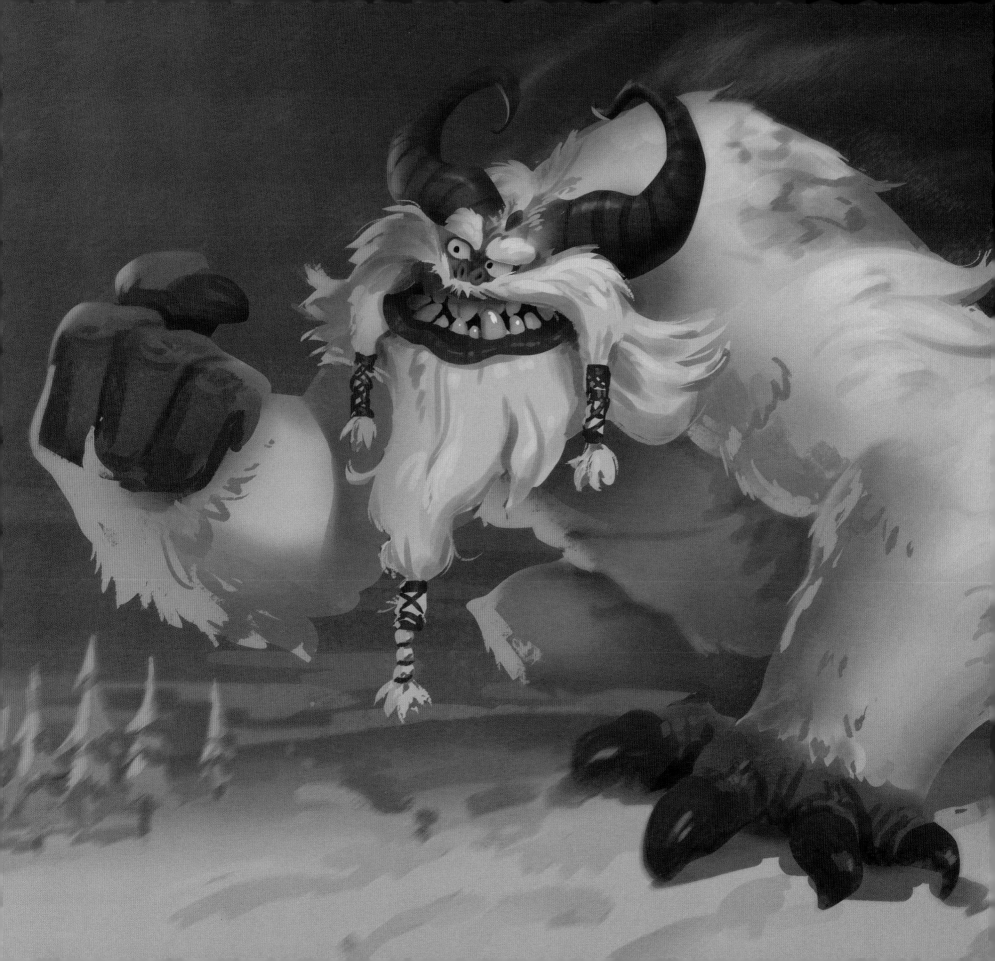

HUMANS

As created by production designer Christophe Lautrette and character designer Max Narciso, the humans in *Rumble* are an entertaining bunch, each with their own unique personality and design. Their quirkiness, humor, and attitude are all very appealing, and visually, these average-sized characters help accentuate and convey the enormity of their larger-than-life counterparts. In terms of the filmmaking process, however, creating that contrast was sometimes easier said than done. Seemingly simple things, like a monster and a human going down the street together, required rethinking. "Having Winnie walk alongside Rayburn may sound great on a script page, but in reality, she would have to sprint at full speed in order to keep up with a casual walk," says animation consultant Simon Otto.

THIS PAGE/ Sequence painting by Paige Woodward.

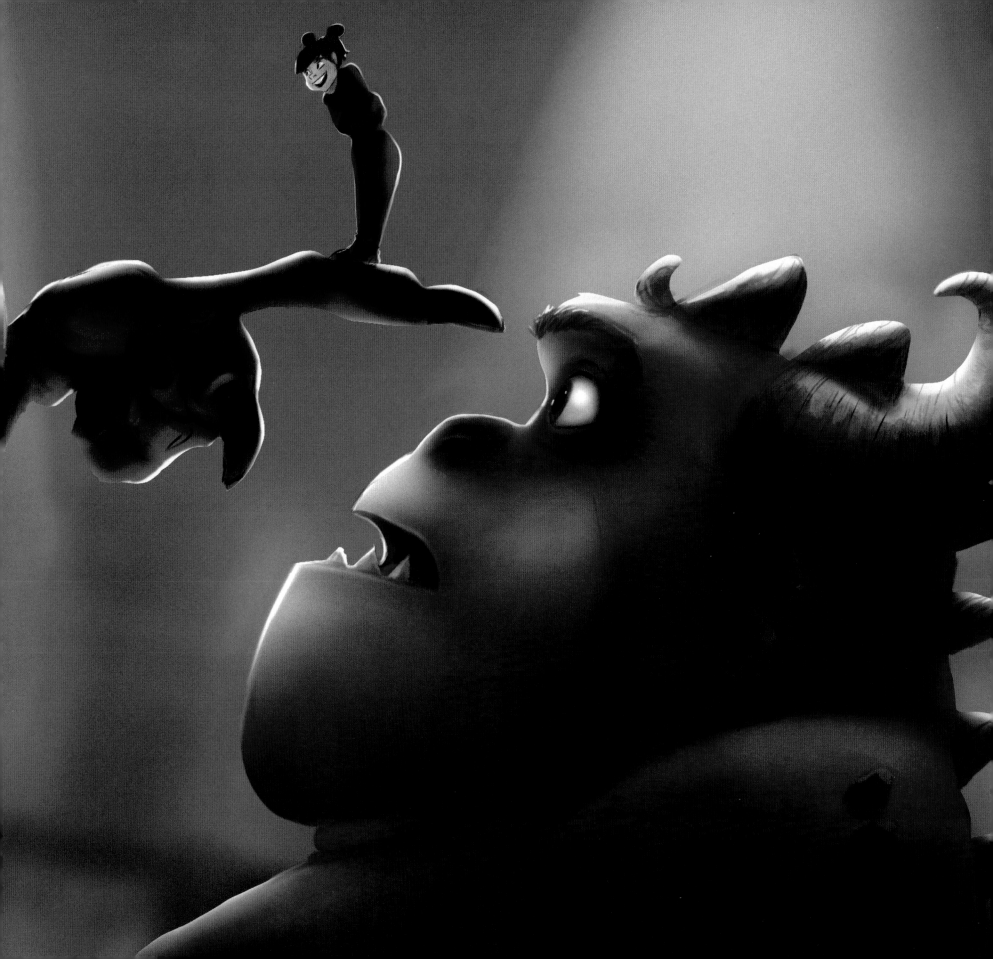

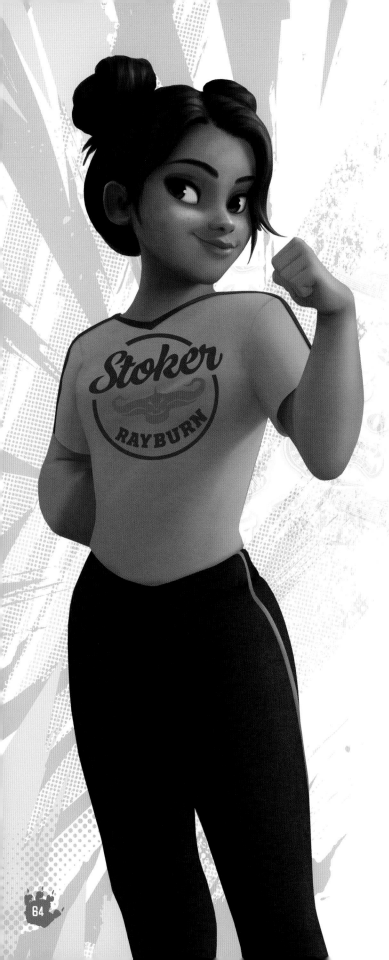

WINNIE

"PUT YOUR GAME FACE ON BECAUSE IT'S TIME TO WRESTLE"

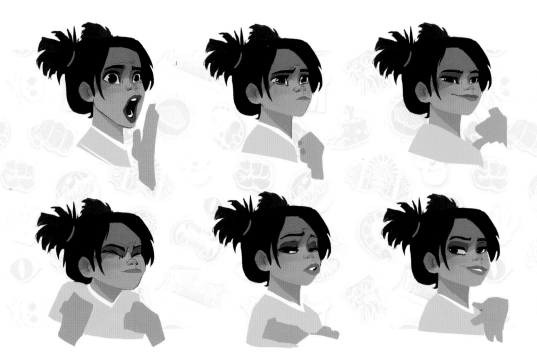

Winnie Coyle knows more about monster wrestling than anyone. As the daughter of legendary coach Jimbo Coyle, she should! She's athletic, spunky, and enthusiastic – except when she isn't. She gives intense high fives. She's a daddy's girl, even though daddy isn't around anymore.

In defining *Rumble*'s heroine, director Hamish Grieve had some particular opinions on the subject. The father of a teenage daughter himself, he says with a laugh, "Teenage girls are the most complicated creatures on the planet. What I really wanted to do was create this character who was very self-possessed, fully rounded, and wasn't a cliché who you could put in a box straight away, and say, 'Oh she's the sports nerd or she's a tomboy.'"

ABOVE/ Facial expression study by Max Narciso.

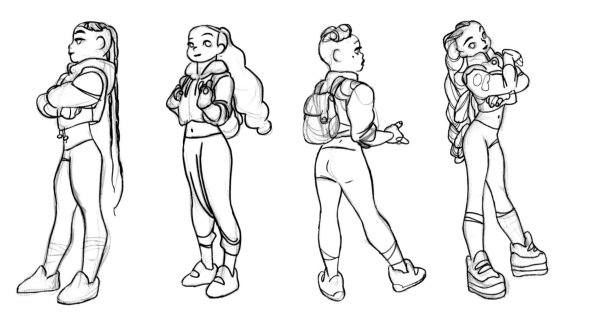

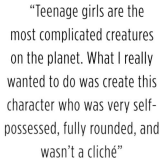

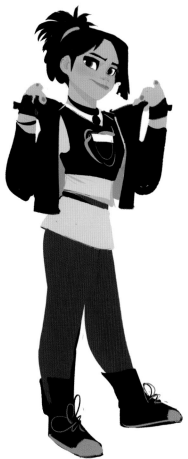

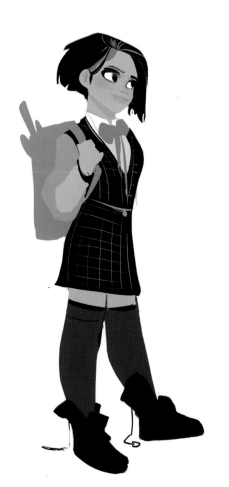

"Teenage girls are the most complicated creatures on the planet. What I really wanted to do was create this character who was very self-possessed, fully rounded, and wasn't a cliché"

HAMISH GRIEVE – DIRECTOR

ABOVE/ Early character sketch by Annette Marnat.

BELOW/ Color concepts by Max Narciso.

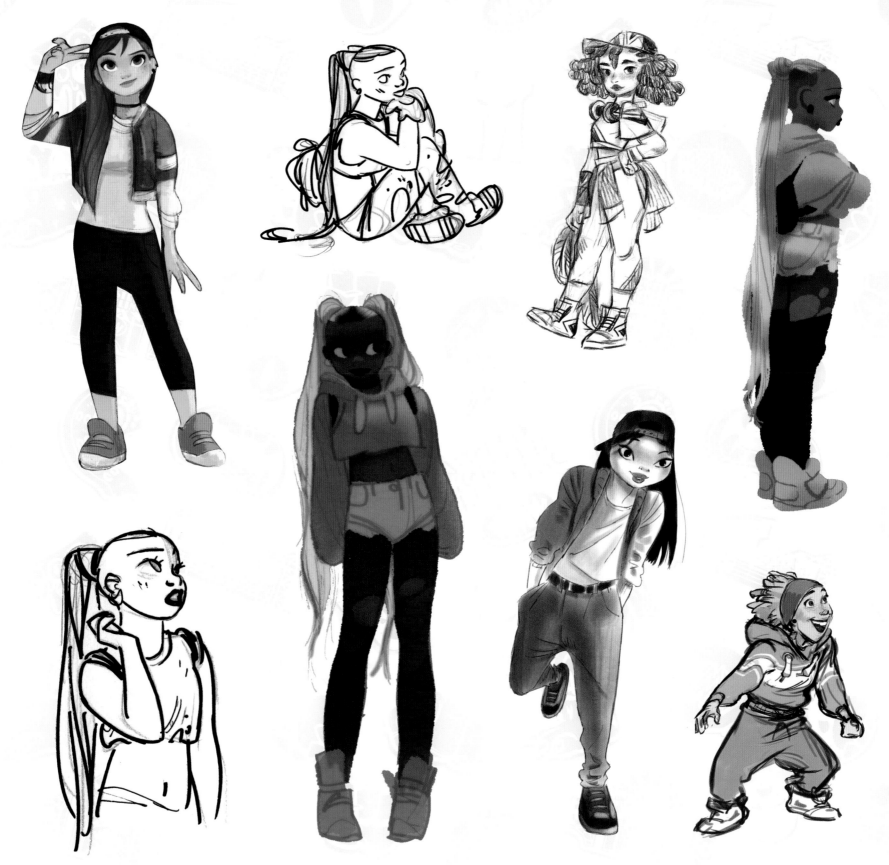

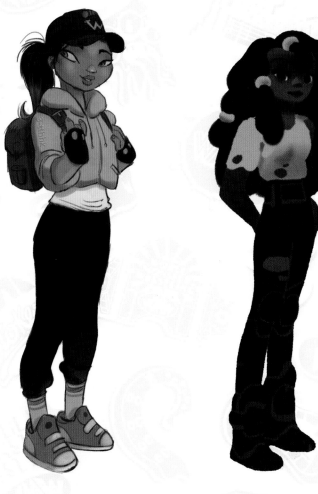

THIS SPREAD/ Color character concepts by Kei Acedera, Wouter Tulp, Annette Marnat, and Julia Blattman.

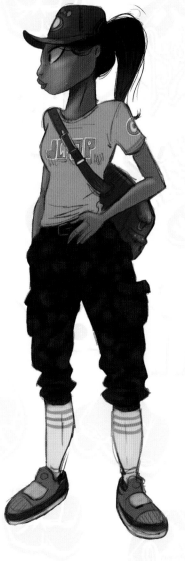

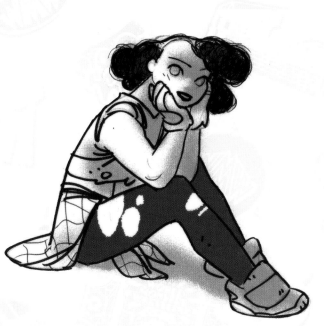

According to animation consultant Simon Otto, that goal was achieved. "Winnie is a mature teenager who can already be a young woman, but that young timid girl is still really much near the surface and can creep out at a moment's notice," he says. "She floats between three stages of confidence. On the one hand, she can be the bratty, feisty teenager who just does her thing. When she's really determined, she can pretend to be 'adulting.' But whenever she oversteps that line, that little girl who is shy and insecure can show up."

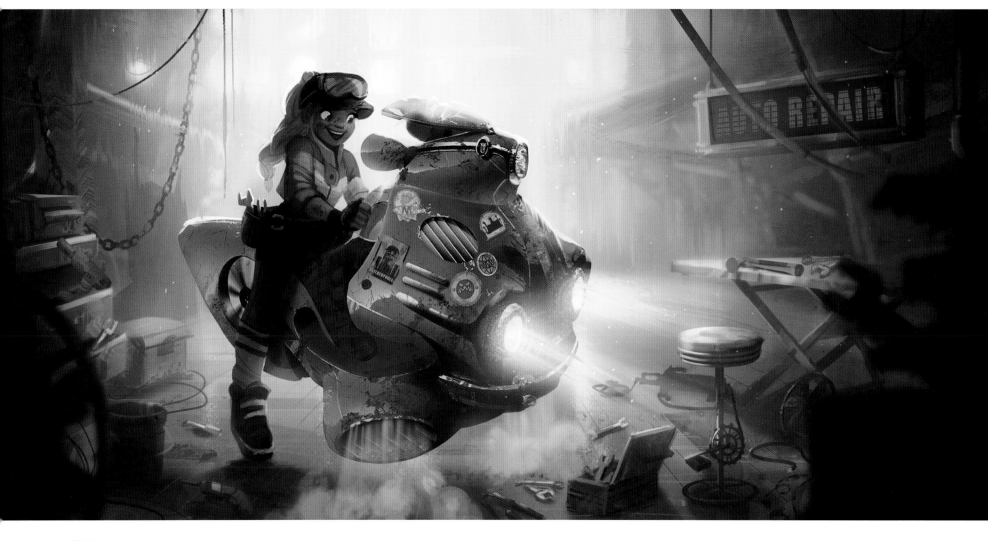

ABOVE/ Storybeat painting by Julia Blattman.

In the early days of preproduction, Winnie was very much gung-ho about finding a new monster for Stoker, "to the point of annoyance," says Grieve, who came onto the project about a year into production, and immediately decided that she needed to be something different than what she was at the time. He wanted to give her a journey to go on rather than have her be a character who says, "'I want to do this, I'm going to do this, I did it,'" he says. The team went in the opposite direction and made her very reluctant to embrace her legacy after Tentacular leaves town, even though she knew she had to. "It turned out that just wasn't as much fun as watching someone who is throwing themselves headlong into it," Grieve says. As a result, she's gone full circle and returned to be a young woman who is determined to get the job done – but with a difference. "Going through that iteration when she was reluctant gave her a lot of color and nuance and made us really understand who she was," Grieve says. "She has become a more interesting version of what she was before."

Winnie also went through a number of physical transformations. Her hair color changed from red to blonde to purple to black; hair styles went from long to short to shaved to corn-rows – and just about everything in between. She was Caucasian at one point, African American at another. "In the end," says production designer Christophe Lautrette, "we decided to make her mixed race, though it's not something that is directly addressed in the film. She's got short, dark brown hair that she dyes pink."

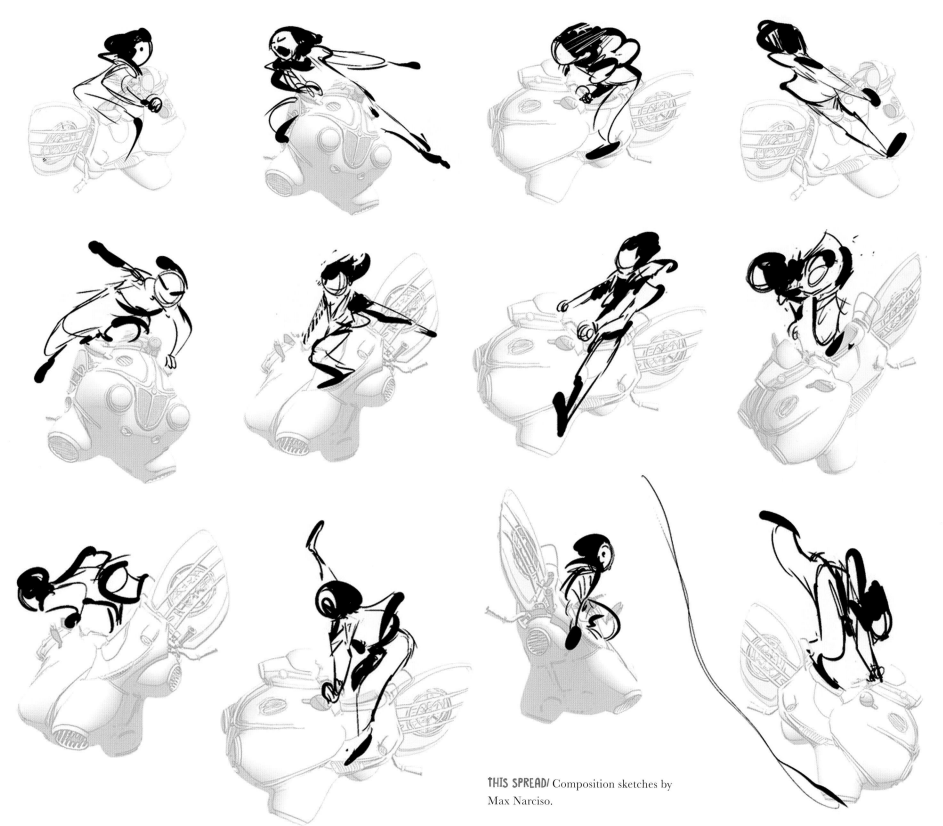

THIS SPREAD/ Composition sketches by Max Narciso.

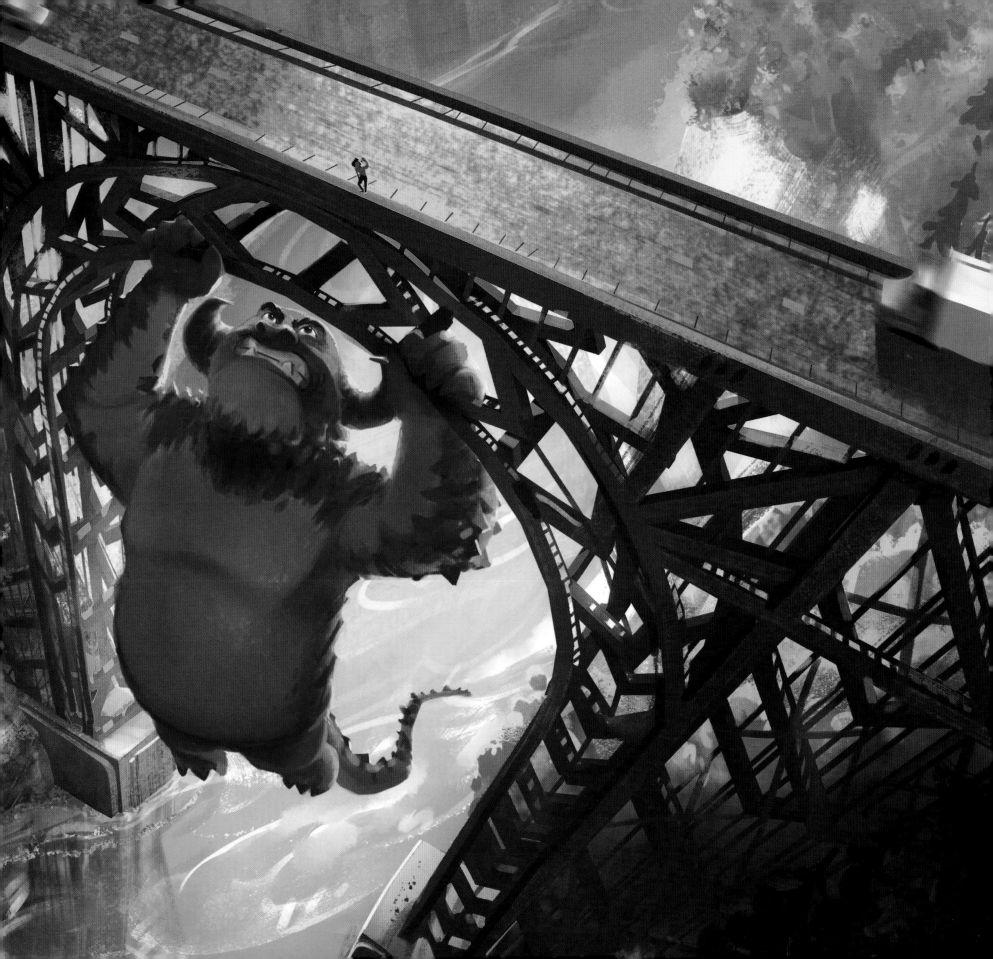

PLAYBOOK

One of the most prominent graphics-inspired props in *Rumble* is Jimbo Coyle's playbook, which Winnie refers to numerous times. It is her wrestling bible, filled with years and years of Jimbo's experience – every strategy and every move, all hand-written (and drawn). "We imagined everything inside," says Lautrette, "and for inspiration, we referenced books that Bruce Lee wrote about the art of fighting." Adds Blattman: "We wanted to show that it was well used and well loved by Jimbo. On the cover, the wear and tear are visible on the leather binding."

PREVIOUS SPREAD/ Sequence painting by Cathleen McAllister.

THIS SPREAD/ Prop designs by Chris Vigil.

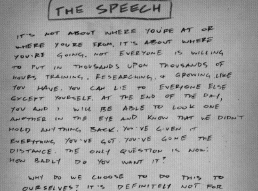

THE SPEECH

IT'S NOT ABOUT WHERE YOU'RE AT OR WHERE YOU'RE FROM, IT'S ABOUT WHERE YOU'RE GOING. NOT EVERYONE IS WILLING TO PUT IN THOUSANDS UPON THOUSANDS OF HOURS TRAINING, RESEARCHING, & GROWING LIKE YOU HAVE. YOU CAN LIE TO EVERYONE ELSE EXCEPT YOURSELF. AT THE END OF THE DAY, YOU AND I WILL BE ABLE TO LOOK ONE ANOTHER IN THE EYE AND KNOW THAT WE DIDN'T HOLD ANYTHING BACK. YOU'VE GIVEN IT EVERYTHING YOU'VE GOT. YOU'VE GONE THE DISTANCE. THE ONLY QUESTION IS NOW: HOW BADLY DO YOU WANT IT?

WHY DO WE CHOOSE TO DO THIS TO OURSELVES? IT'S DEFINITELY NOT FOR EVERYONE. SOME MONSTERS ARE COMPLETELY CONTENT EATING & SLEEPING, BUT THOSE LIKE YOU AND I RAY, WE CAN CHANGE THINGS. WE'RE WILLING TO PUSH OURSELVES AND GO TO A PLACE WHERE FEW HAVE GONE TO BECOME THE TRUEST VERSION OF WHO WE ARE. WE'RE NOT DEAD YET. EVERY MOMENT EVERY DAY IS A GIFT. SO CHERISH THE DAY, USE THE DAY & I PROMISE YOU MY FRIEND AT THE END, YOU WILL STILL BE STANDING.

THE RECIPE

INGREDIENTS

- 658 EGGS (OR 32 OSTRICH EGGS)
- 120 GALLONS OF MILK
- 6 SHOVELS OF SALT
- A BUCKET OF PEPPER
- 80 POUNDS OF CHEESE OR 1 GOAT (OPTIONAL)

1. MIX ALL INGREDIENTS IN GIANT INDUSTRIAL SIZED VAT
2. GENEROUSLY APPLY BUTTER OR COCONUT OIL TO GIANT INDUSTRIAL SIZED PAN
3. POUR INGREDIENTS INTO PAN AND COOK ON MEDIUM HEAT
4. FLIP OMELET AND COOK THE OTHER SIDE

MONSTER WRESTLING NIGHT

AT TIMES I WOULD ASK MYSELF: AM I DOING THE RIGHT THING? AM I GOING THE RIGHT WAY? TONIGHT AFTER SEEING WINNIE & RAY, I KNEW THAT WE WERE BEING TRUE TO OURSELVES AND THAT THIS HOLDS GREAT POTENTIAL FOR ALL OF US. JUST A VERY MEMORABLE & EXCITING NIGHT OVERALL.

ADMIT ONE
GENERAL ADMISSION
LOS ANGELES TOWN SQUARE
RAW
SATURDAY, MAY 11TH
STARTS PROMPTLY AT 7PM
Nº 0511

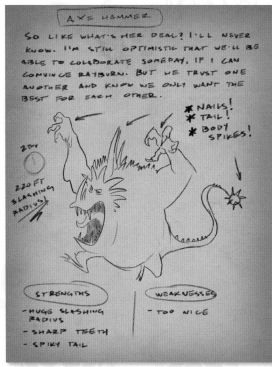

AXE HAMMER

SO LIKE WHAT'S HER DEAL? I'LL NEVER KNOW. I'M STILL OPTIMISTIC THAT WE'LL BE ABLE TO COLLABORATE SOMEDAY, IF I CAN CONVINCE RAYBURN. BUT WE TRUST ONE ANOTHER AND KNOW WE ONLY WANT THE BEST FOR EACH OTHER.

* NAILS!
* TAIL!
* BODY SPIKES!

2 FT

220 FT SLASHING RADIUS

STRENGTHS
- HUGE SLASHING RADIUS
- SHARP TEETH
- SPIKY TAIL

WEAKNESSES
- TOO NICE

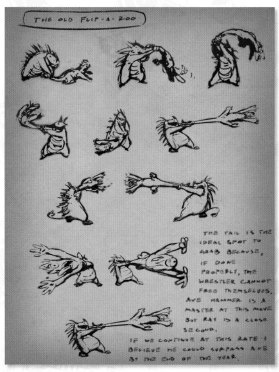

THE OLD FLIP-A-ROO

THE TAIL IS THE IDEAL SPOT TO GRAB BECAUSE, IF DONE PROPERLY, THE WRESTLER CANNOT FREE THEMSELVES. AXE HAMMER IS A MASTER AT THIS MOVE BUT RAY IS A CLOSE SECOND. IF WE CONTINUE AT THIS RATE I BELIEVE HE COULD SURPASS AXE BY THE END OF THIS YEAR.

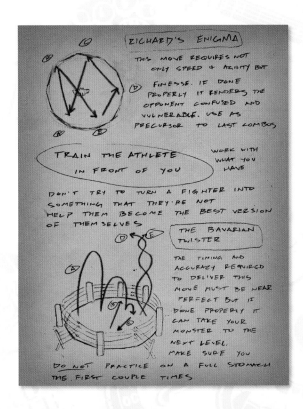

RICHARD'S ENIGMA

THIS MOVE REQUIRES NOT ONLY SPEED & AGILITY BUT FINESSE. IF DONE PROPERLY IT RENDERS THE OPPONENT CONFUSED AND VULNERABLE. USE AS PRECURSOR TO LAST COMBOS

TRAIN THE ATHLETE IN FRONT OF YOU

WORK WITH WHAT YOU HAVE

DON'T TRY TO TURN A FIGHTER INTO SOMETHING THAT THEY'RE NOT HELP THEM BECOME THE BEST VERSION OF THEMSELVES

THE BAVARIAN TWISTER

THE TIMING AND ACCURACY REQUIRED TO DELIVER THIS MOVE MUST BE NEAR PERFECT BUT IF DONE PROPERLY IT CAN TAKE YOUR MONSTER TO THE NEXT LEVEL. MAKE SURE YOU DO NOT PRACTICE ON A FULL STOMACH THE FIRST COUPLE TIMES

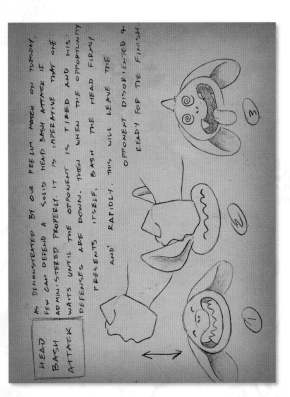

AS DEMONSTRATED BY OUR PRELIM MATCH ON TUESDAY. A FEW CAN DEFEND A SOLID HEAD BASH ATTACK IF ADMINISTERED PROPERLY. IT IS IMPERATIVE THAT ONE WAITS UNTIL THE OPPONENT IS TIRED AND HIS DEFENSES ARE DOWN. THEN WHEN THE OPPORTUNITY PRESENTS ITSELF, BASH THE HEAD FIRMLY AND RAPIDLY. THIS WILL LEAVE THE OPPONENT DISORIENTED & READY FOR THE FINISH

HEAD BASH ATTACK

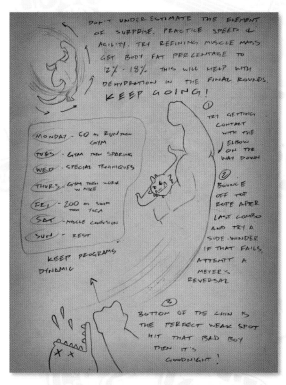

DON'T UNDERESTIMATE THE ELEMENT OF SURPRISE. PRACTICE SPEED & AGILITY. TRY REFINING MUSCLE MASS GET BODY FAT PERCENTAGE TO 12% - 18% THIS WILL HELP WITH DEHYDRATION IN THE FINAL ROUNDS. **KEEP GOING!**

MONDAY - 50 m RUN THEN GYM
TUES - GYM THEN SPARING
WED - SPECIAL TECHNIQUES
THURS - GYM THEN WORK W MIKE
FRI - 200 m SWIM THEN YOGA
SAT - MUSCLE CONFUSION
SUN - REST

KEEP PROGRAMS DYNAMIC

1. TRY GETTING CONTACT WITH THE ELBOW ON THE WAY DOWN
2. BOUNCE OFF TOP ROPE AFTER LAST COMBO AND TRY A SIDE-WINDER IF THAT FAILS, ATTEMPT A MEYER'S REVERSAL
3. BOTTOM OF THE CHIN IS THE PERFECT WEAK SPOT HIT THAT BAD BOY THEN IT'S GOODNIGHT!

- FUNNY - POIGNANT

MOTIVATIONAL QUOTES

EVERYBODY LIKES A GOOD INSPIRATIONAL QUOTE. THEY GET PEOPLE MOTIVATED AND A GOOD ONE WILL MAKE YOU THINK.

- LET'S BEGIN THIS - STEP UP
- KEEP ON STEPPIN
- STEP IN OR STEP OUT - GET UP OR GET DOWN - MOVE IN OR MOVE OUT
- LET'S GET THIS PARTY STARTED 2?

STEP UP OR STEP ASIDE

- GIVE IT EVERYTHING YOU'VE GOT - NEVER GIVE UP - NEVER DON'T ALWAYS DO YOUR BEST ?
- GO THE DISTANCE - KEEP GOING - KEEP ON TRUCKIN?
- STEP UP OR STEP TO THE SIDE
- STEP FORWARD IF YOU CAN - STEP UP OR DON'T STEP AT ALL

CRAZY BEATS STRONG

DON'T GIVE UP!

HOW TO DEFEND AGAINST LEAPING ATTACKS

LAST WEEKEND WE FACED OUR TOUGHEST OPPONENT YET IT MADE ME REALIZE THAT WE HAVE TO BRUSH UP ON OUR DEFENSE

HOW DO YOU STOP SOMETHING WITH UNLIMITED AGILITY? USE HIS OWN STRENGTH AGAINST HIM.

WHEN HE LEAPS AT YOU IT IS IMPERATIVE THAT YOU MOVE OUT OF HIS WAY AT THE VERY LAST SECOND.

HAVE HIM SLAM INTO THE POST & IT'LL BE LIKE HE JUST GOT SLAPPED BY A BRICK WALL. THAT OR GET OUT OF THE WAY

LEGAL QUANDARY

TO GET THROUGH THIS ONE IT TAKES STEALTH. YOU HAVE TO BE ARTFUL, SLICK, AND CUNNING. IF YOU CAN GET THROUGH LEGAL, YOU CAN GET THROUGH JUST ABOUT ANYTHING.

IT IS IMPERATIVE TO STAY NIMBLE

BRAIN FAILURE

TRUST YOUR INSTINCTS BUT DON'T RELY ON THEM EXCLUSIVELY BE BOLD. TRY THIS MOVE IN THE SECOND OR THIRD ROUND JUST WHEN THE OPPONENT THINKS HE'S FIGURED YOU OUT. IT'LL WORK ALMOST EVERY TIME.

JIMBO COYLE

"BRING US LUCK TODAY, DAD" – WINNIE

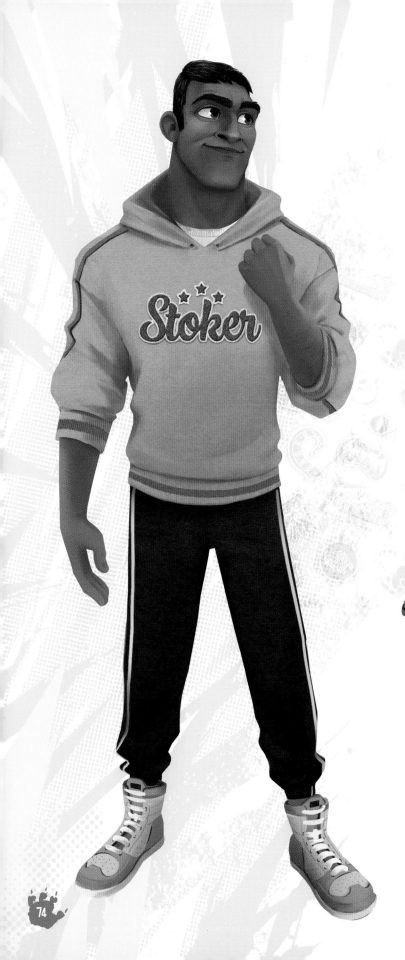

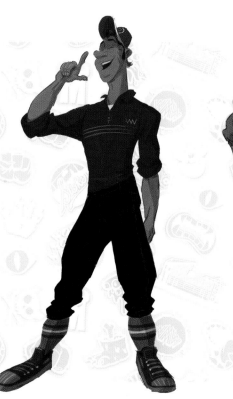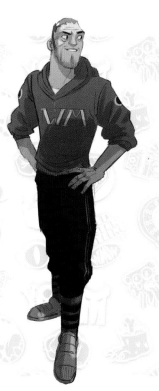

Winnie's dad, Stoker's revered, superstar coach Jimbo Coyle, has always been a huge, positive influence in her young life. "Everything Winnie does is shaped by Jimbo, and his memory," says director Hamish Grieve. Jimbo is only seen a couple of times in *Rumble*, in emotional flashback sequences where the audience sees his role in Winnie's life. For inspiration in defining such an important, albeit little-seen character, the film's artists looked at a lot of real-life coaches. "We wanted him to feel like an athlete in his prime," says art director Fred Warter. "He was a big guy who maybe wrestled when he was in college."

ABOVE/ Ink concepts by Christophe Lautrette.

LEFT/ Color character design by Cathleen McAllister.

 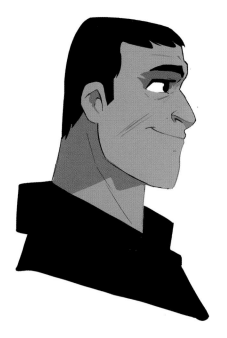

"We wanted him to feel like an athlete in his prime. He was a big guy who maybe wrestled when he was in college."

FRED WARTER –
ART DIRECTOR

ABOVE/ Facial expression study by Max Narciso.

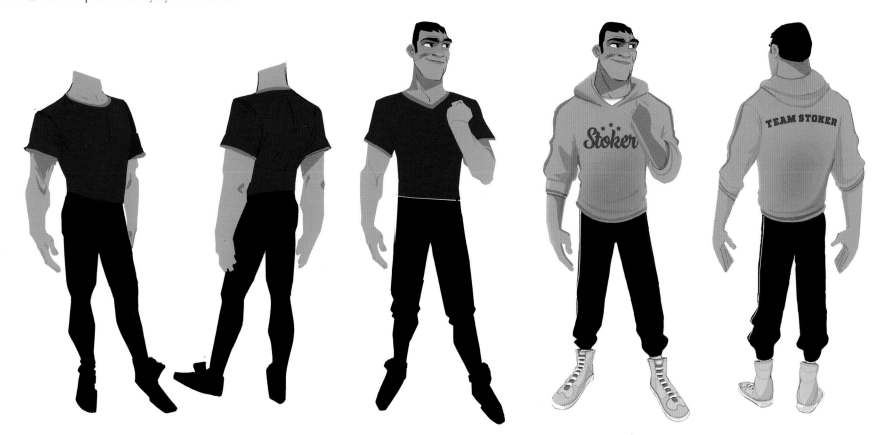

ABOVE/ Color character concepts by Max Narciso (Left) and Luis Grane (Right).

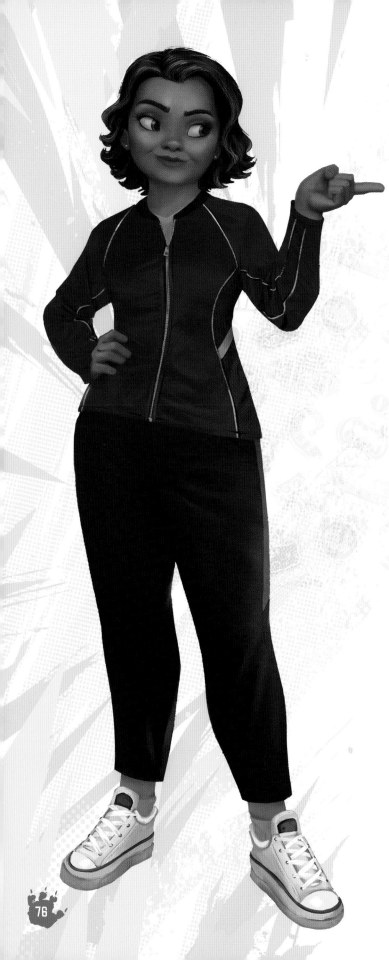

MAGGIE COYLE

"I'M SO READY TO RUMBLE!"

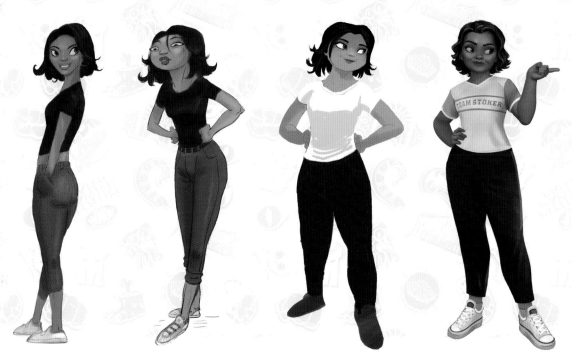

Maggie is Winnie's protective and supportive mom. She's a tough, practical, and no-nonsense kind of gal. Like Winnie, Maggie knows the world of monster wrestling inside and out, which isn't surprising: she was by Jimbo's side during the glory days and was integral to his success. She's great with pep talks and dispenses sage advice just when Winnie needs to hear it most. "Maggie and Winnie have been through the toughest of times together," says director Hamish Grieve. "They're a true team. Maggie pushes her daughter when she needs it, but also there to catch her if she falls."

ABOVE/ Character concepts by Christophe Lautrette, Max Narciso, and Cathleen McAllister (Left to Right).

LEFT/ 3D illustration of the final character design by Cathleen McAllister.

FRED

"FREE FRO-YO FOR EVERYBODY!"

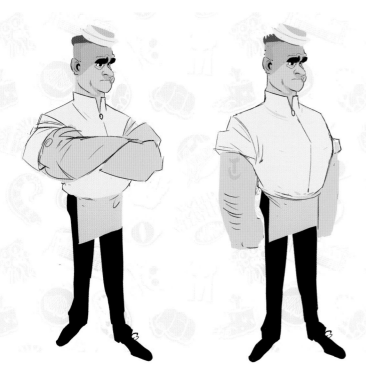

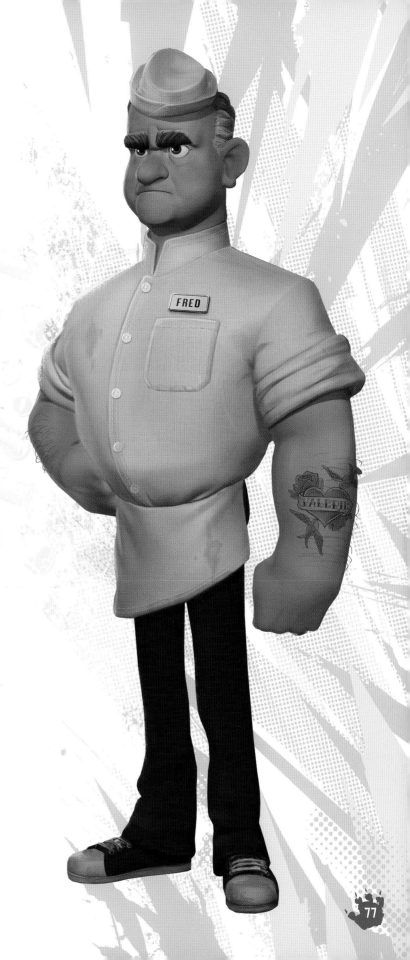

Fred is the middle-aged chef and owner of Fred's Diner. He's friends with Winnie and is a Tentacular superfan. Like everyone else in Stoker, he's horrified when the monster decides to leave town, but it doesn't take him too long to get on the Steve/Rayburn bandwagon. Fred is excitable and has a habit of not watching a fight in its most precarious moments.

Clean shaven, with gray hair and bushy eyebrows, he sports a chef's hat on his head, a 'Valerie' tattoo on his forearm, and well-worn Chucks on his feet. His uniform consists of a slightly stained white shirt and black pants. His proportions are exaggerated, with slim legs and a big upper torso and arms.

ABOVE/ Character pose study by Max Narciso.

LEFT/ 3D illustration of the final character design by Julia Blattman.

MARC REMY

"THIS AIN'T MONSTER WRESTLING"

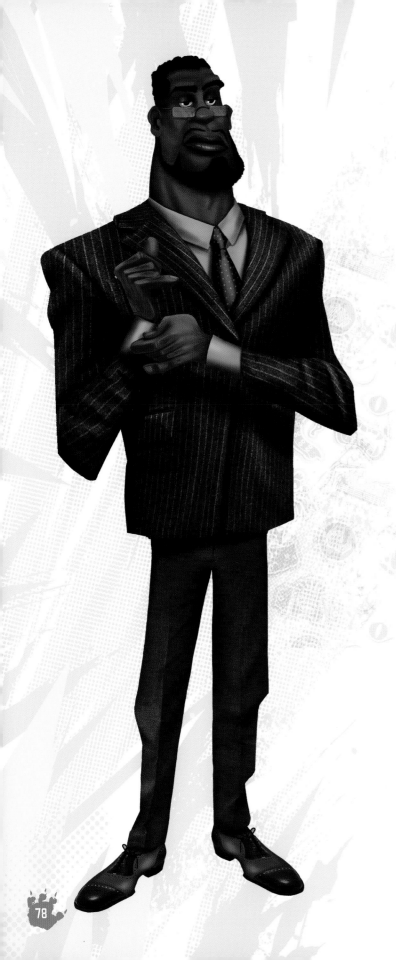

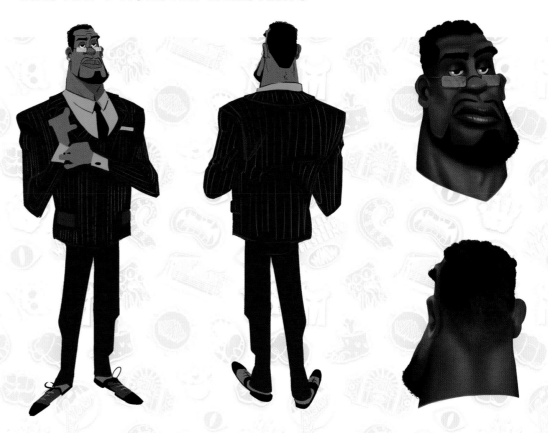

Marc Remy is the opinionated sports broadcaster who co-hosts the WMW show with his titanic monster partner, Lights Out McGinty. He doesn't think that Steve's winning dance moves in the ring qualify as wrestling and he's got some unresolved issues at home that manage to sneak into his commentary. He's a sharp-looking, well-dressed guy with a trim beard and fly fade. His broad shoulders and upright posture indicate that he was once an athlete himself.

ABOVE/ Character concept by Max Narciso (Left). Face study by Paige Woodward (Right).

LEFT/ 3D illustration of the final character design by Paige Woodward.

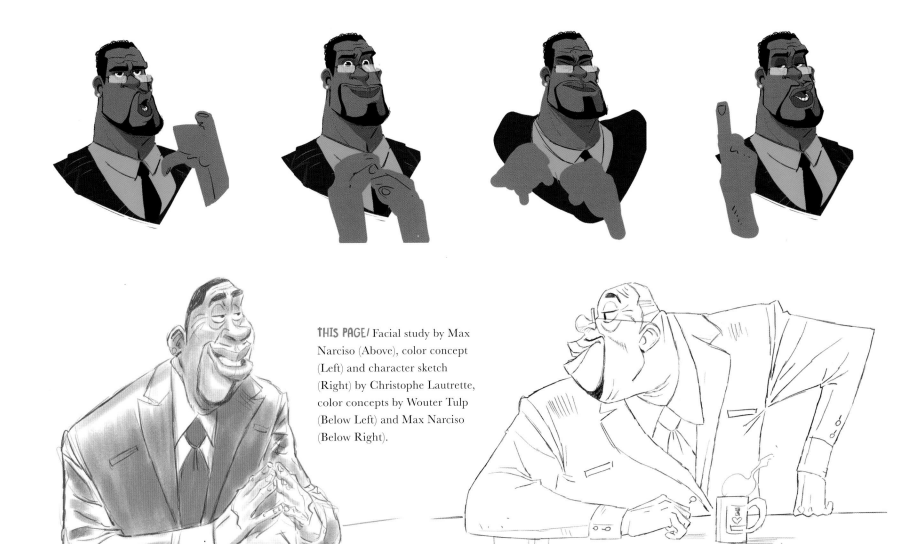

THIS PAGE/ Facial study by Max Narciso (Above), color concept (Left) and character sketch (Right) by Christophe Lautrette, color concepts by Wouter Tulp (Below Left) and Max Narciso (Below Right).

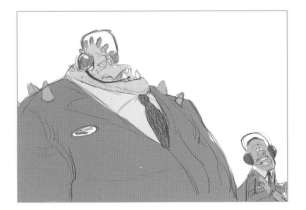

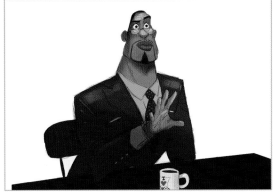

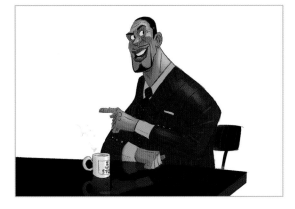

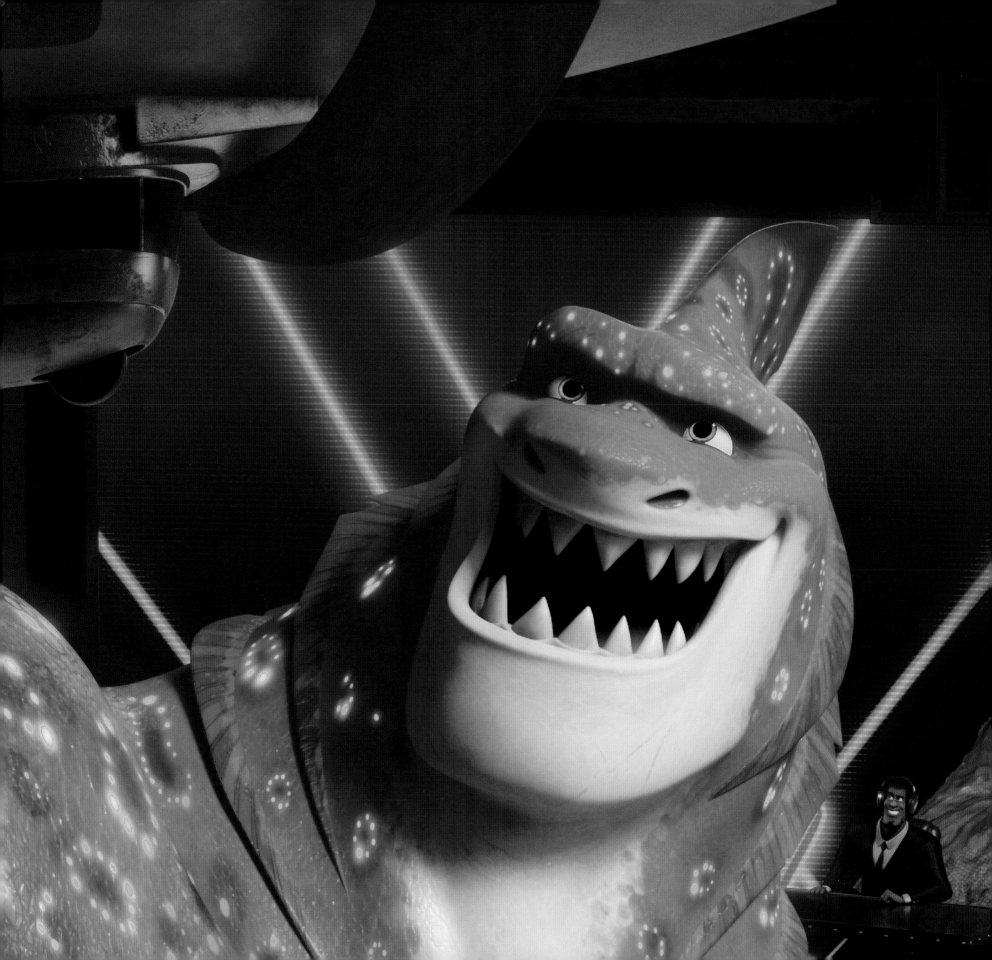

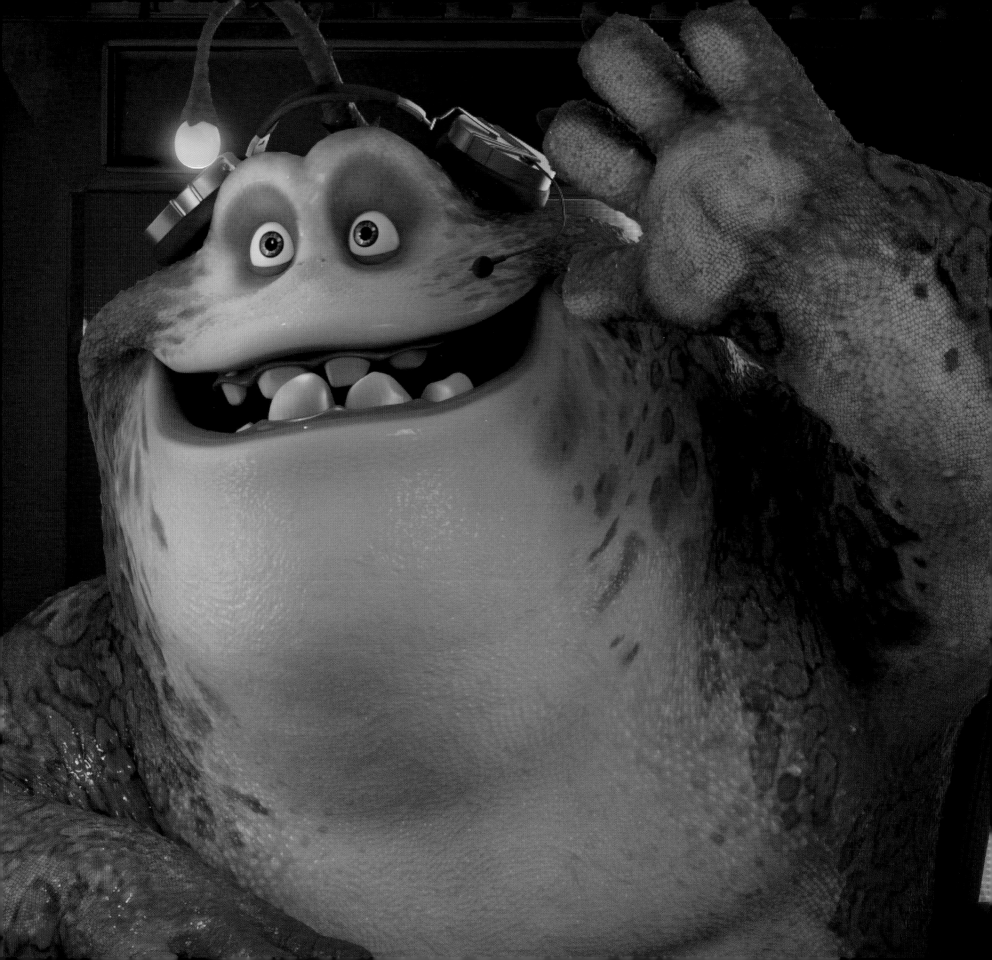

JIMOTHY BRETT-CHADLEY III

"THIS IS GONNA GO SO VIRAL"

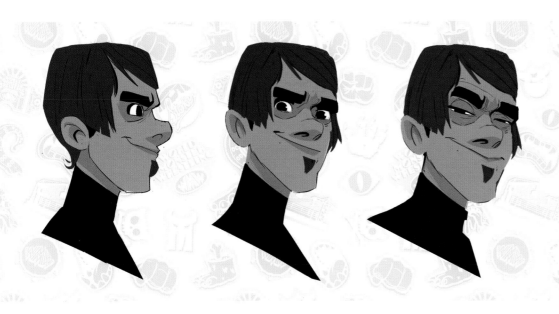

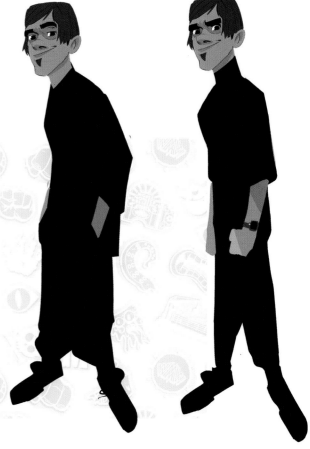

Jimothy Brett-Chadley III, the well-dressed but irritating owner of the Slitherpoole franchise, can best be described as a hype beast and a tech bro – a dude who gives off a hipster vibe with his carefully trimmed soul patch and shaggy short hair. Tentacular simply calls him his "ticket to bigger and brighter things." Director Hamish Grieve says that the filmmakers are "poking fun at a whole genre of Silicon Valley dude." In the beginning of production, though, Jimothy was a whole different character with a completely different look. "He was much more of a money-grubbing businessman," says head of story Lawrence Gong. That changed when the team decided to make Tentacular the true villain of the story; Jimothy became an exasperating, hapless guy who is manipulated by the monster. Fun fact: "His name is actually the result of a competition we had in the office to come up with the most annoying entitled name we could think of," says Grieve. "Jimothy Brett-Chadley III is a combination of the winners!"

PREVIOUS PAGE/ Still from the movie.

ABOVE/ Face and pose studies by Max Narciso.

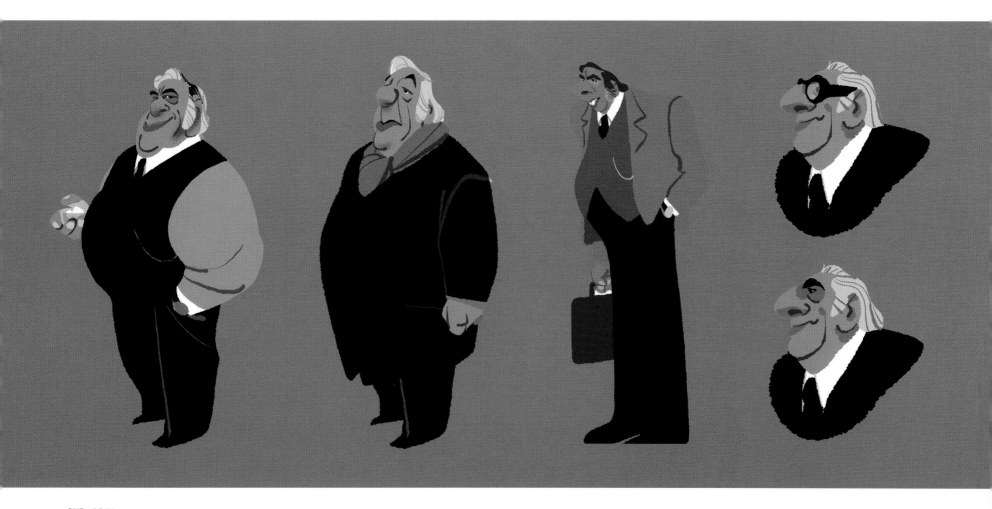

THIS PAGE/ Character concepts by Annette Marnat.

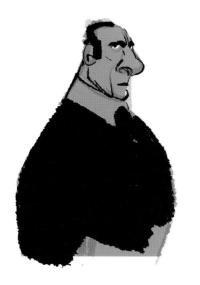
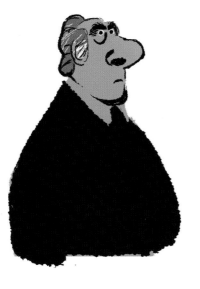
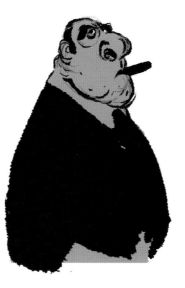

"His name is actually the result of a competition we had in the office to come up with the most annoying entitled name we could think of."

HAMISH GRIEVE — DIRECTOR

MAYOR
"MAYBE I'LL GET RE-ELECTED"

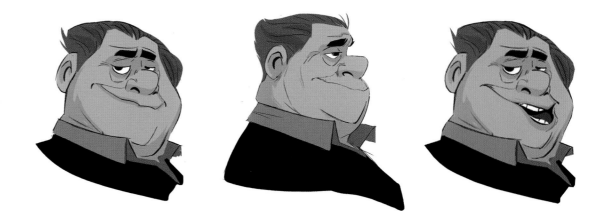

The middle-aged mayor of Stoker doesn't have a lot of backbone. What he does have is a receding hairline and an extra-large waistband. He likes bacon.

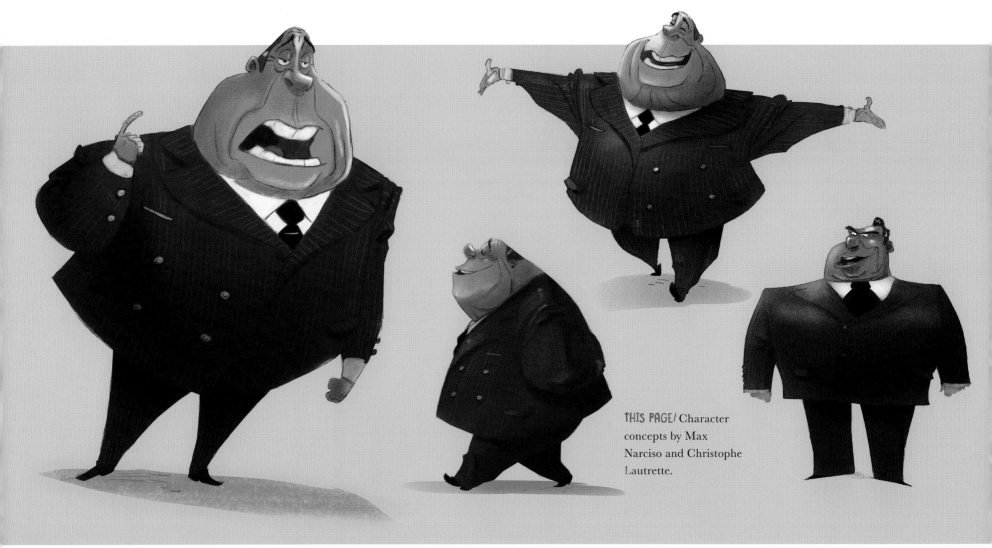

THIS PAGE/ Character concepts by Max Narciso and Christophe Lautrette.

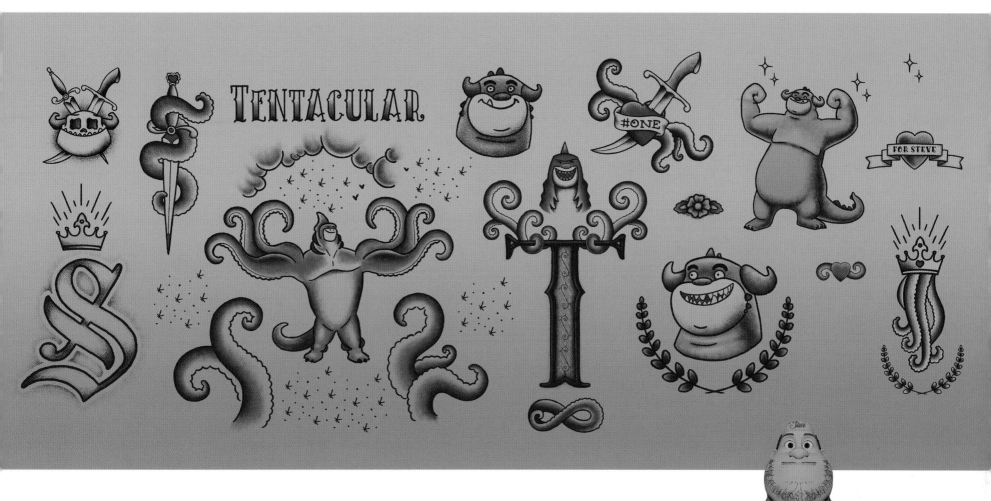

TATTOO GUY

"OHHH, NOOO!"

There are lots of superfans in Stoker but Tattoo Guy takes fanaticism to a new level: he's got Tentacular's life story tattooed on his entire body. Being the good citizen of Stoker that he is, however, Tattoo Guy's loyalty to Tentacular ends when the new Big Belt holder leaves town. He starts the arduous process of removing the tats but when Steve the Stupendous starts winning matches, Tattoo Guy does what you'd expect: He starts collecting Steve tattoos. But then it's revealed that Steve's name, actually, is Rayburn…

THIS PAGE/ Tattoo designs and character concept by Chris Vigil.

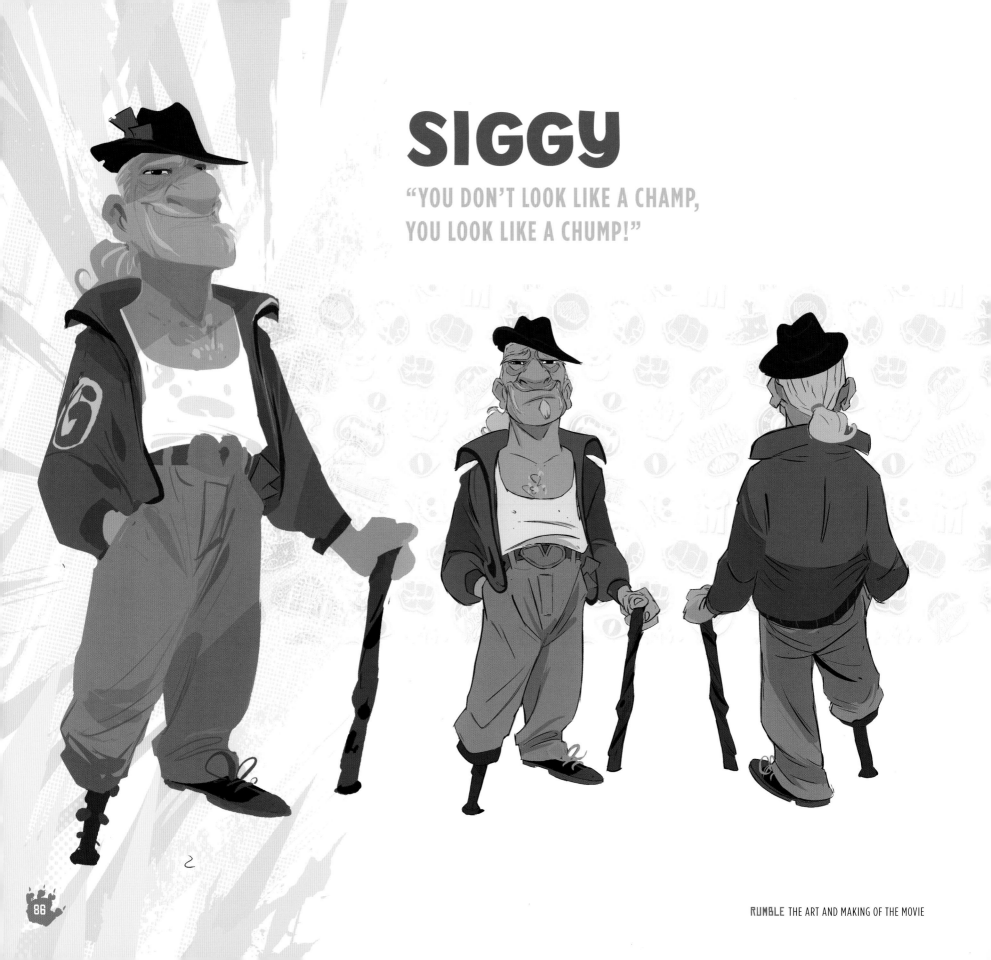

SIGGY

"YOU DON'T LOOK LIKE A CHAMP,
YOU LOOK LIKE A CHUMP!"

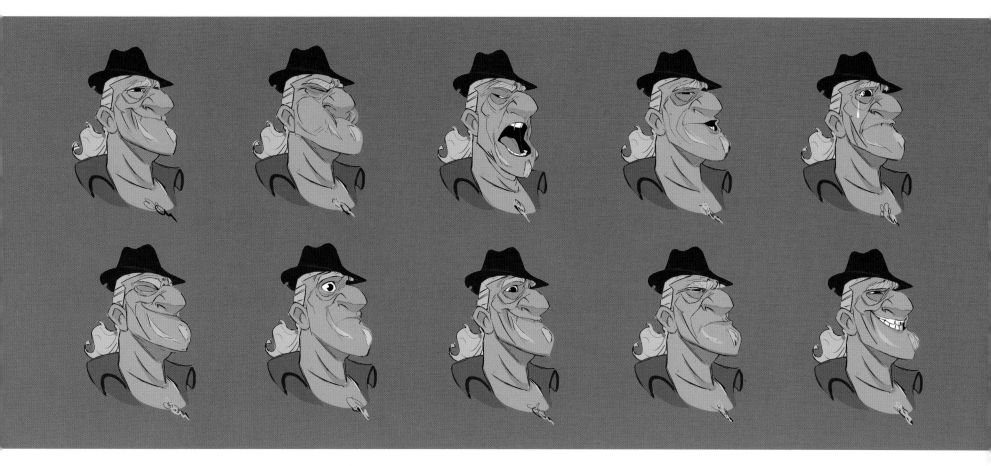

Siggy, Tentacular's old-school coach and Jimbo Coyle's former assistant, is a short, gray-haired, ponytail-wearing, nononsense kind of guy. He's been in the business for decades and has the scars to prove it, most noticeably his missing leg: back in the day, an overzealous monster took a chunk of Siggy's leg and he's been getting around on a monster-style prosthetic ever since. Because of that, he also walks with a cane.

PREVIOUS PAGE/ Character concepts by Max Narciso.

THIS PAGE/ Facial expression study by Max Narciso (Above). Character concepts by Wouter Tulp (Below).

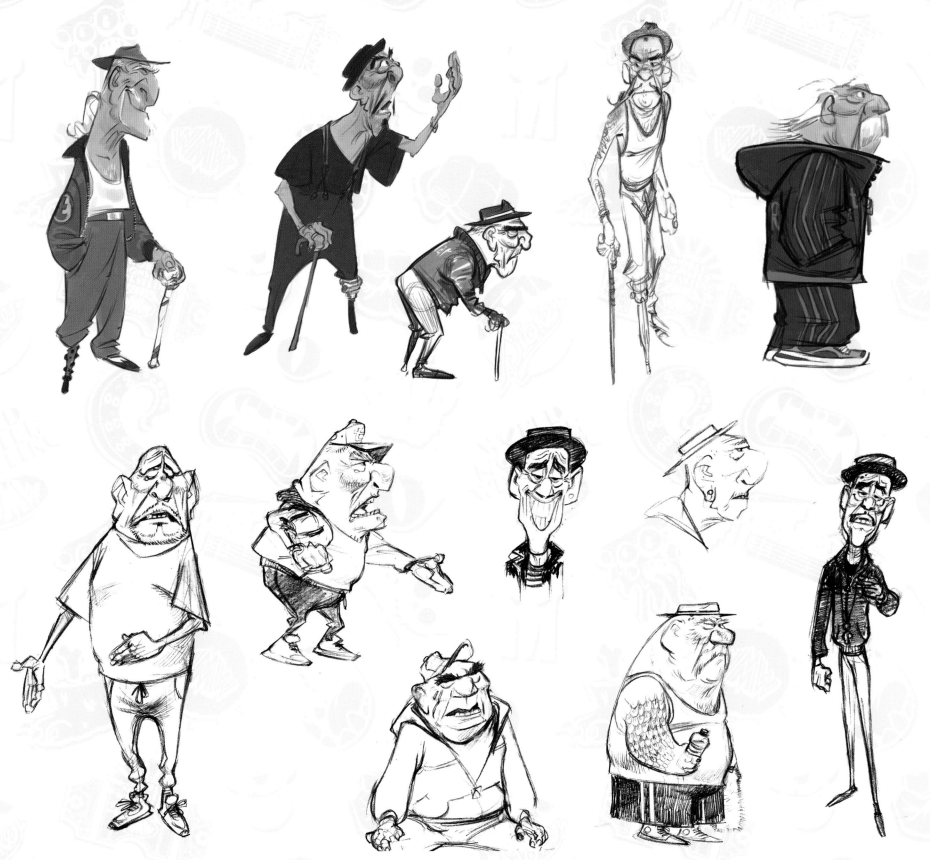

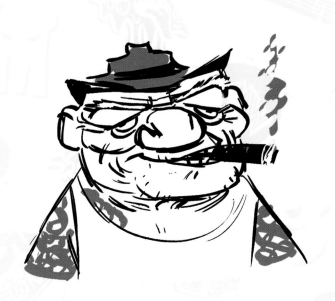

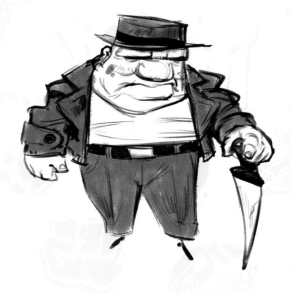

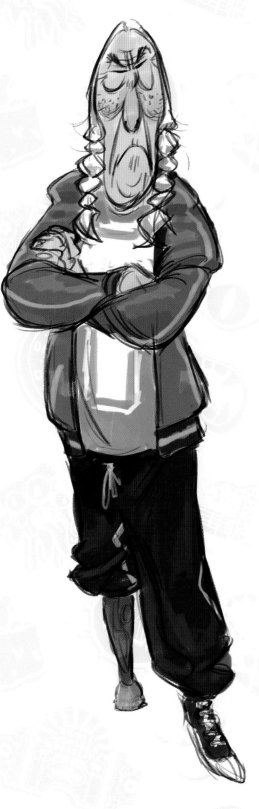

THIS SPREAD/
Character sketches asnd concepts by Wouter Tulp.

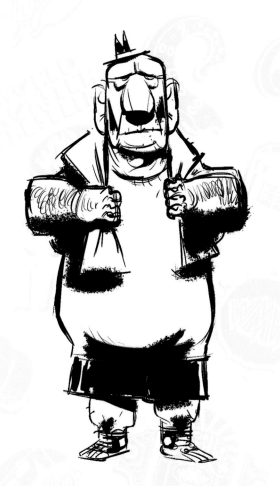

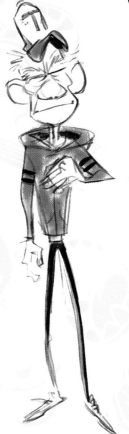

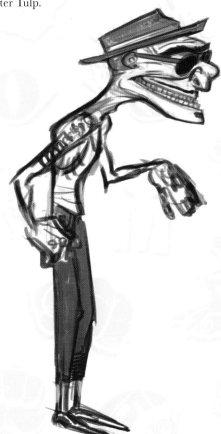

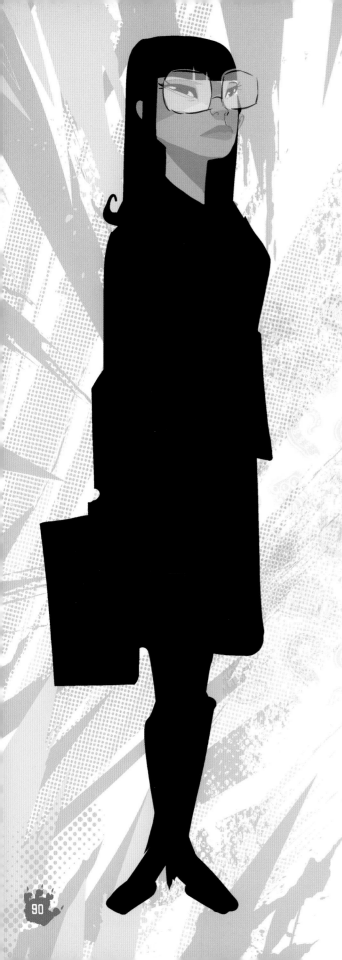

BACKGROUND HUMANS

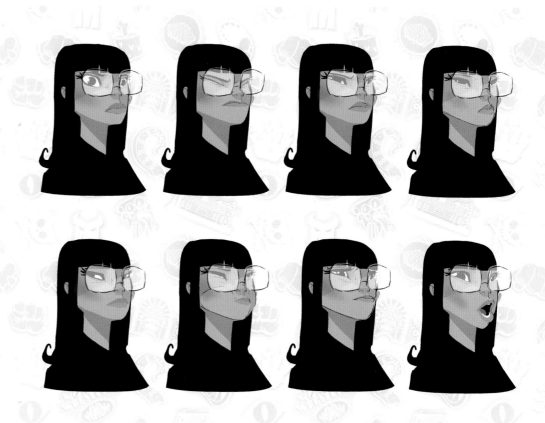

The other humans who populate *Rumble* include the farmer, a pleasant, slightly overweight woman who has spent years in the sun; and the councilwoman, who is a no-nonsense, all business Asian woman. Other inhabitants include fans, coaches, referees, stadium employees, and news announcers.

THIS PAGE/ Facial expression study and illustration of the final character design by Max Narciso.

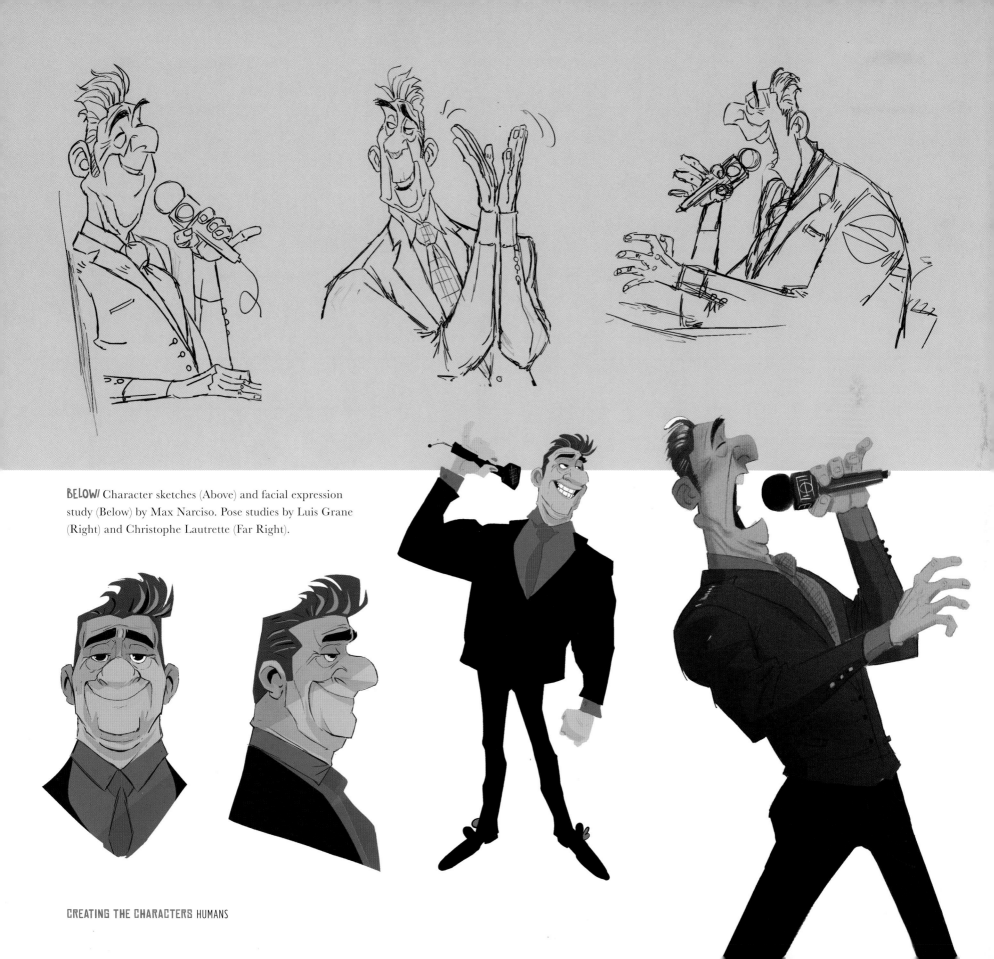

BELOW! Character sketches (Above) and facial expression study (Below) by Max Narciso. Pose studies by Luis Grane (Right) and Christophe Lautrette (Far Right).

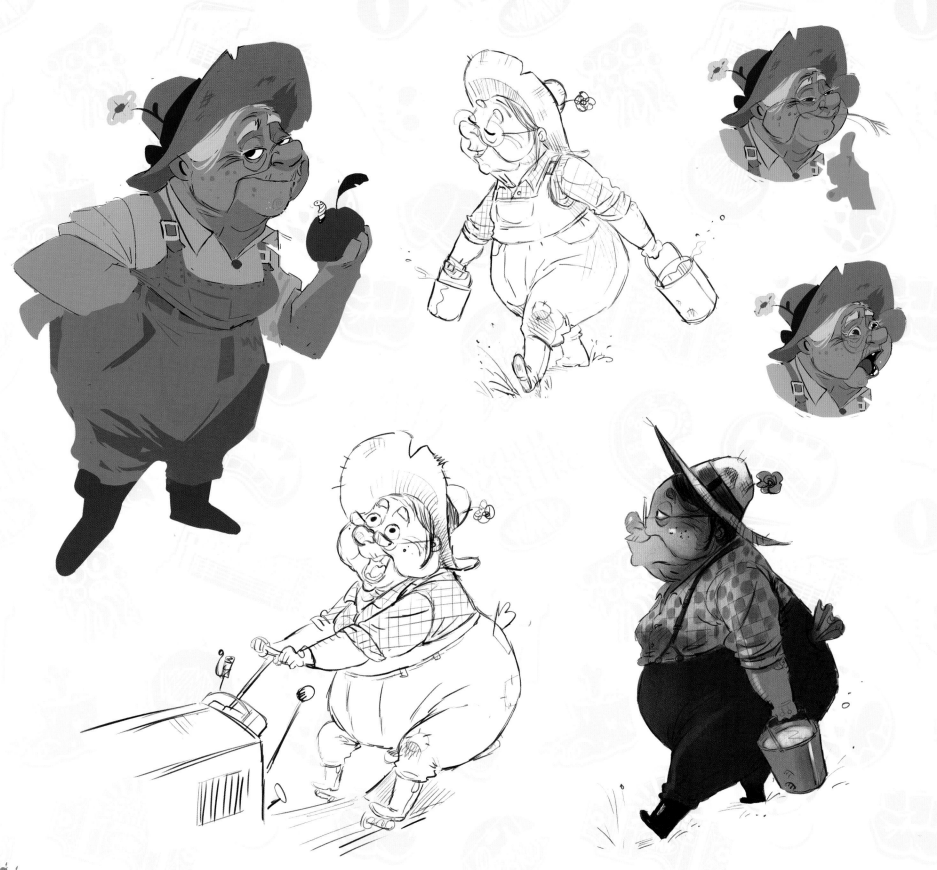

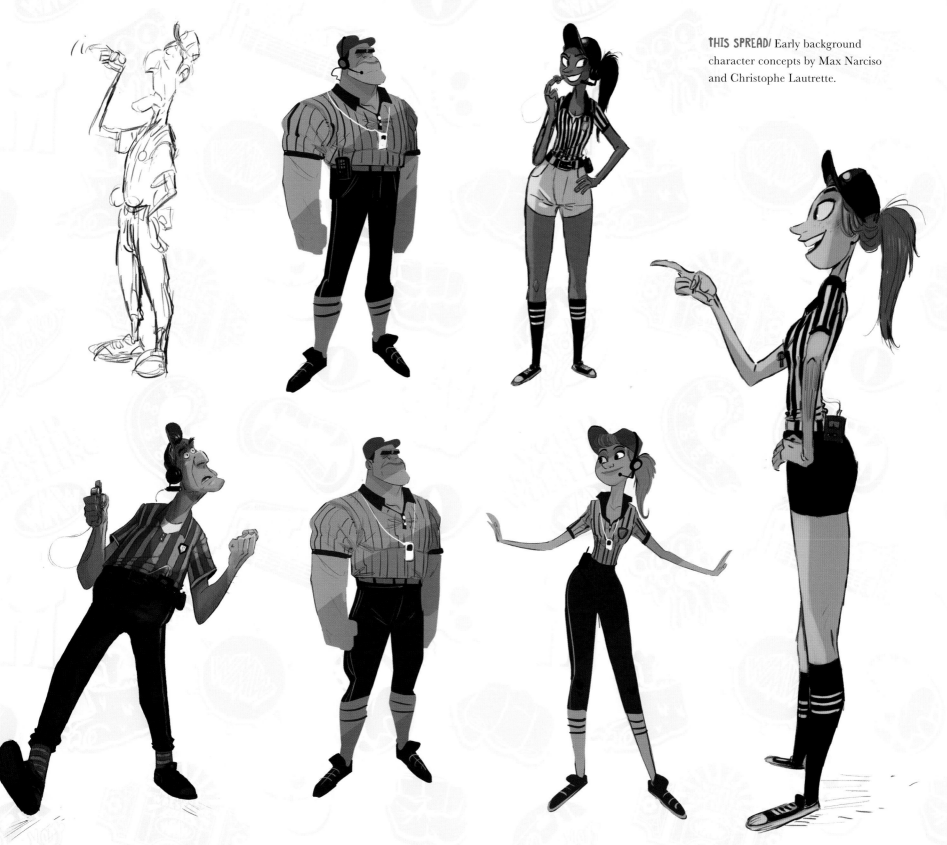

THIS SPREAD/ Early background character concepts by Max Narciso and Christophe Lautrette.

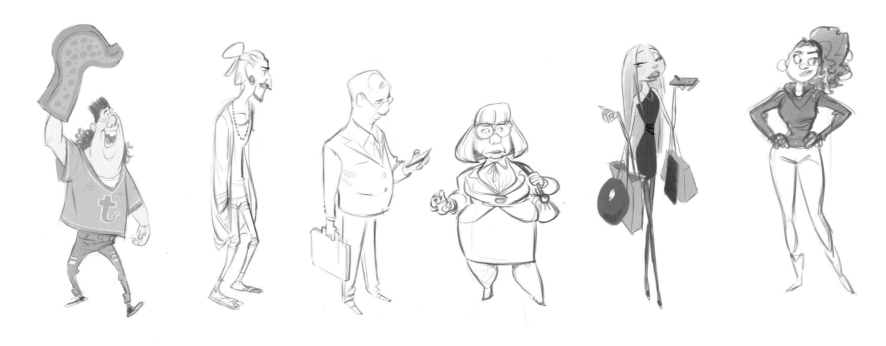

THIS PAGE/ Character sketches and concepts by Wouter Tulp (Above) and Julia Blattman (Below).

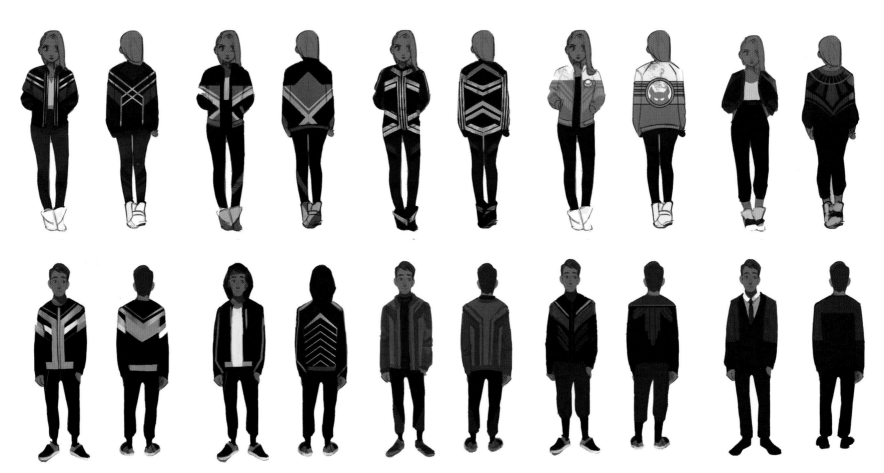

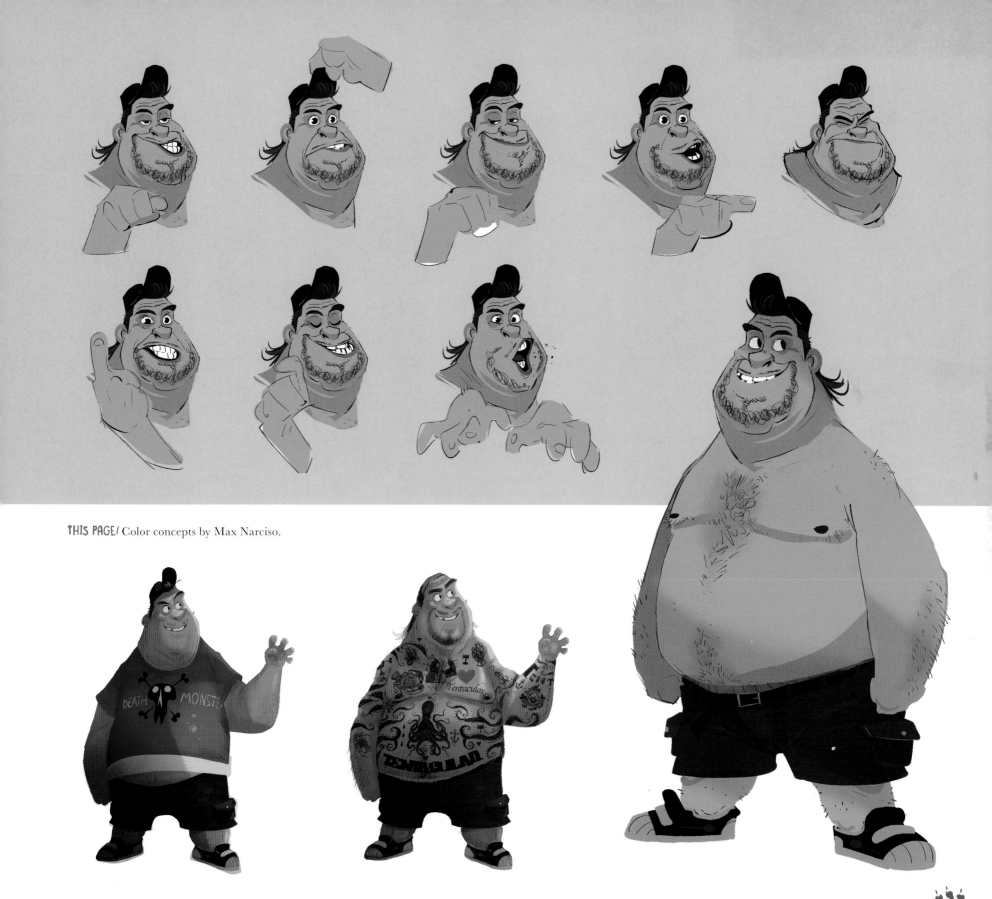

THIS PAGE/ Color concepts by Max Narciso.

BIG FIGHT!

COME SEE THE **BIGGEST** AND THE **BADDEST**

ENTER AT YOUR OWN **RISK**

YOU'RE IN TENTACULAR TERRITORY

SOMEDAY ALMOST WHAT IF IF ONLY

POST NO BILLS

AMBER'S REVENGE

Stoke

WORLD MONSTER WRESTLING

COME WITNESS UNBELIEVEABLE FEATS OF GLORY!

STOKER ARENA

SATURDAY MAY 11 AT 8 AM · GET YOUR SEATS AS EARLY AS POSSIBLE!

RAMARILLA
— VS. —
BRANDON

DENISE VS. FRANKENDOG

SPOT VS. DRAGOON THE MERCILESS

TICKETS ARE AVAILABLE FOR PURCHASE FOR $7 AT THE BOX OFFICE

...AYBURN ...MBO COYLE

THE ULTIMATE SHOWDOWN...

LIGHTS OUT

VERSUS **FRANKENDOG**

THIS SATURDAY AT STOKER STADIUM

7PM

GET TICKETS EARLY AT THE BOX OFFICE. THIS EVENT WILL SELL OUT!

WRESTLING TRYOUTS:

This Saturday at the Stoker Arena

Do you have what it takes to be the next international sensation?

Are you around 50 feet tall?

Have you ever eaten a car?

MONSTER XING

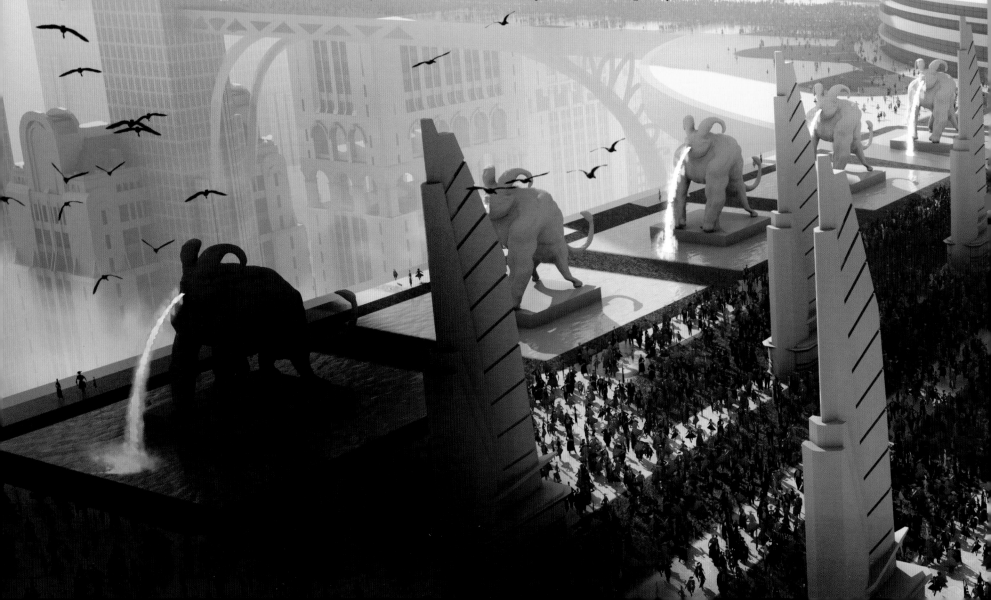

SETTING THE SCENES

Rumble, loosely based on Rob Harrell's graphic novel *Monster on the Hill*, takes place in present-day in a world that looks a lot like ours… but isn't. Art director Fred Warter calls it a parallel Earth; director Hamish Grieve says it's Earth 2: "It's basically our Earth but as if the history of it was very different because there are giant monsters."

In creating the fantastic yet familiar milieu of *Rumble*, the filmmakers were keen to tell a modern-day tale infused with a sense of history and nostalgia ("Winnie is always looking back on her dad and the glory days," says Warter). To that end, they chose art deco-inspired elements as an homage to the film's studio, Paramount Pictures. Like the design style itself, Paramount came to prominence during the 1920s and 1930s; it also had art deco elements in its architecture. Serendipitously, in researching the era, Warter found that modern professional boxing was becoming a popular sport in the United States during that period. "That was an 'aha' moment for me," he says. "I imagined that in our world, monster wrestling really took off as a professional sport in the 1920s."

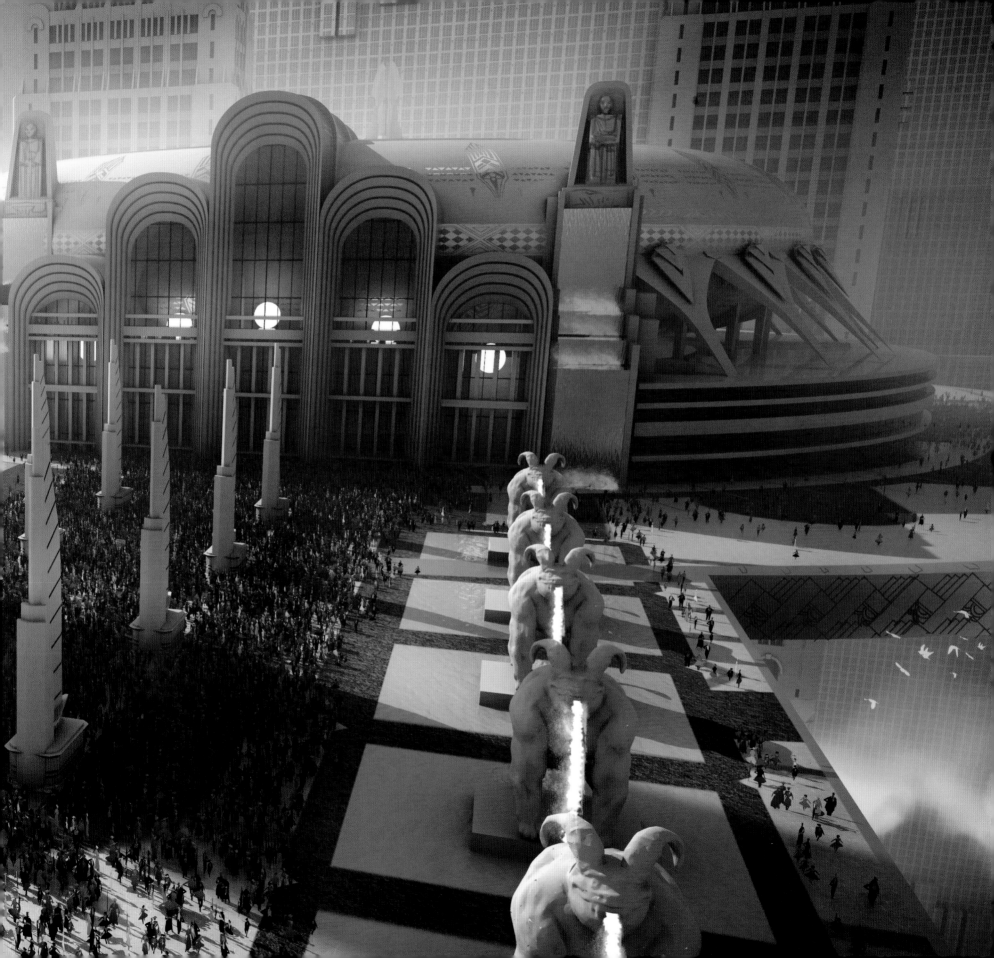

In the beginning, *Rumble* artists put art deco elements into as many things as they could, to give the world a coherent look, "down to buildings to the tiniest props," says artist Julia Blattman. But because *Rumble* is a modern tale, they dropped the motif little by little, because "we didn't feel like it was helping," says production designer Christophe Lautrette. "It felt old!" Nevertheless, art deco remains woven in the film's DNA: it can be found in the architecture, product design, and retro-futuristic modes of transportation, all of which is seamlessly blended with a modern-day sensibility.

The innate familiarity of the *Rumble* world goes beyond its recognizable design elements to its landscapes. In this alternate environment, there are no real-life American cities but Stoker, where much of the film's action takes place, is reminiscent of small towns in the Eastern Seaboard; the megalopolis Slitherpoole is an obvious stand-in for New York City.

Color and lighting play a powerful role in telling the *Rumble* story. Grieve points out that the film's deep, jewel-toned color palette is heavily influenced by the theatrics of the WWE. "Those sports events are very colorful, so we wanted to have that sense of richness in the palette," he says. Artist Julia Blattman concurs: "We didn't shy away from color when it came to exciting explosive moments in the stadiums. For each

scene, we really played around with manipulating light to create a certain atmosphere, too. When doing lighting keys, we loved trying lighting scenarios with bold statements, not shying away from strong silhouettes and almost a graphic approach." Lighting supervisor Liz Hemme agrees: "From the beginning, Hamish encouraged us to 'go bold' and push the drama in lighting," she says. According to visual development artist Naveen Selvanathan, *Rumble* artists used tones that were more mature than the average animated movie. "We took inspiration from highly stylized movies like *Amelie* and *Blade Runner* where every shot is curated, and camera color filters are heavily used to enhance the mood of the scene,"

 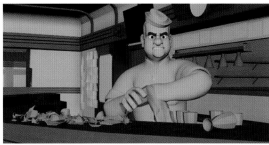

PREVIOUS PAGE/ Environment painting by David Levy. THIS PAGE/ Color keys by Julia Blattman.

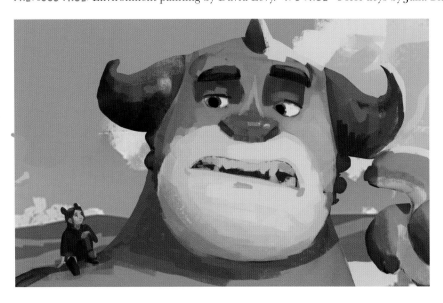

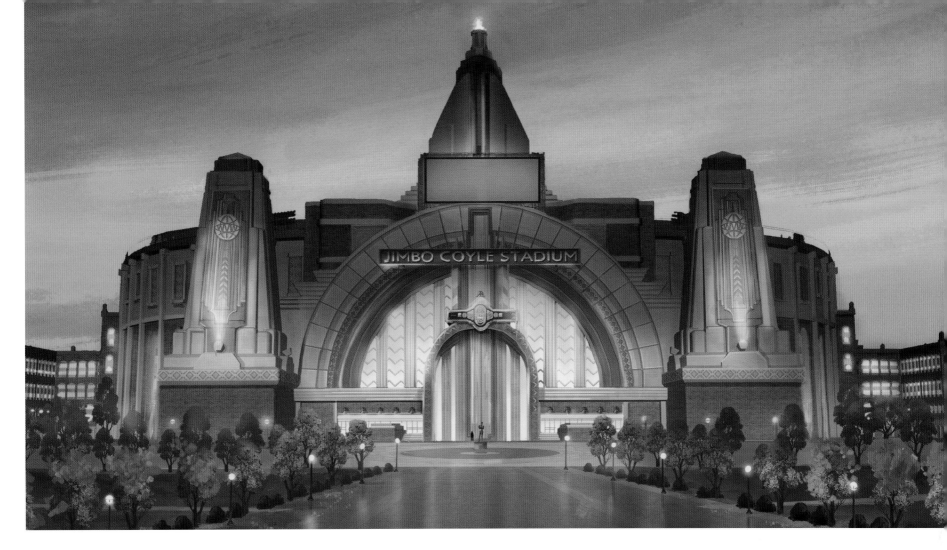

THIS PAGE/ Environment painting by Julia Blattman.

he offers. "Most animated movies look too pretty, brightly lit, and perfect. We pushed the colors to convey that the world this story is happening in is imperfect and full of grit and texture. We focused on mood over realism."

For the audience to be fully immersed in the story and accept that this is a world of tiny humans and humongous monsters, head of cinematography Kent Seki says the use of longer lenses to emphasize the creatures' proportions was an important tool. "The longer lenses also helped create compositions with 'reverse perspective' in which objects further from camera (the monsters) were larger in frame," he adds. When it came to lensing the epic fight scenes,

most of which show Rayburn Jr.'s progression from zero to hero, there was a mandate to make each one distinct. "I didn't want there to be fight fatigue from an endless display of monsters punching each other in the face," says Grieve. "Very early on, we made a huge effort to differentiate each fight in the movie."

Seki elaborates: "We shot each hero fight scene in a slightly different way to emphasize the context and significance in the film. The King Gorge/ Tentacular fight represented our audience's first exposure to monster wrestling. It is the 'promise of the premise.' It's very much a combination of TV coverage and an insider look though Winnie's

eyes when she climbs on top of the turnbuckle. The Underground Fight takes the audience through a raw experience in this scene where we relied more on a hand-held point of view that emphasized the scale of the monsters as we approached the ring. In the Docks Fight, we shot with a slightly more refined take, but still with an 'operator' feel whenever possible. As the fight gets more out of control, the camera follows suit. In the Final Fight, we throw in everything to deliver both a cinematic and emotional experience. There's a great 'oner' (one continuous take) in the third round that takes us through the match as it becomes an equal fight between Rayburn and Tentacular."

STOKER CITY

The action in *Rumble* starts in Stoker and the town is first revealed in the opening frames of the film as Winnie walks through the streets on her way to the stadium. It's a warm and friendly hamlet that has the energy of a lively college town. Everyone knows each other and residents are united in their love for monster wrestling as well as in the well-being of their community. To accentuate the dynamics of the place, artist Julia Blattman says the team used compelling colors – intense oranges, grassy greens, and vivid blues.

The use of color in Stoker was also used to represent Winnie. "Winnie is vibrant teenager, so we wanted the city she lives in to be vibrant as well," says production designer Christophe Lautrette.

Geographically, the filmmakers envisioned Stoker to be located in New England, but the primary visual inspiration for the All-American city was actually the charming Ozark Mountains town of Eureka Springs, Arkansas, population 2,091, known for the preserved buildings in its historic district.

THIS PAGE/ Building studies by Julia Blattman (Top and Bottom Left) and Paige Woodward (Bottom Right).

NEXT PAGE/ Enviroment paintings by Naveen Selvanathan (Top) and Jim Alles (Bottom).

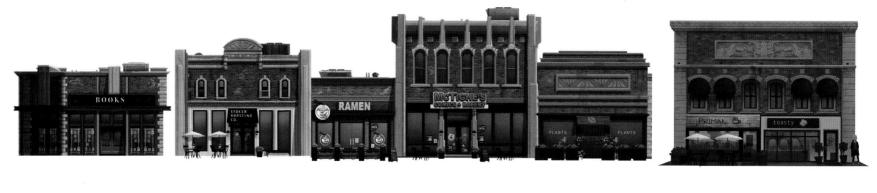

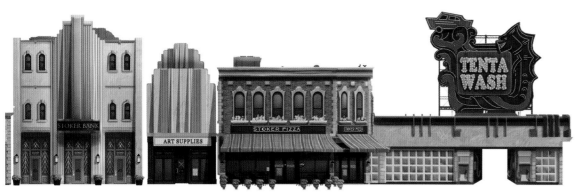

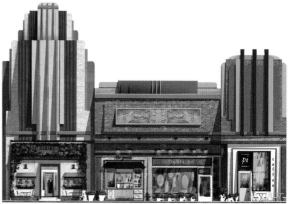

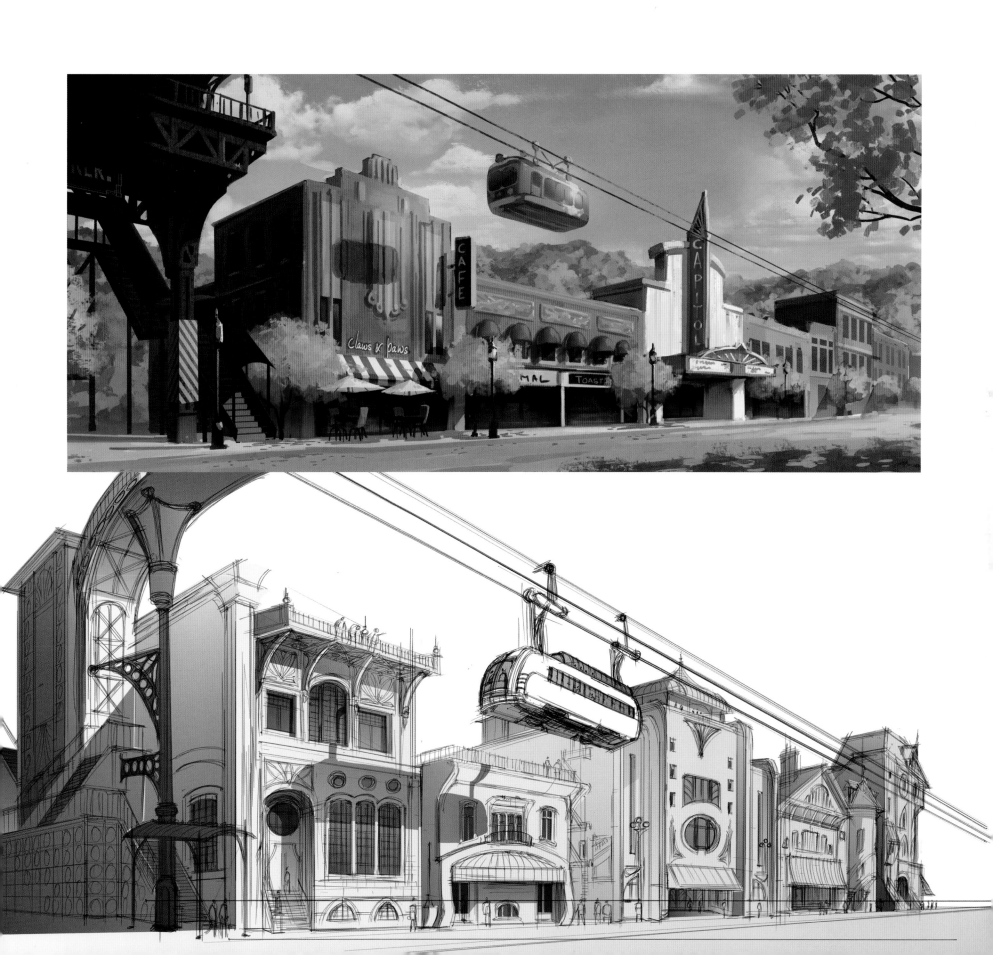

"It's built in a canyon and has winding streets," says art director Fred Warter. Because of that, according to Lautrette, who is French, it has a bit of a European feel to it, too. Both the buildings and the town's layout influenced their designs.

The art deco vibe is strong in Stoker, embellishing the numerous brick storefronts that are home to coffee shops and pizza parlors, with arches, chevrons, and other decorative elements. Together, the buildings provide Stoker with a cohesive look, while individually, they have their own unique character, exemplified by their signs, awnings and lighting fixtures. Several of the buildings, in homage to the hometown hero, display Tentacular-themed touches. "There's a bank, hotel, and hair salon that all have some architectural façade that tips their hat to him," says Grieve. "A theater, too," adds Warter, "which was patterned after a real-life art deco Paramount-owned theater in New York."

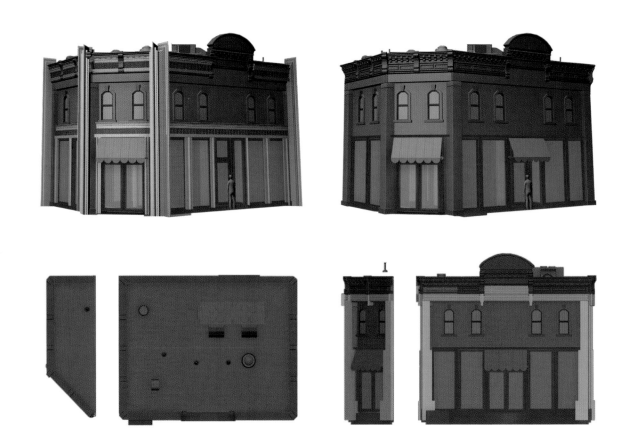

THIS PAGE/ Building studies by Richard Lee (Above). Environment painting by Naveen Selvanathan (Below).

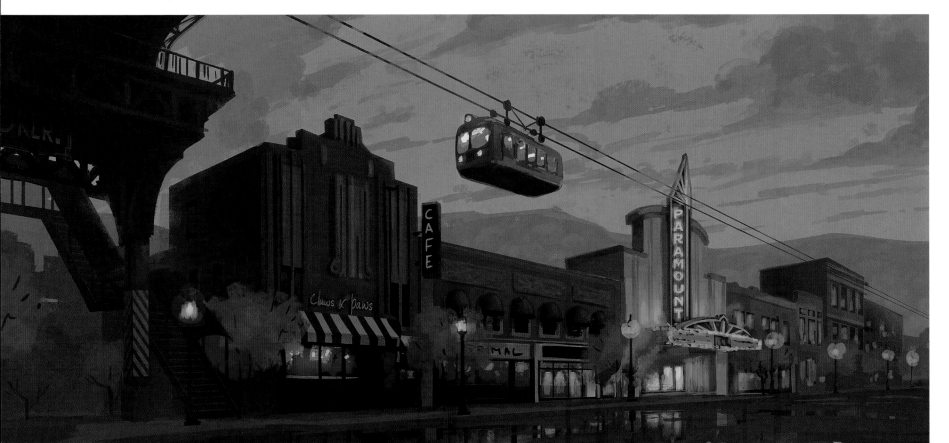

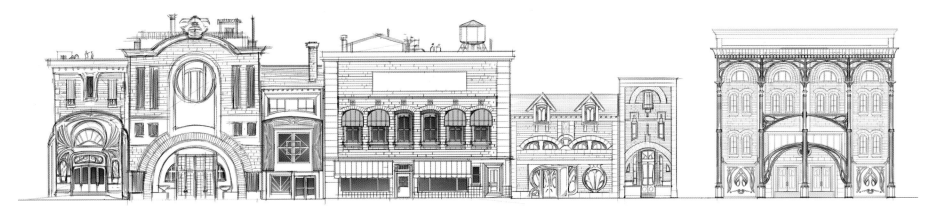

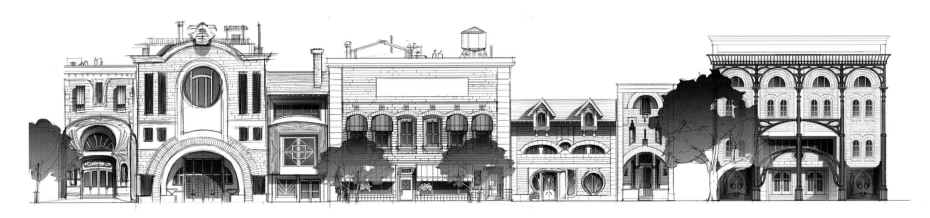

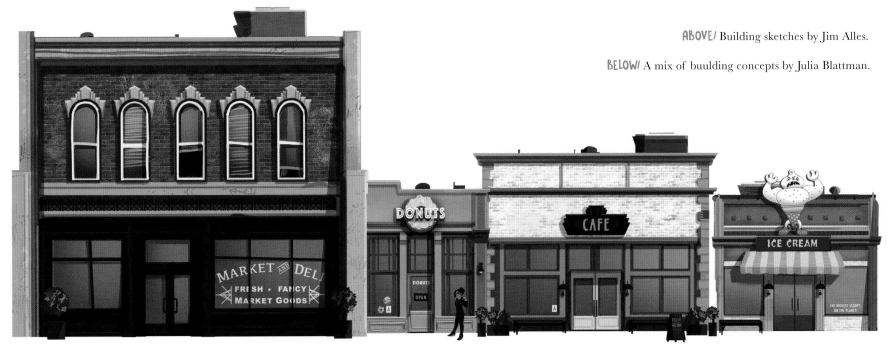

ABOVE! Building sketches by Jim Alles.

BELOW! A mix of buulding concepts by Julia Blattman.

STOKER JIMBO COYLE STADIUM

Jimbo Coyle Stadium is the heart of Stoker and a source of pride for the citizens of the town who have a vested interest in its ongoing success: they own part of it!

"The analogy we used is Green Bay, Wisconsin, where the town are actually the shareholders of their football team, the Green Bay Packers," director Hamish Grieve says. "So, every part of Stoker is reliant upon the stadium and the success of Rayburn and Jimbo." Art director Fred Warter, who referenced the Rose Bowl in Pasadena and the Los Angeles Coliseum when he conceptualized the arena, agrees: "It's the hometown

stadium. It's a more intimate environment than the other ones in our world."

Named after Winnie's dad, the venerable amphitheater sits at the end of the town's largest street on its own special Stadium Island, surrounded by the river that runs through Stoker. Rising up countless stories high as a beacon of hope and glory, fans and monsters alike walk across an ornate, lamp-lined pedestrian bridge to get to it. The statue of Jimbo Coyle that everyone touches for good luck stands outside the coliseum in its own place of prominence.

The stadium has all the hallmarks of an art deco-designed structure. Zig zag and chevron patterns

THIS PAGE/ Environment painting by Julia Blattman.

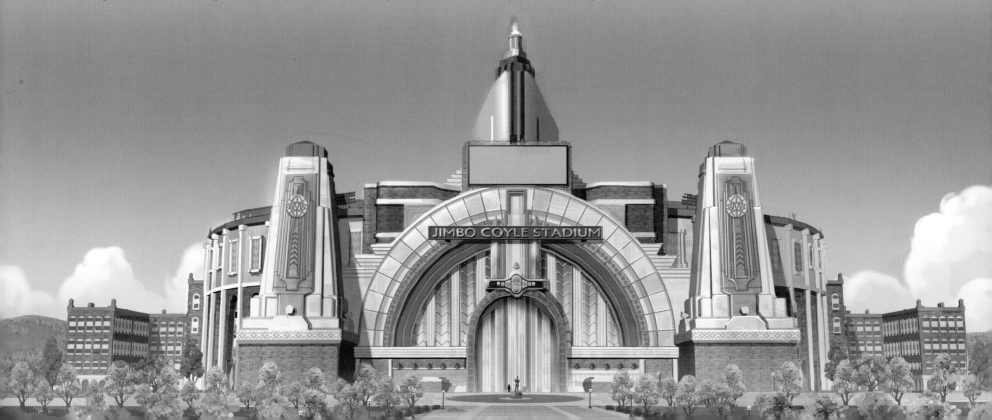

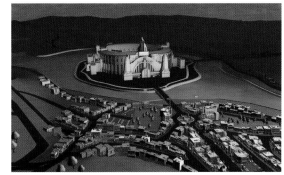

ABOVE/ Stadium designs by Dennis Greco (Left) and Richard Lee (Right). BELOW/ Stadium sketch by Fred Warter (Top). Environment painting by Julia Blattman (Bottom).

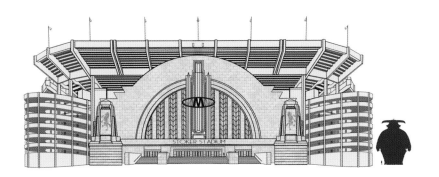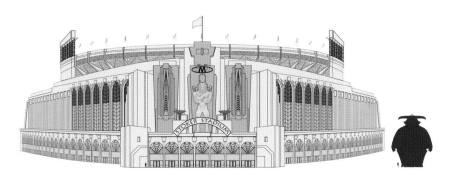

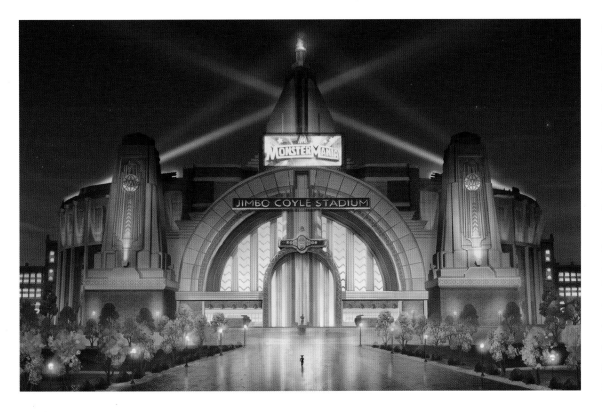

decorate the building, which features two symmetrical pillars, each with clean vertical and horizontal lines, rising up on either side of the main entrance. The entrance itself is a central focal point, thanks to two exaggerated arches over the doorway, and a lighted triangular and stepped tower at the top. "We gave it an open rooftop, like older stadiums found in many college towns," says production designer Christophe Lautrette. "It accommodates about 40,000 fans in retractable wooden seats, the kind they used in the 1950s. They're not rundown or anything but they've never been replaced. They're vintage." Adds artist Julia Blattman, who worked on the building's surfacing: "We wanted this place to feel like it had history to it, where legends like Winnie's father used to be. Warm red bricks helped tie in the stadium to the look of the rest of the town; green verdigris on the roof made it seem old; and the brass trim, used sparingly at the entrance, gave it high value."

FRED'S DINER

If there's another place in Stoker that's almost as popular as the stadium, it has to be Fred's Diner. It's the town's hub: it's where everyone goes for good food and good conversation... about monster wrestling, of course. The diner is Winnie's home away from home, too, according to production designer Christophe Lautrette, "it's where she goes to do her homework," he says, and Stoker's de facto town hall, where townsfolk gather to discuss all important matters. Wrestling memorabilia covers the interior walls of the eatery and, at the start of the film, Fred has also installed a neon tentacle holding a coffee cup on the top of the diner, an homage to Tentacular. It's hard to beat Fred's enthusiasm for the sport!

THIS PAGE/ Environment paintings by Julia Blattman.

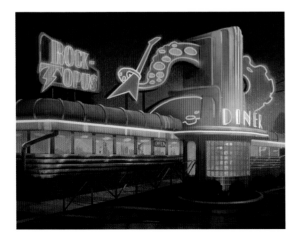

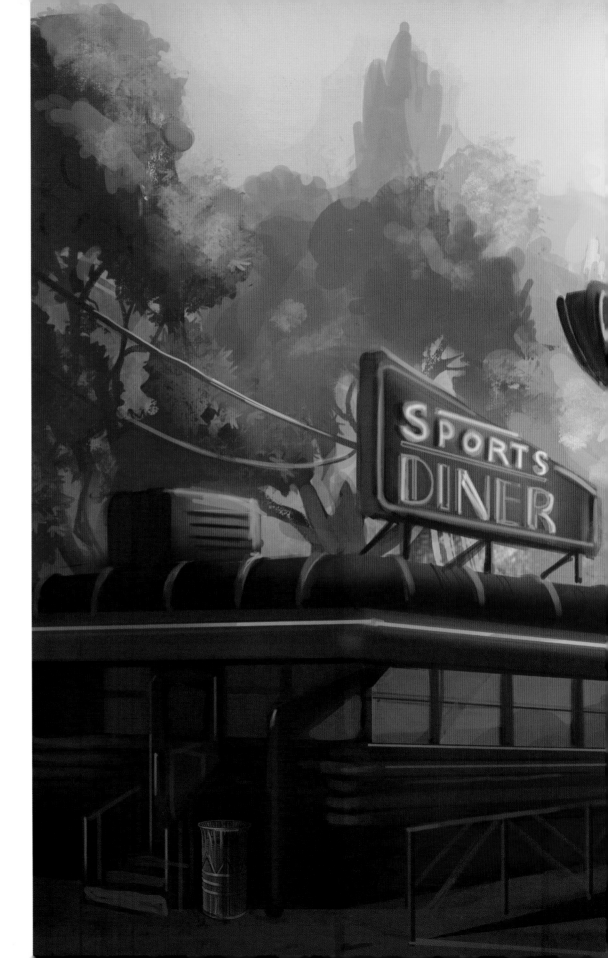

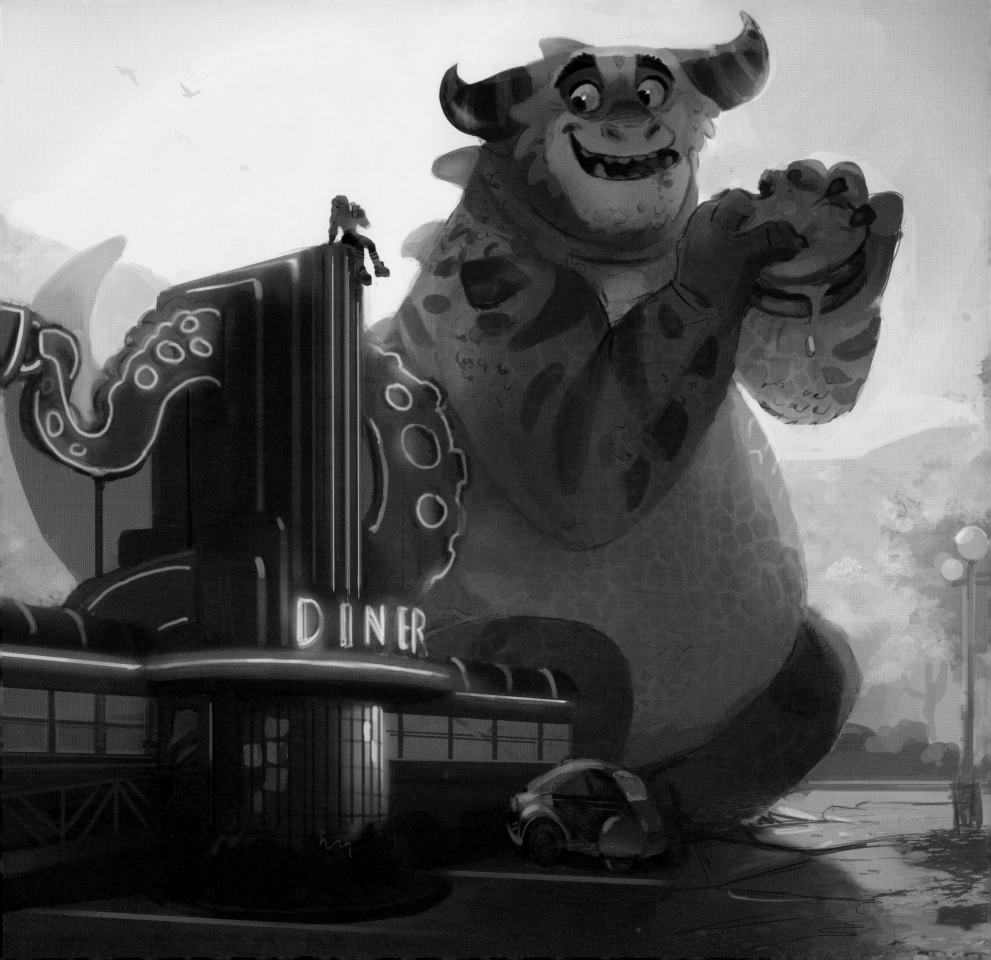

Artist Julia Blattman says she had fun incorporating monster elements into the diner and patterned the building's overall design after the sleek art deco diners that first gained popularity in the U.S. during the 1930s. "I wanted Fred's Diner to feel like an actual place that had decades of history to it," she adds. To create the evocative look, Blattman gave the diner plenty of large windows that provide lots of light; stainless-steel elements throughout; a curved roofline; and a glass blocks entrance. Bold splashes of color, mostly red, help establish the character of the place. There are additional neon lights inside the diner which, she says, "gave us opportunities for fun colorful lighting scenarios at night."

According to art director Fred Warter, the diner is one of the first buildings audiences see at the start of the film, which helps establish the town's cool retro vibe. "It plays into that 1920s and 1930s aesthetic," he says. "We wanted it to feel like a very friendly place."

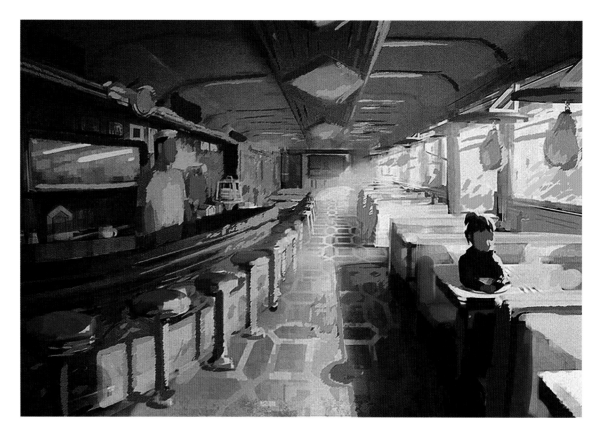

"It plays into that 1920s
and 1930s aesthetic.
We wanted it to feel like
a very friendly place."

**FRED WARTER –
ART DIRECTOR**

THIS SPREAD! Prop and furnishing designs by Julia
Blattman (Above). Enviroment paintings by Naveen
Selvanathan (Bottom Left) and Julia Blattman
(Bottom Right).

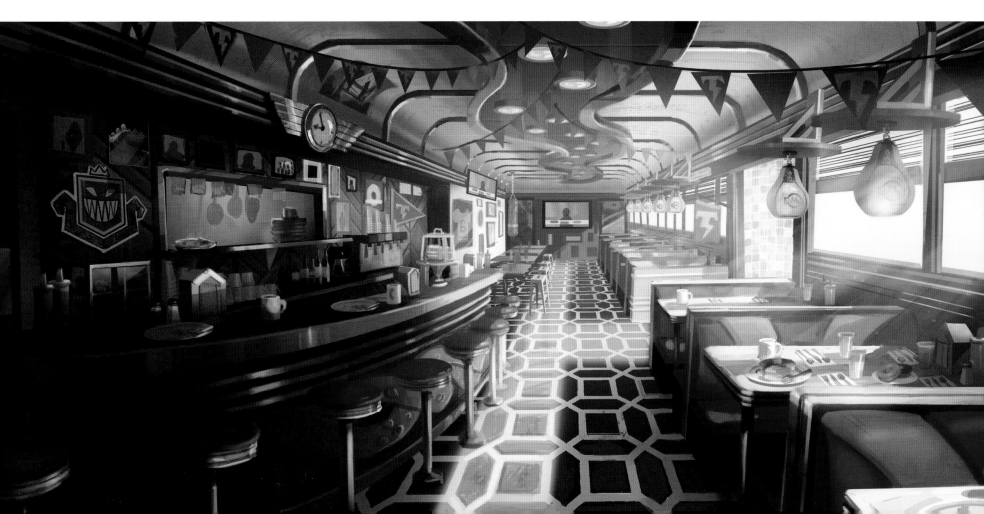

SIGGY'S APARTMENT

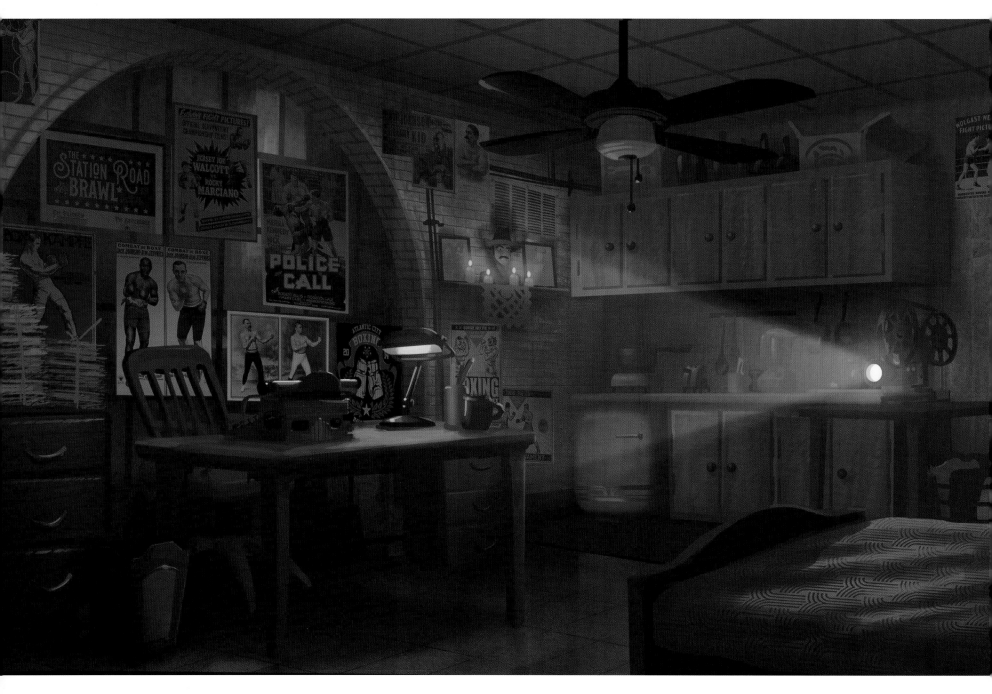

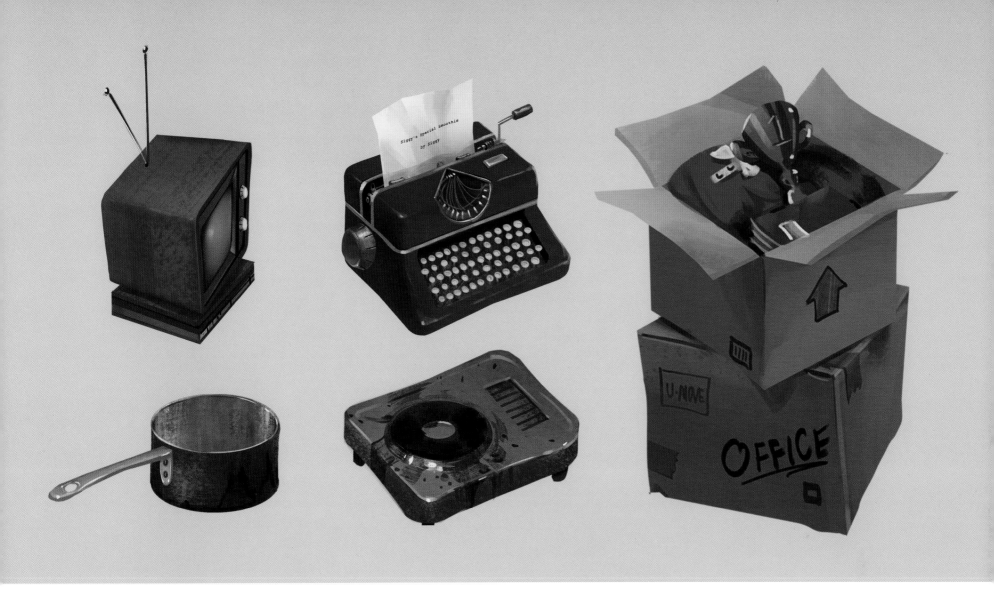

After **Tentacular announces his** intention to leave Stoker, Siggy reveals that he is going with him. Winnie goes to his apartment to persuade him to stay but it's no use: he's convinced that he's hitched his wagon to a brighter star. When she arrives, he's packing his bags.

Positioned in the back of the gym where Rayburn Sr. had trained for so many years, the dark and dank room serves as both Siggy's office and living space; there's a bed on one side and filing cabinets on the other; the floor is hard and cold. The space reinforces to audiences the idea that he is completely devoted to wrestling and has been for a long, long time. There's a nostalgic feel to it: an old projector, used for reviewing fights, sits on a counter; vintage boxing photos and wrestling match posters from days gone by are everywhere.

"We wanted the past to be imbedded on the wall," says production designer Christophe Lautrette of the images, and the darkness of the space also evokes emotion. "He's leaving town. We didn't want too much light or hope coming in."

THIS PAGE/ Environment painting by Naveen Selvanathan (Left). Prop designs by Cathleen McAllister (Right).

WINNIE'S APARTMENT

Winnie and her mom live on the top floor of a beautiful old four-story structure in Stoker, reminiscent of New York City's famed Flatiron Building. It's positioned between two streets and is in direct line of sight with Stoker Stadium.

"We found a corner building in Eureka Springs that is very similar to Winnie's," says art director Fred Warter of the Arkansas town they referenced. "That was our main inspiration for the building."

Of the building's positioning, production designer Christophe Lautrette says, "The idea was that Jimbo Coyle, when he was alive, lived for the stadium: he went from home to the stadium, from the stadium back home. We also wanted it to stand out and be iconic, as if it were the only building in town."

Inside, the apartment is a warm, cozy place infused with rich color, which "reinforces the sense that the space is inviting and safe," says artist Julia Blattman. It's a sunny spot, too, with high ceilings and big windows that allow the light to come in, all of which reflects the happy personalities of Winnie and her mom.

THIS PAGE/ Building illustrations by Julia Blattman.

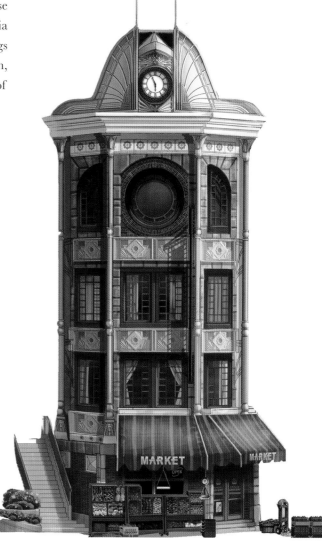

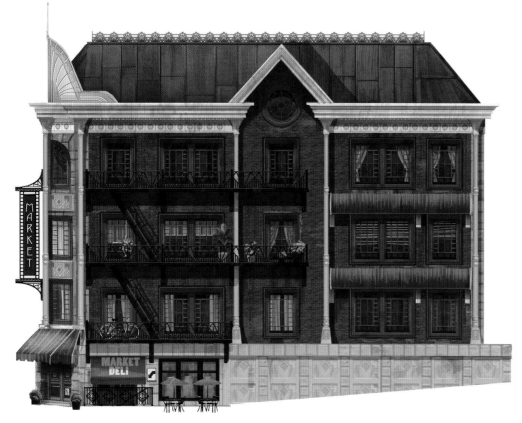

114

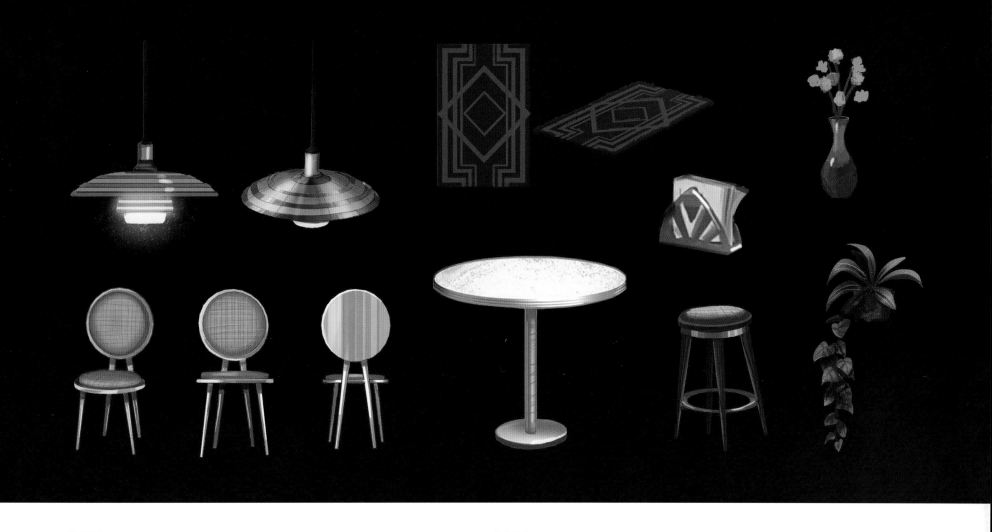

ABOVE/ Prop and furnishing designs by Julia Blattman.

BELOW/ Concept by Julia Blattman (Left). Building sketch by Jim Alles (Right).

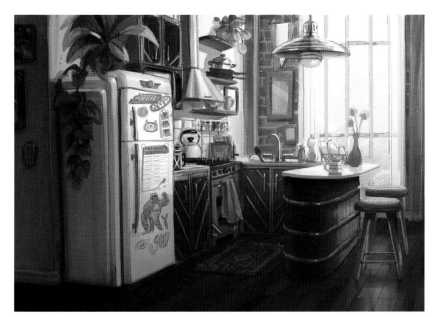

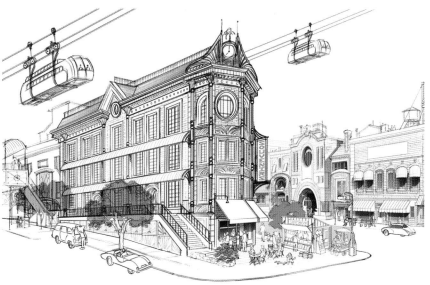

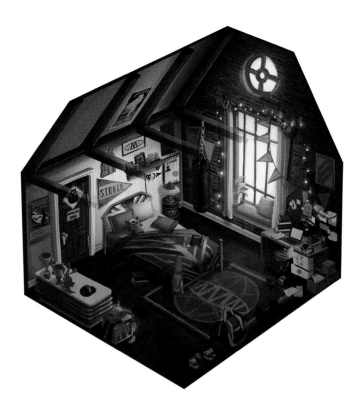

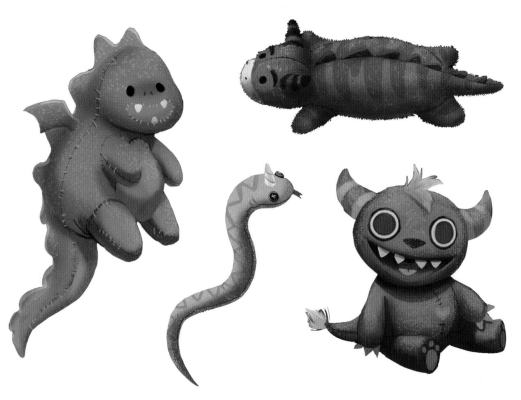

ABOVE/ 3D concept design and props by Julia Blattman.

BELOW/ Environment painting by Julia Blattman.

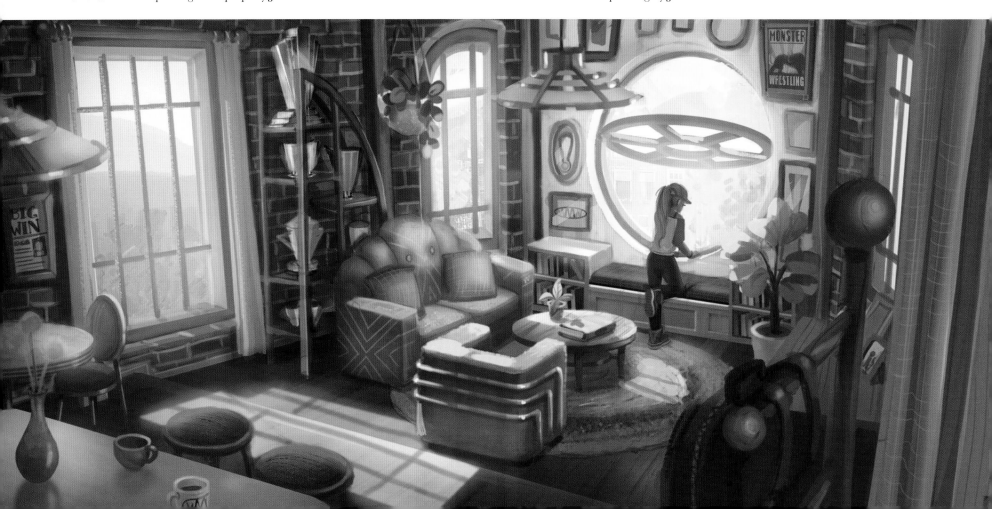

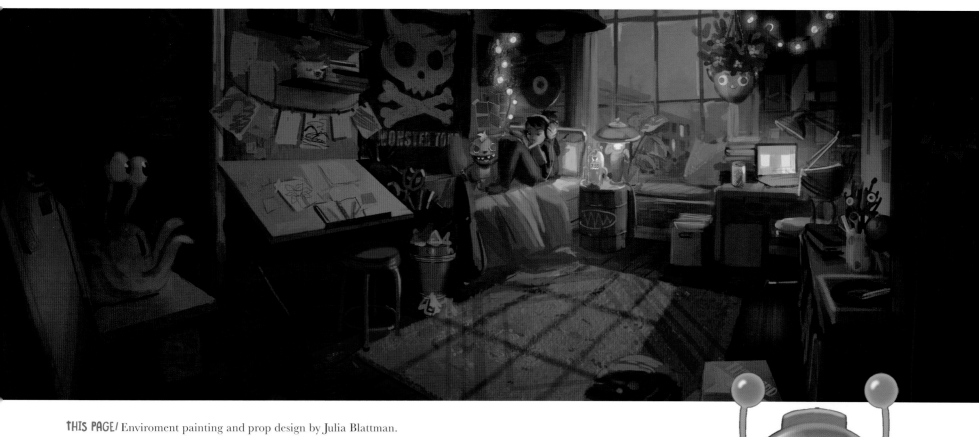

THIS PAGE/ Enviroment painting and prop design by Julia Blattman.

Like so much of Stoker, the rounded shapes of the apartment's furniture are art-deco inspired, while the apartment as a whole is a bit eclectic in style. Jimbo's presence is felt through old family photographs, framed posters, training tools, and wrestling memorabilia.

Blattman wanted Winnie's bedroom to showcase Winnie's interests and convey her personality. She drew inspiration from her own teenage bedroom, which had "band posters on the wall, drawings of things I liked, loads of stuffed animals – in Winnie's case, monster stuffed animals," she says. She loved adding little details, too, such as the monster alarm clock that "annoyingly roars her awake for her 5:00 a.m. training routine; the box of pink hair dye on her nightstand; her growing heaps of laundry that she doesn't have time to deal with."

"Earlier in story development, Winnie was supposed to be an artist," adds Lautrette, "so we designed an artist's desk for her. Even though there's not a focus on that anymore, we left it in her room."

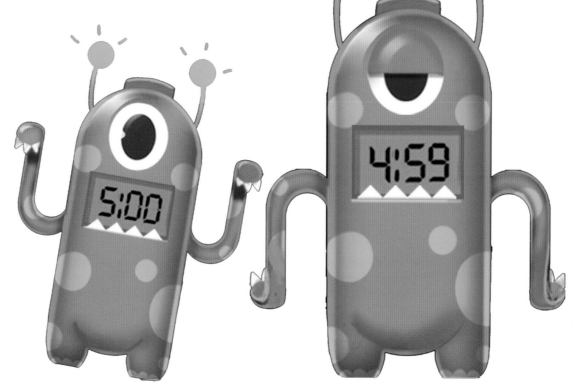

STOKER TRAINING FACILITY

In Stoker, everything is sized for its human inhabitants – except for the stadium and the training facility, which were designed to accommodate the colossal monsters who use them. The *Rumble* team played with the idea of making the Stoker Training Facility an open-air space but ultimately, the concept of an enclosed location prevailed, which meant they had to dig a little deeper to find their source of design inspiration. They looked at airplane hangars, which were certainly big enough to accommodate sixty-five-foot monsters, but it was the historic Buffalo Central Terminal, a majestic old train station built in 1929 in Buffalo, N.Y., that served as inspiration. "It had these awesome, giant arched windows," production designer Christophe Lautrette says, "and for our version of it, I could envision the inhabitants of Stoker clearing out the interior of the station to make room for Rayburn to train."

THIS PAGE/ Concept by Naveen Selvanathan.

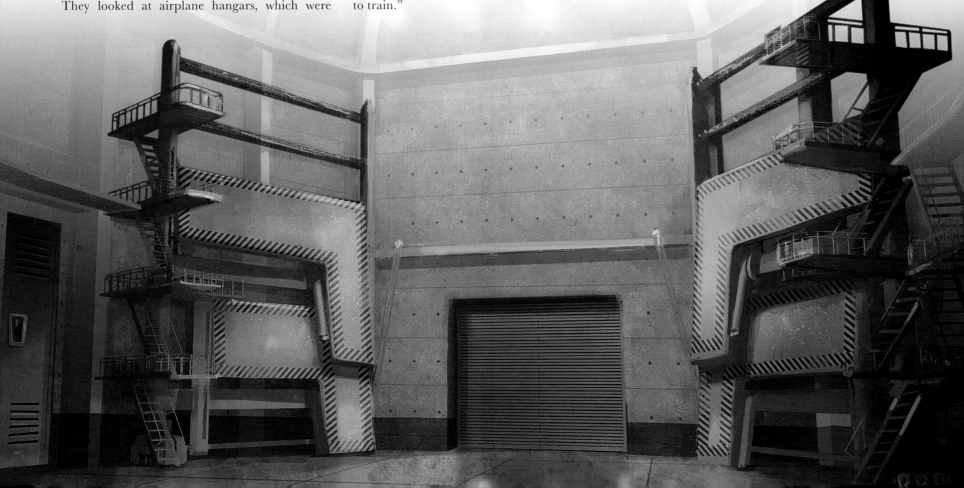

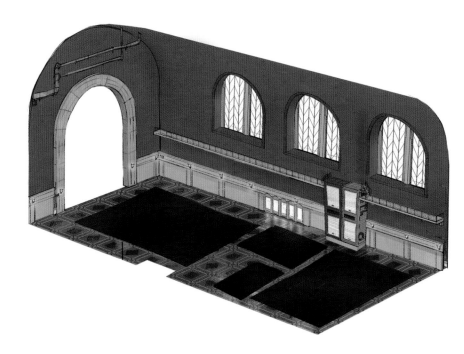

ABOVE/ 3D concept and prop designs by Cathleen McAllister.

BELOW/ Furnishing concepts by Cathleen McAllister.

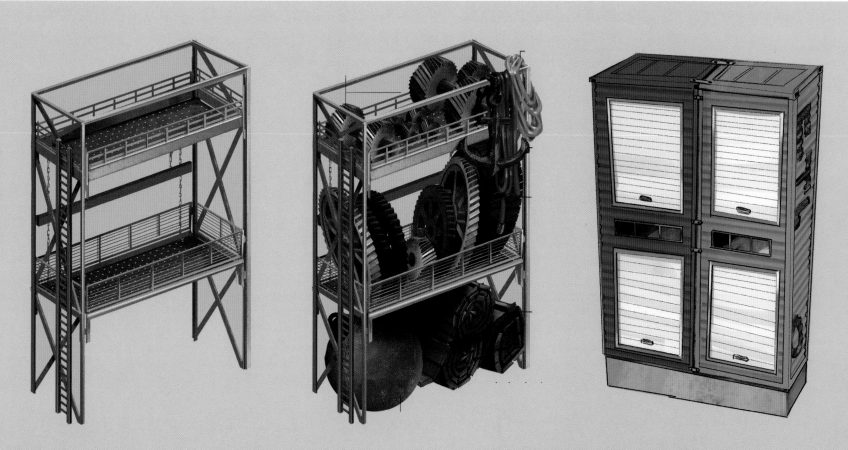

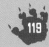

OBSTACLE COURSE MACHINE

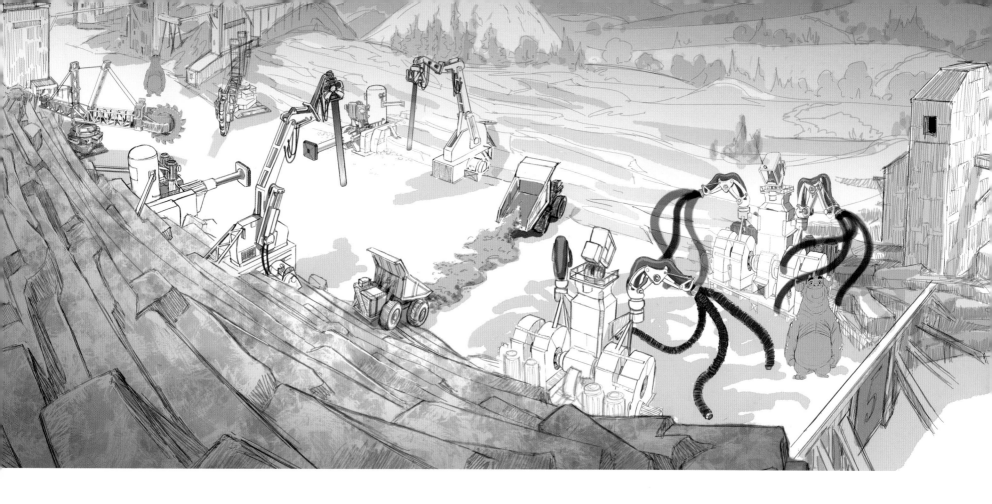

PREVIOUS PAGE/ Detailed concepts of the graffitied obstacle course by Chris Vigil (Top). A variety of different machine designs by Naveen Selvanathan (Bottom).

THIS PAGE/ Sequence painting by Dennis Greco (Top). Detailed machine design by Chris Vigil (Bottom).

SLITHERPOOLE

Five hours by tram and a world away from quaint little Stoker stands the retro-futuristic megacity of Slitherpoole. It's where Tentacular has set his sights on becoming the G.O.A.T., at the state-of-the-art Slitherpoole Stadium.

The filmmakers intended the teeming metropolis to have a prominent visual role in *Rumble*. It was one of the first built sets and some striking imagery was created. But in the end, that was not to be. "Slitherpoole was a victim of the story changes that always happen on a production," says director Hamish Grieve. "There is so much great stuff that won't be in the final movie." Agrees art

director Fred Warter: "It kept getting trimmed back further and further; there just weren't as many opportunities to go back there. Hopefully in the sequel we'll be able to see it more!"

Production designer Christophe Lautrette referenced a number of illustrations created by present-day artists who specialize in creating dystopian, post-apocalyptic cities, and particularly gleaned inspiration from German director Fritz Lang's dystopian silent film classic *Metropolis* (1927), which showcased an immense vertical city to great effect. "You can't see the bottom of the city, which emphasizes the vertical growth of the

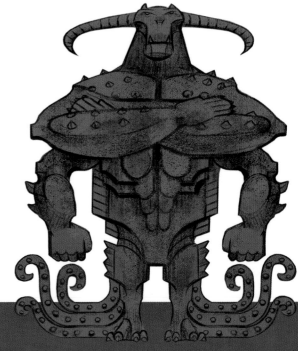

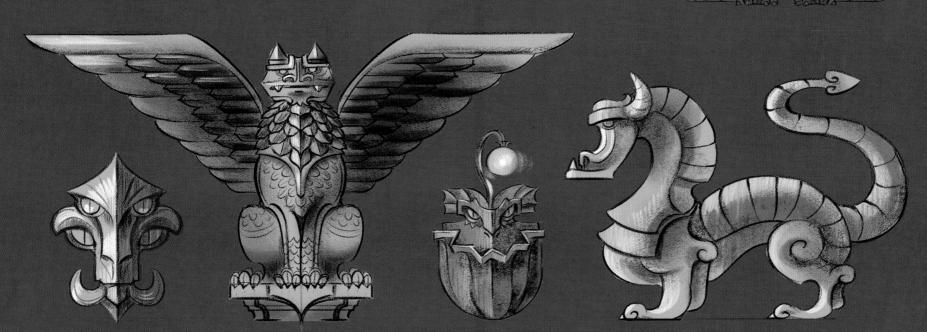

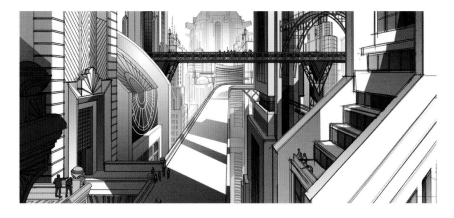

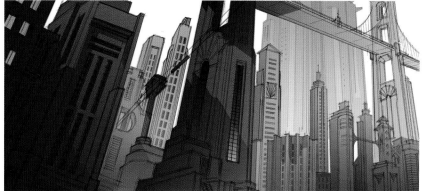

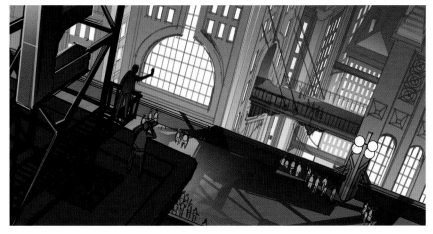

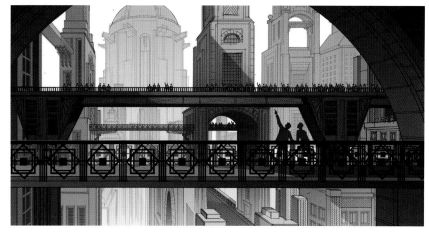

PREVIOUS PAGE/ Building embellishment concepts by Cathleen McAllister.

THIS PAGE/ Building concepts by Jim Alles (Above) and Jon Messer (Below).

place," Lautrette says of Slitherpoole. "It's a vain, overcrowded, uncomfortable environment – all metal and glass; steel grey and deep emerald. In our original design, there were some trees and I said, 'No, we shouldn't have any trees; everything created should emphasize the idea that nature doesn't even have its place here anymore.'"

Ultimately, Slitherpoole is referred to numerous times but it is seen only once. It's a sad moment, just after Winnie and Rayburn have learned that the sale of Stoker Stadium is a done deal; the architecture of the place reinforces the mood. "The city surrounds them in a very oppressive way," says Warter. "It overpowers the scene."

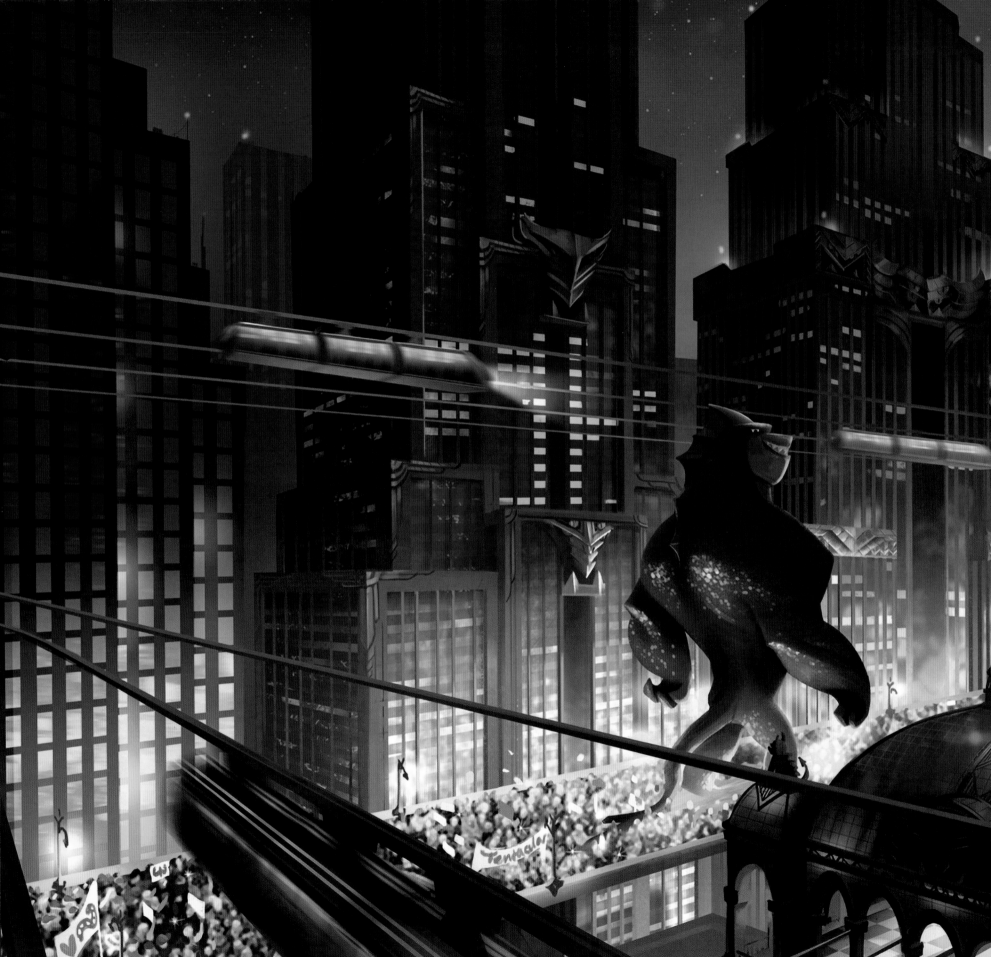

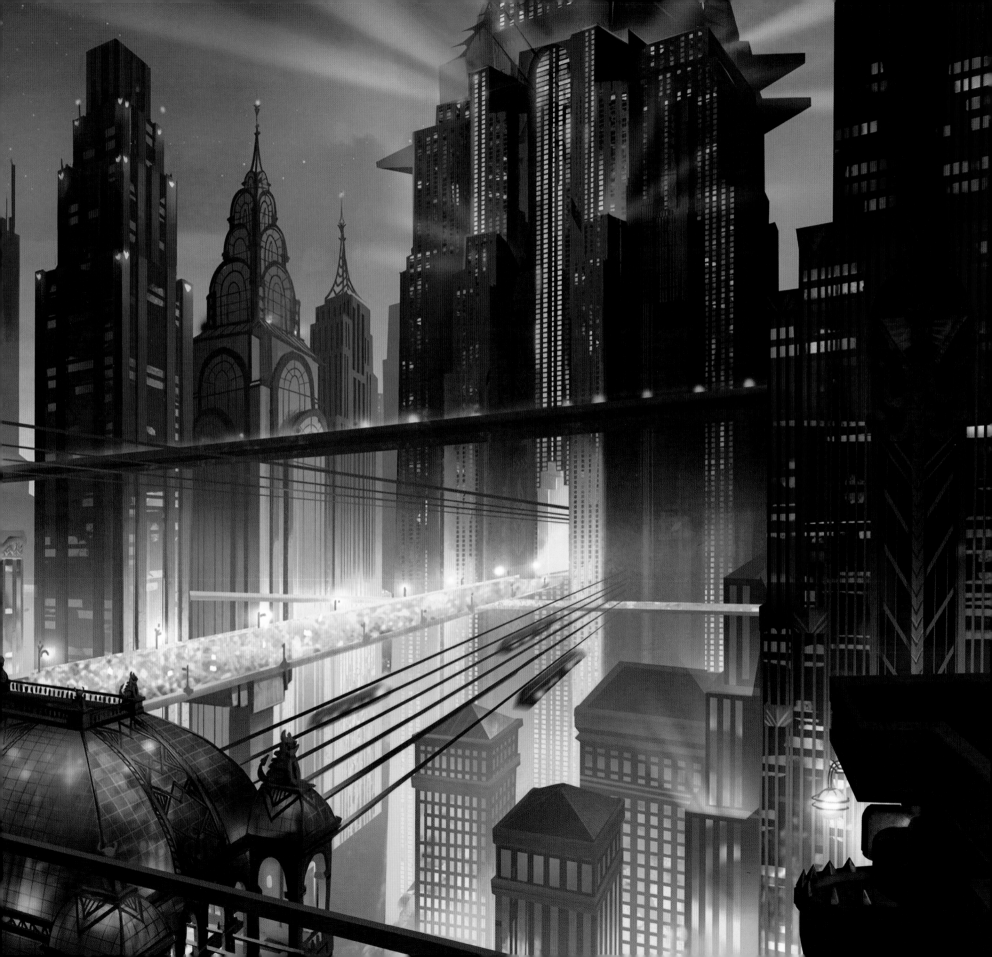

SLITHERPOOLE STADIUM

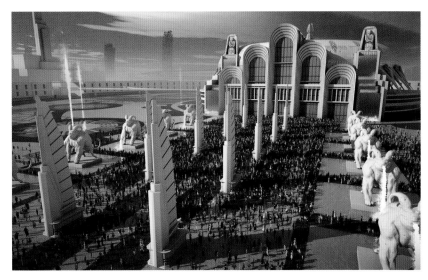

PREVIOUS PAGE/ Scene painting by Cathleen McAllister.

THIS PAGE/ Stadium concepts by David Levy.

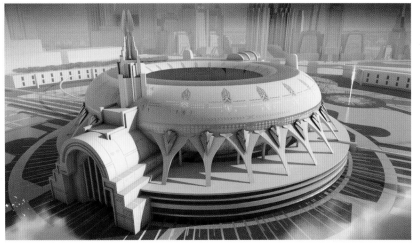

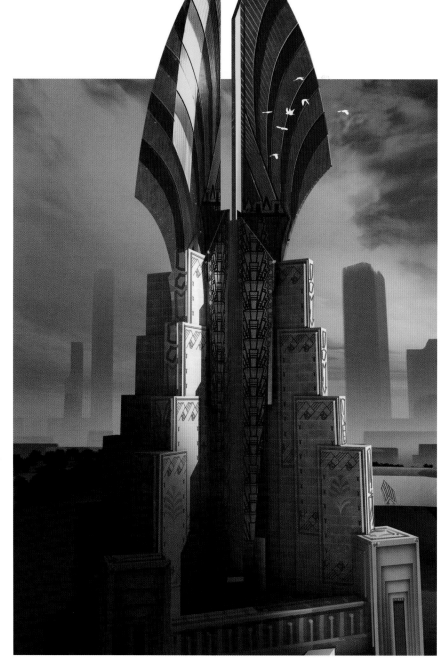

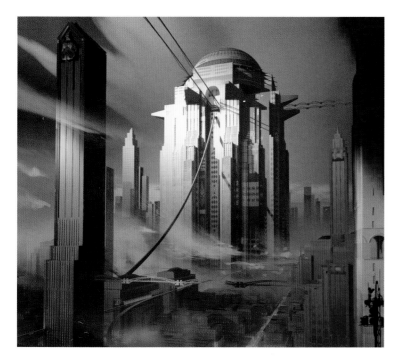

THIS PAGE/ Concepts by David Levy.

Slitherpoole **Stadium stands in complete contrast to** the more collegiate Stoker Stadium. It's a colossal structure that accommodates 200,000 fans. "We looked at a lot of the top soccer stadiums around the world for inspiration: Camp Nou Stadium in Barcelona was a really big one we referenced," production designer Christophe Lautrette says.

Located high above the ground atop the city's tallest skyscraper (and headquarters of the WMW), the stadium is the epicenter of Slitherpoole; all of the city's trams lead to it. Not surprisingly, it has all the bells and whistles you'd expect from a state-of-the art facility, including dazzling jumbo screens, amazing lighting effects, and a jaw-dropping retractable roof that opens like a flower, much like the real-life Mercedes-Benz Stadium in Atlanta, Ga., which the team also referenced. "All this is intended to sell the idea that only the best of the best could ever fight here," Lautrette says.

In the final film, though, only the interior of the stadium is seen. Giant podiums from which camera people, inside protective cages, safely chronicle fight proceedings, help sell the scale of the place from above. Coaches also have podiums so that they can more easily manage their powerful super athletes.

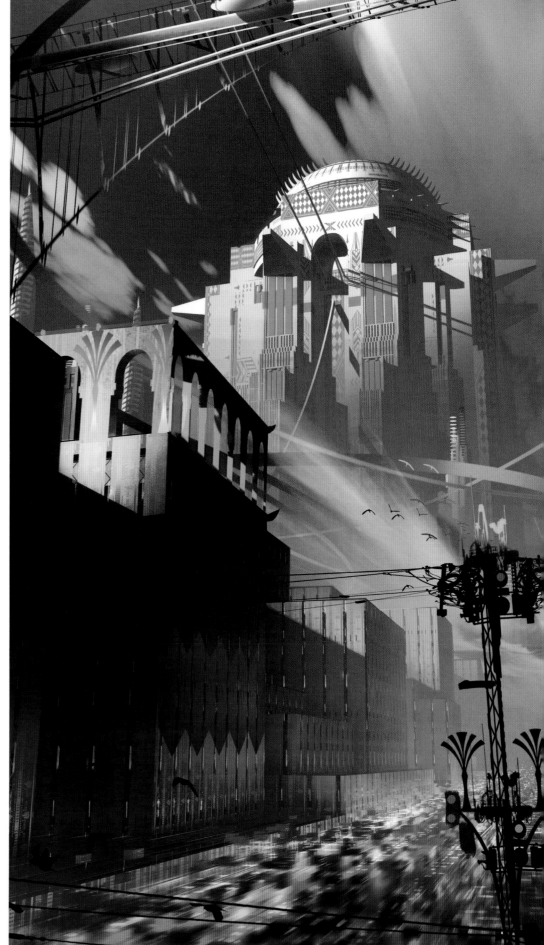

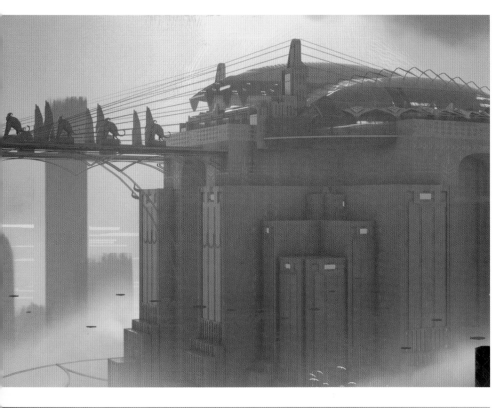

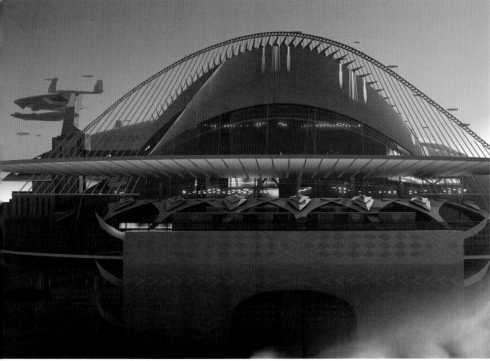

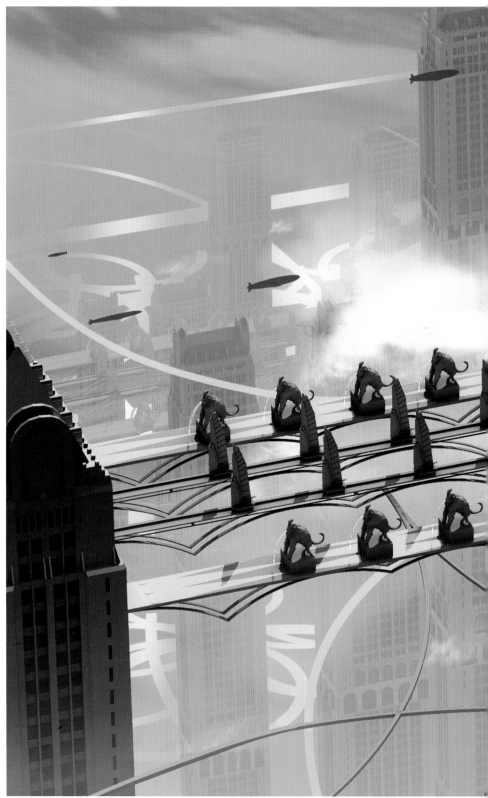

THIS SPEAD! Building concept paintings by David Levy.

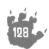

COUNTRYSIDE

The countryside, with its rolling hills, winding river and charming covered bridge, is not only a beautiful location for one of the film's crucial moments – it's where Winnie convinces Rayburn to really train with her, despite his lack of confidence – it solves some concrete logistics, too, because when you're dealing with gigantic monsters, you have to consider: where do they live? While it's not stated implicitly, the idea is that, with its wide-open spaces, "the countryside accommodates the monsters," production designer Christophe Lautrette says, and also serves as a location for Rayburn to train.

"I did a lot of doodles of Rayburn in the countryside doing really fun, comical things," Lautrette says of his brainstorming sessions for the setting. "I had him jumping over a river and out of a waterfall; racing trains and horses; jumping on cars; training Rocky Balboa-style in the countryside." They only kept one idea, though, Rayburn doing pull-ups on an arched bridge that goes across a gorge, which helps remind the audience of the monster's scale. A second covered bridge, which could easily be found in Massachusetts or Vermont, serves the same purpose during a somber moment when Rayburn and Winnie sit and talk on top of it.

Even though *Rumble* takes place in the summer, for the countryside's color palette, Lautrette was inspired by the rich colors of an East Coast foliage during the autumn: a vibrant mix of red, yellow, green, and orange. "Orange is Rayburn's color, of course, so this color scheme just felt right to me," he says.

BELOW! Color scene painting by Julia Blattman (Left). Black and white environment illustration by Dennis Greco (Right).

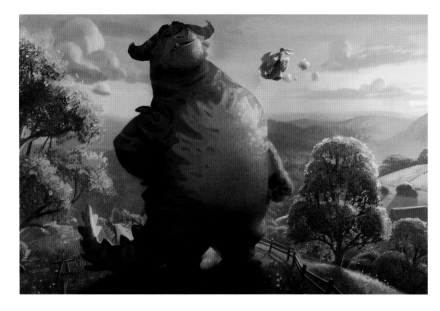

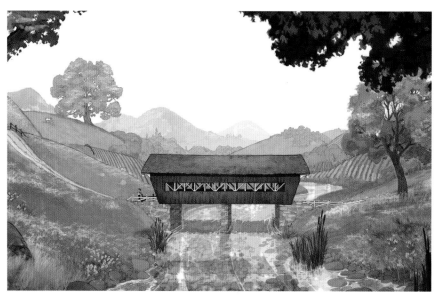

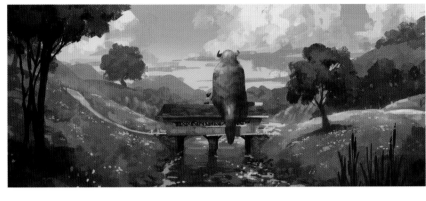

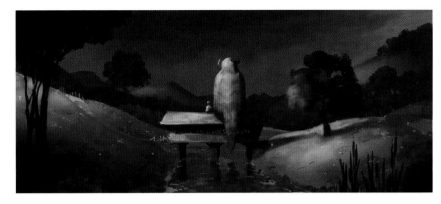

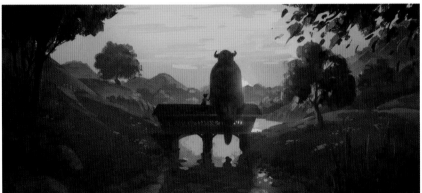

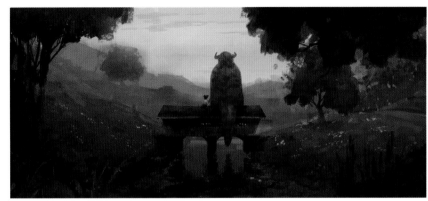

ABOVE/ Color keys by Naveen Selvanathan.

BELOW/ Building concepts by Cathleen McAllister.

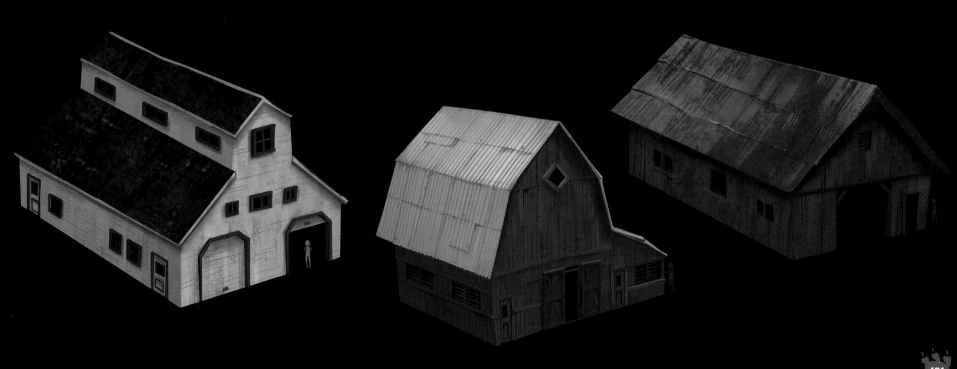

PITTSMORE

Pittsmore, simply said, is the pits. It's a godforsaken place many years past its prime. That's immediately clear when Winnie arrives at the Pittsmore tram station on her way to an underground fight club where she hopes to find a new monster to bring back to Stoker. It's rusting and literally falling apart; what's left of it is covered in graffiti; trash is piling up everywhere. "Since the tram station is our first impression of what Pittsmore is like, it had to immediately read as an absolute dump compared to Stoker, which is so nice and appealing," artist Julia Blattman says.

Pittsmore wasn't always like that. The town used to have its own wrestling monster and a thriving economy. "Once LeBrontasaurus left, the town couldn't sustain itself," production designer Christophe Lautrette says. "The town's success had depended upon them having a monster that won fights and brought in audiences."

Now, the illegal fight club is the town's only claim to dubious fame. It's just across the street from the tram station, and housed in a vast, abandoned bobblehead factory. "Winnie has to muster the courage to walk into a very foreign environment," says head of cinematography Kent Seki. "We wanted to show this from Winnie's 'outsider' point of view with more handheld shots before transitioning into more traditional cinematic language."

THIS PAGE/ Building concept by Cathleen McAllister.

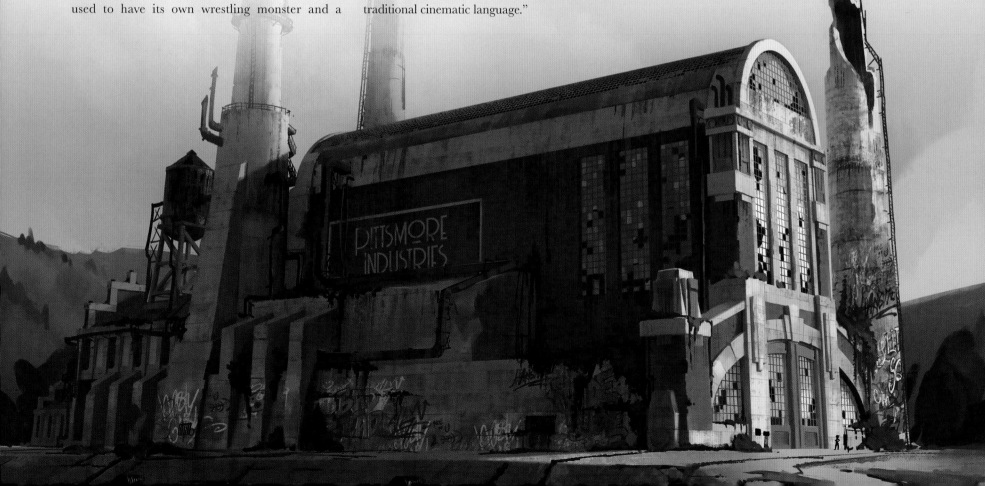

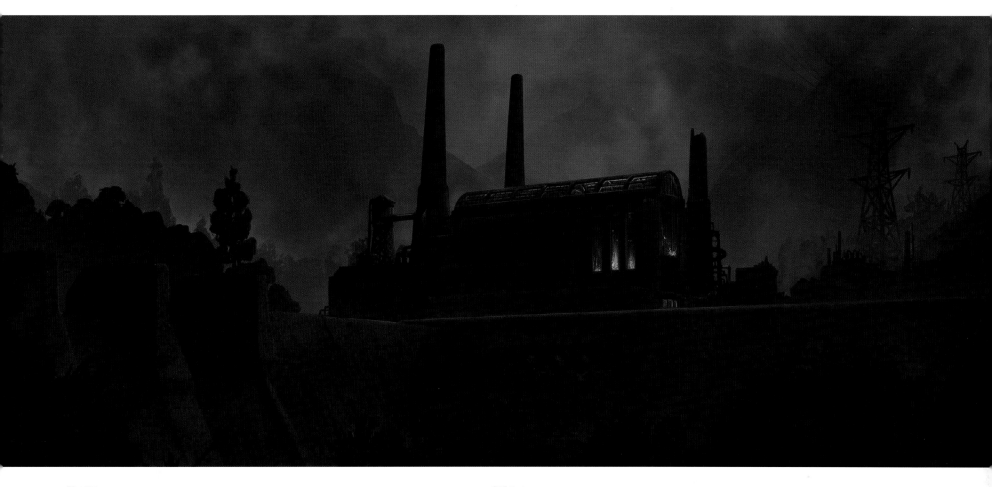

ABOVE/ Building design by Paige Woodward.

BELOW/ Concepts by Cathleen McAllister (Left) and Robh Ruppel (Right).

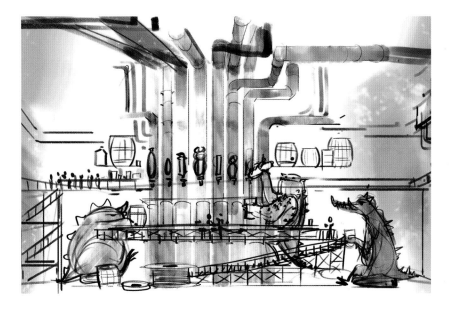

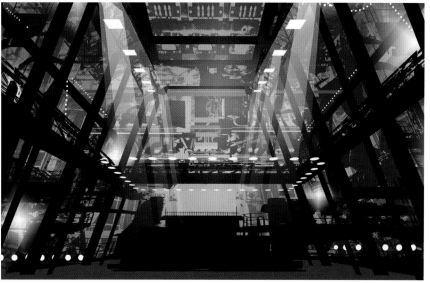

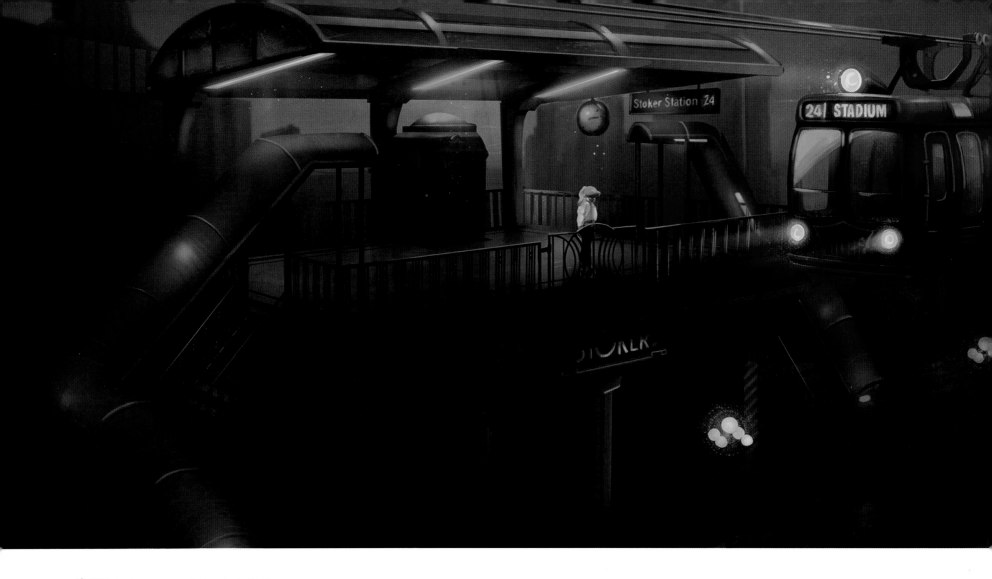

ABOVE/ Environment painting by Julia Blattman.

Like everything else in *Rumble* that has to be big enough to accommodate monsters, the scale of the factory/fight club was crucial, says production designers Christophe Lautrette. In his research, he found as inspiration "many cool photos of huge, old abandoned factories with huge chimney stacks that had been left to rot," particularly the imposing and iconic Battersea Power Station, a decommissioned coal-fired power station on the outskirts of London, first built in 1929. It was just what he was looking for.

He put a series of vertical windows almost the height of the building and more on the ceiling to allow the club's intense neon glow to escape; three soaring chimney stacks reach for the sky; and some secret entrances. "The idea is that patrons have to get invitations to visit the place," Lautrette says.

Inside, the artists used existing materials that would have been found in the building's former status as a working factory and incorporated them into its new life as a club. The cavernous main hall, complete with betting booths on one side and a bar on the other, contains tremendous steel pipes, immense turbines, steel radiators, and high metal platforms that have been transformed into useful elements at the spacious bar. The fighting ring, made from oversized truck tires and chains, is placed squarely in the middle of the room. An early artist's rendering had monsters sitting at the bar, complete with a monster bartender attending to them; tiny humans share the space and stand on scaffolding above them.

To give the club its down-and-dirty vibe, Lautrette used a base of black and white mixed with high-saturated color. "The lighting cinematographer Roger Deakins used in *Blade Runner 2049* was my inspiration," he says. "It was monochromatic, but it had a lot of atmosphere. He used that technique to great effect."

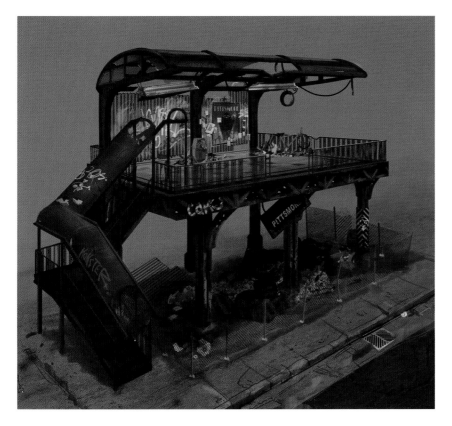

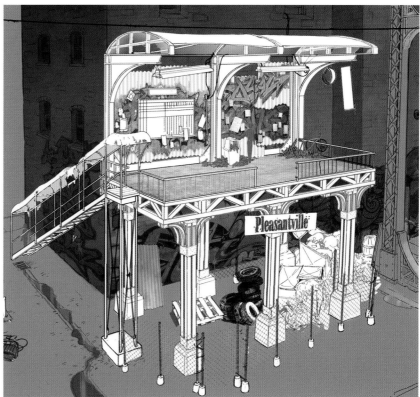

ABOVE/ Tram station concepts by Julia Blattman (Left) and Dennis Greco (Right).

BELOW/ Building concepts by Julia Blattman.

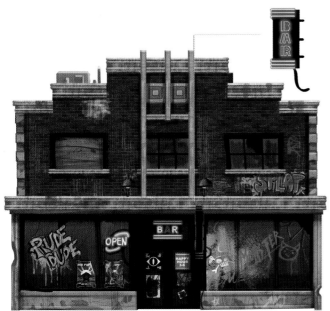

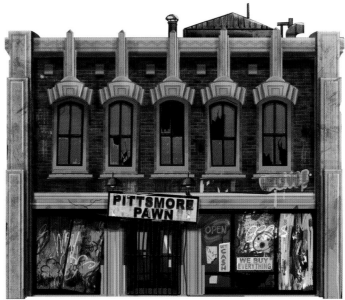

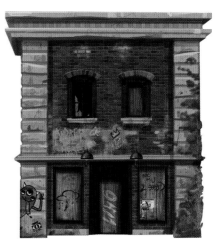

STADIUMS

As Rayburn's training progresses, Winnie gets him legitimate international wrestling matches in preparation for a return to Stoker. The production design team created monumental Russian, Japanese and Mexican structures that were intended to be seen only fleetingly on screen. Because of this, they had to be recognizable with a single glance, says production designer Christophe Lautrette. To that end, he says that the designs are "cliché" – but in the best sense of the word: the Russian stadium displays the iconic structural domes found in Moscow; the Mexican Aztec pyramid stadium is bold and colorful, hearkening back to the architecture of native peoples; the black and red Japanese pagoda stadium is grandiose and stately. Each are distinct and unmistakable in their design. Ultimately, script changes kept just the Mexican and Japanese arenas in the film.

THIS SPREAD/ Color keys by Julia Blattman.

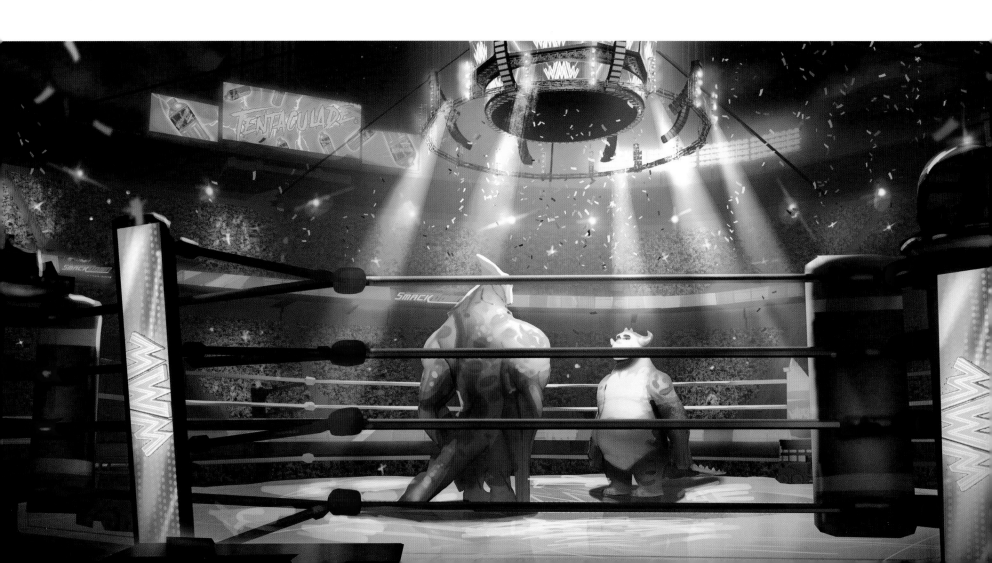

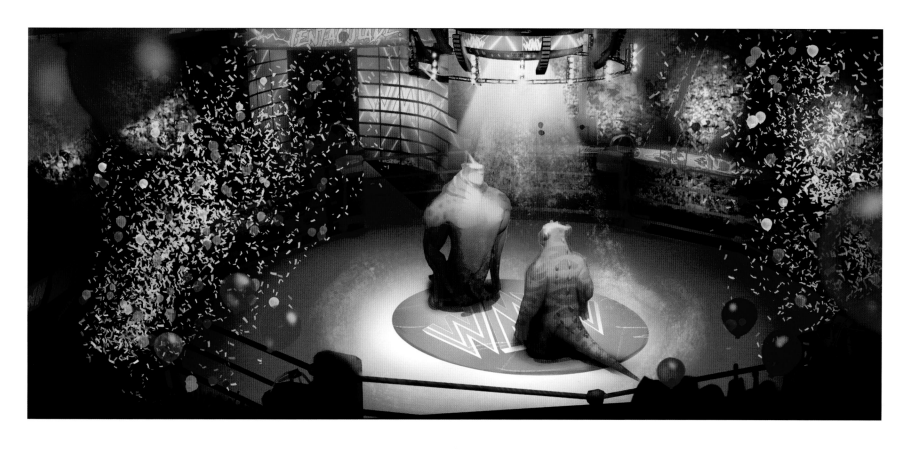

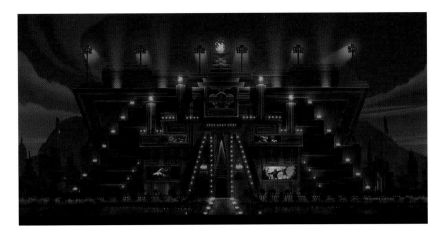

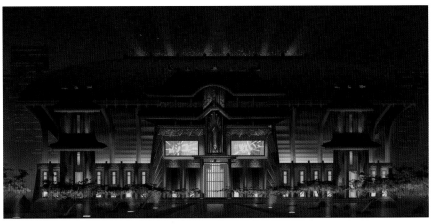

ABOVE/ Concepts by Paige Woodward (Left) and Naveen Selvanathan (Right).

BELOW/ Stadium painting by Naveen Selvanathan.

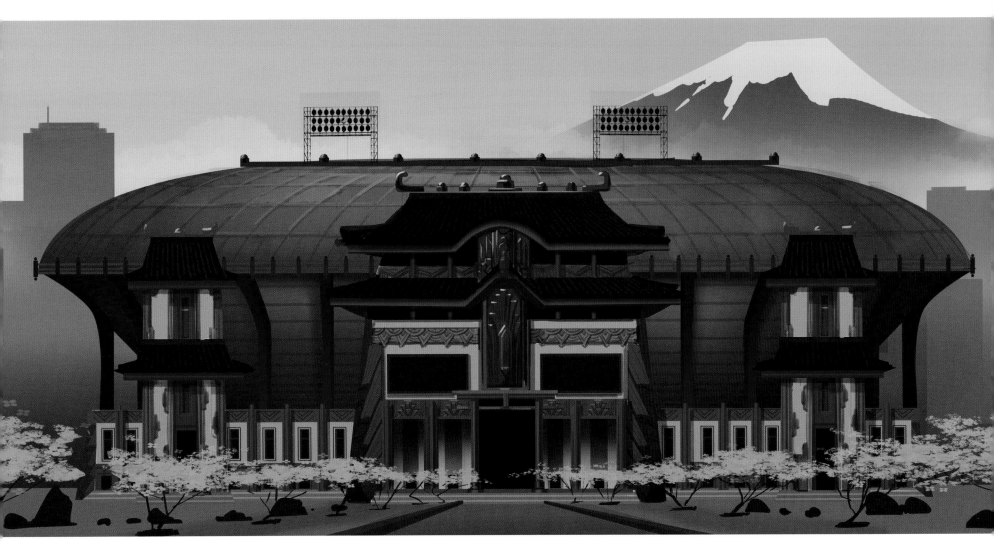

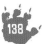

ABOVE! Stadium concept by Naveen Selvanathan.

BELOW! Concepts by Naveen Selvanathan (Left) and Jon Messer (Right).

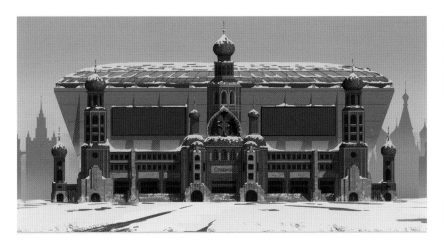

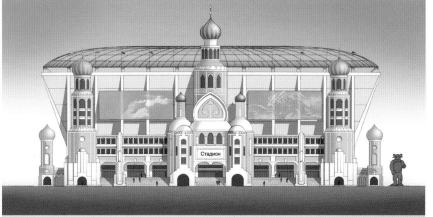

VEHICLES

HOVER BIKES

Hover bikes are the transportation of choice for the trainers and referees who regularly interact with monsters; they're the most efficient way for them to get to eye level with their immense athletes! A cross between a motorcycle and a scooter without wheels, they're quiet vehicles propelled by whirring fans under the drivers' seats and bear the distinctive colors and logos of their respective teams. Winnie's orange Team Rayburn bike stands out among the rest. It was inspired by the aerodynamic lines of Streamline Moderne trains and has a rounded front end with three headlights: two large round ones and a third smaller one above them. Decorative chrome gives it a cool, retro look.

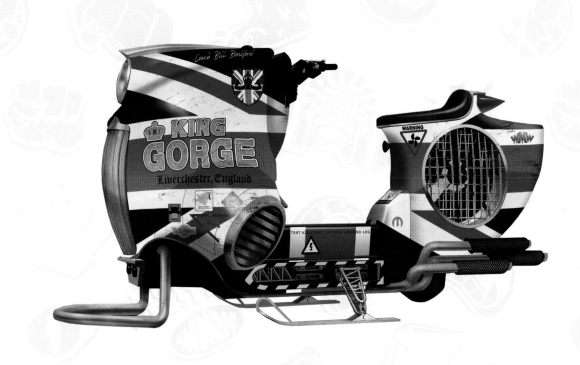

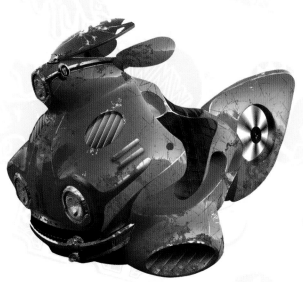

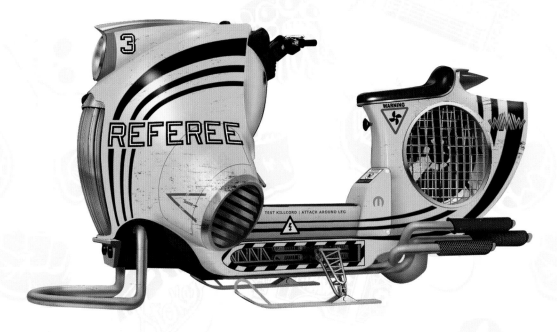

140

STOKER TRAM

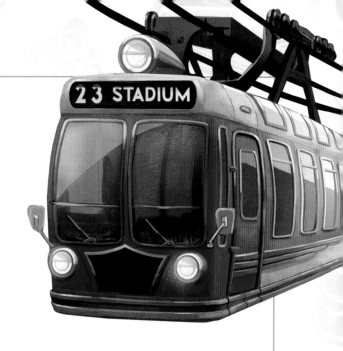

The trams in Stoker, which move by overhead cable, were designed to be just as charming as the town in which they travel. Artist Julia Blattman incorporated vintage attributes such as "old-school" destination rollsigns mixed with more modern features. "Attention to detail in minor things such as a bus can bring a sense of believability to the world you're seeing," she says. She drew inspiration from the shapes of the cable cars and retro trolleybuses she saw when she lived in San Francisco. "The tram doesn't have the most aerodynamic shape, so I imagined it wouldn't go too fast and would be a bit wobbly taking corners," she says. "I went with a nostalgic color scheme, a vintage orange and cream for the paint. The paint isn't perfect; it has weathering from lots of use through the years."

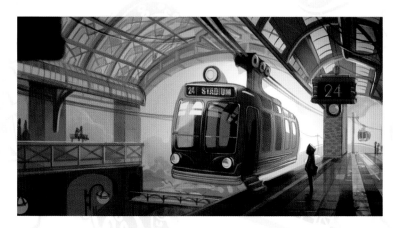

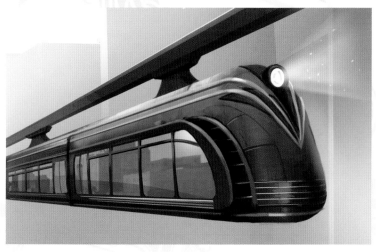

SLITHERPOOLE TRAM

Just as the city of Slitherpoole contrasts sharply with Stoker, so too, do their trams. The Slitherpoole tram is streamlined and aerodynamic, and, like Winnie's hover bike, was inspired by the curved shapes and steel exteriors of real-life Streamliner trains that were popular from the 1930s to 1950s. "Seeing Slitherpoole's tram can give the viewer an immediate read that the city is more advanced when it comes to technology and money," Blattman says.

THIS SPREAD: Hoverbike concepts by Fred Warter and David Levy (Previous Page). Tram concepts by Julia Blattman (Above and Left) and David Levy (Below).

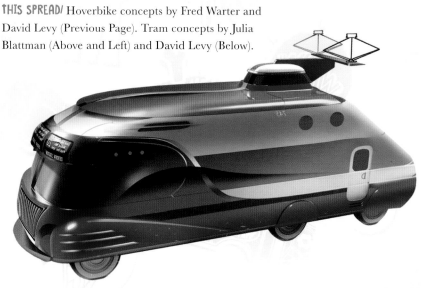

GRAPHICS & PROPS

Dynamic, colorful, and sometimes nostalgic graphics of all kinds populate *Rumble*. They decorate the walls as posters in Winnie's bedroom and as framed articles in Siggy's apartment; they hang from the ceiling as banners in Stoker Stadium; they adorn the sides of hover bikes as team logos and stickers… they live on the belly of Tattoo Guy.

They're small details that play a silent but important part in telling the *Rumble* story. The posters in Winnie's room, for example, "show her passion for monster wrestling as well as her other interests such as music and art," says artist Julia Blattman. According to art director Fred Warter, the clever stickers and logos created by visual development

THIS PAGE/ Prop designs by Chris Vigil.

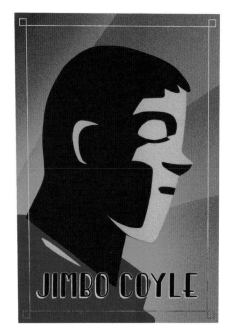

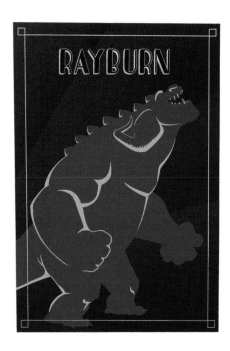

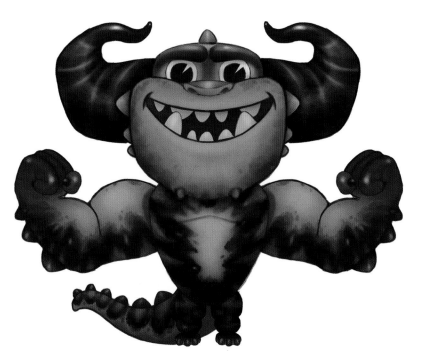

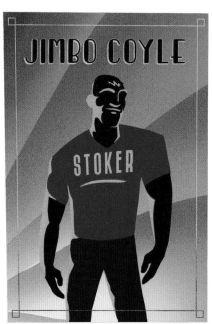

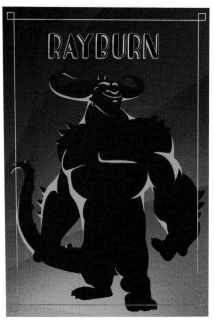

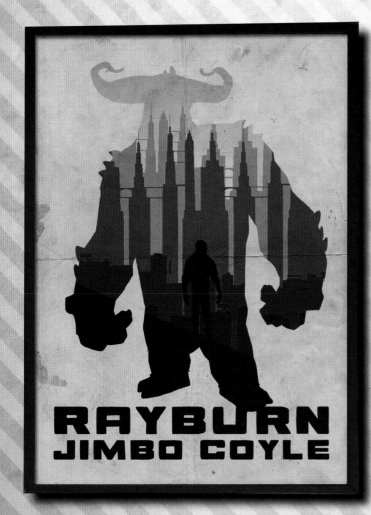

GOING THE DISTANCE!

Rayburn Does It AGAIN!

Rayburn Greets His Enthusiastic Fans After the Match

WORLD MONSTER WRESTLING

MEET AT THE TOWN SQUARE

SAT. MAY 11 5:00 P.M.

ONE NIGHT ONLY! WMW CHAMPIONSHIP

RAYBURN
-VS.-
SLIMEY LIMEY

TAG TEAM CHAMPIONSHIP MATCH

KING GORGE AND DENISE VS. FRANKENDOG AND LADY MAYHEN

YOU WILL NOT WANT TO MISS THE MAIN EVENT!

MONSTER XING

MEET AND GREET WITH THE WORLD CHAMPIONS!

JIMBO COYLE & RAYBURN

SATURDAY
MAY 11
7 PM
STOKER MAIN PLAZA

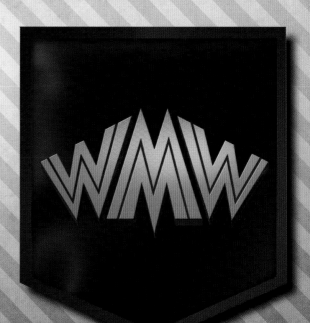

WMW

[LOVE] Poster and prop designs by Julia Blattman and Chris Vigil.

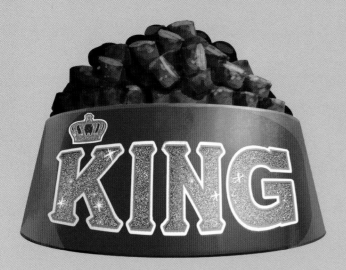
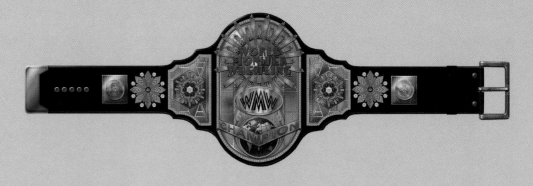

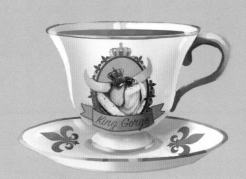

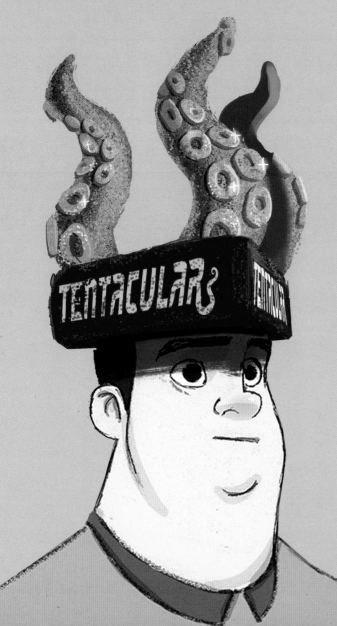

artist/graphic designer Chris Vigil, in particular, help to keep the movie feeling contemporary and familiar… in addition to just being really cool to look at! "One of the pushbacks we got about using art deco from Paramount executives was the fear that the film would look like a period piece," Warter says; incorporating these modern graphics provides the necessary balance – and fun. But because many of them were inspired by the logos of real-life sports teams, the names, treatments, and graphics themselves had to be cleared through the Paramount legal department. They had to make sure that they weren't too similar to something that actually exists. "It was definitely a challenge," Warter continues. "There was one logo that went through the approval process five times because it kept getting kicked back."

There was no such issue with the rich, art deco-inspired banners that hang outside the Stoker Stadium museum. They honor the visages of Jimbo Coyle and Rayburn Sr. in shades of purple, blue, and red. "They're nostalgic, visual reminders of how awesome they were," says production designer Christophe Lautrette. "In doing our research, we looked at small-town football museums that had trophies and belts on display. They also had banners such as these hanging from their ceilings."

THIS SPREAD/ Poster and prop designs by Julia Blattman, Fred Warter, and Chris Vigil.

BIG FIGHT!

ENTER AT YOUR OWN **RISK**

COME SEE THE *BIGGEST* AND THE *BADDEST*

YOU'RE IN TENTACULAR TERRITORY

SOMEDAY ALMOST WHAT IF IF ONLY

POST NO BILLS

AMBER'S REVENGE

Stoke

ANATOMY OF A SCENE

STOKERING THE FIRE

The first scene in *Rumble* sets the stage for what's to come in the film and lets the audience know that they're in for a wild ride…

THIS PAGE/ Scene painting by Max Narciso.

STOKERING THE FIRE

Inside Stoker Stadium, there's palpable excitement in the air. It's raucous, loud, and colorful. Residents of Stoker have been waiting nine years for this moment: Stoker will once again be the center of the World Monster Wrestling universe if hometown hero Tentacular wins the Big Belt in his championship match against King Gorge, the current title holder. Waving spotlights cross the stadium and beam down strategically on the battle floor.

Sequence 0400, known as "Stokering the Fire," drops audiences into the explosive world of monster wrestling right at the start of *Rumble*.

"The scope of the sequence is huge," says director Hamish Grieve. "We have crowds flooding into this stadium and we track Winnie through it... before you know it, you're totally accepting that giant monsters wrestling in stadiums is a normal thing that people would go and watch."

What happens in "Stokering the Fire" is pivotal to the movie, as it presents the film's main dilemma: Tentacular abandons Stoker, leaving the town without its own monster. How will it survive? For the filmmakers, though, the devil was in the details. "We had to figure out who Tentacular's opponent

would be, how the fight would flow...we had to get that WWE feeling just right and add our own twist on it," says head of story Lawrence Gong. "It took a lot of massaging."

Once they decided that King Gorge was the monster to beat, they focused on playing up the bulldog monster's proper English gentleman mannerisms as well as Tentacular's posturing to the crowd, says cinematographer Kent Seki. "We did an initial first pass based on the story reel, but Hamish wanted to amp it up more, especially for hometown favorite Tentacular."

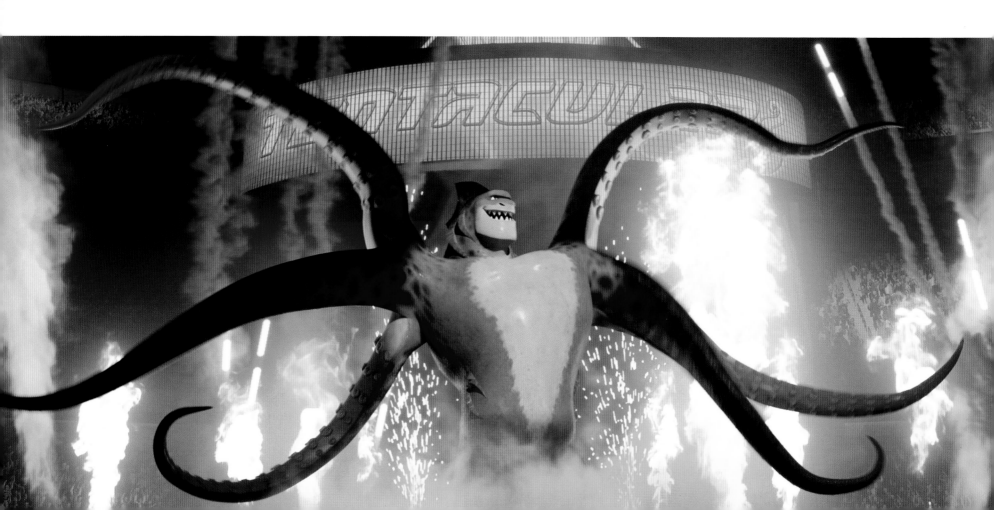

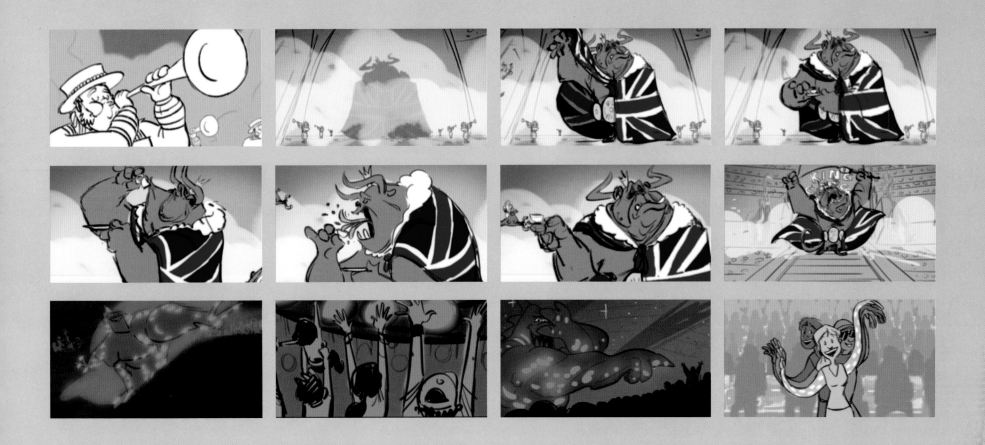

THIS SPREAD/ Concept art by RFX (Left). Storyboards by Lawrence Gong, Rod Douglas, Erik Kuska, Joe Giampapa, and Carolyn Gair (Above).

The effect was electric.

When Tentacular bursts into the wrestling ring, his bioluminescence lights up across his massive frame, making the crowd go crazy as heavy rock music and fireworks erupt. This guy loves to showboat and plays to audience in a big way: He runs around the ring, grabs a passing blimp with a Jumbotron on its side and poses for a selfie; he pops his pecs and soaks in the adoration.

Fitting Tentacular into the area around the ring proved to be difficult, though, because there were crowds and support vehicles everywhere. "We had to strategically place them out of his foot path and use metal barricades to show a modicum of safety for the fans," Seki adds. "In truth, if this really existed, many fans would have been squashed by Tentacular. Striking the balance between comedy and scale in a scene like this is always important."

Next, to the sounds of trumpets blaring, comes King Gorge, decked out in his royal regalia. He flicks one of his trumpeters off screen then sips from his teacup; his royal mannerisms rile up the audience as he shows off the Big Belt. He enters the ring and takes off his paraphernalia. Roaring fiercely, he slobbers on the crowd.

"The introductions had to be literally larger than life," says Seki. To make sure they were, the *Rumble* team drew inspiration from a real-life WWE event they attended.

> "In truth, if this really existed, many fans would have been squashed by Tentacular. Striking the balance between comedy and scale in a scene like this is always important."
>
> KENT SEKI –
> CINEMATOGRAPHER

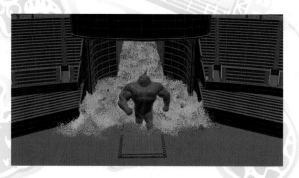
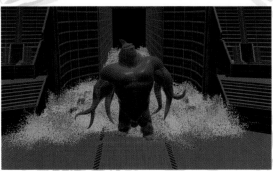
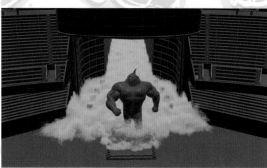
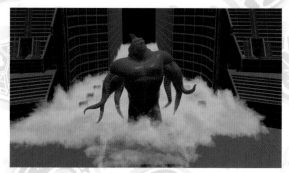

THIS PAGE/ 3D storyboards.

THIS PAGE/ Color keys by Julia Blattman.

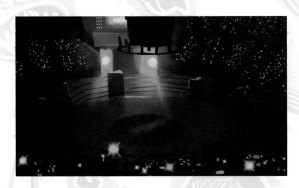

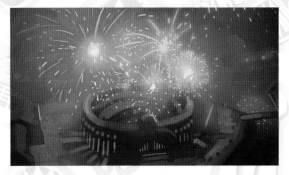

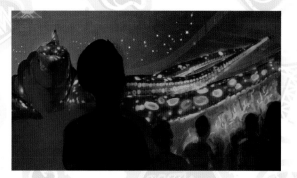

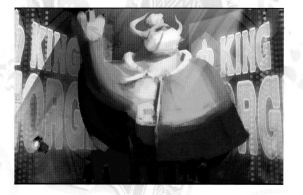

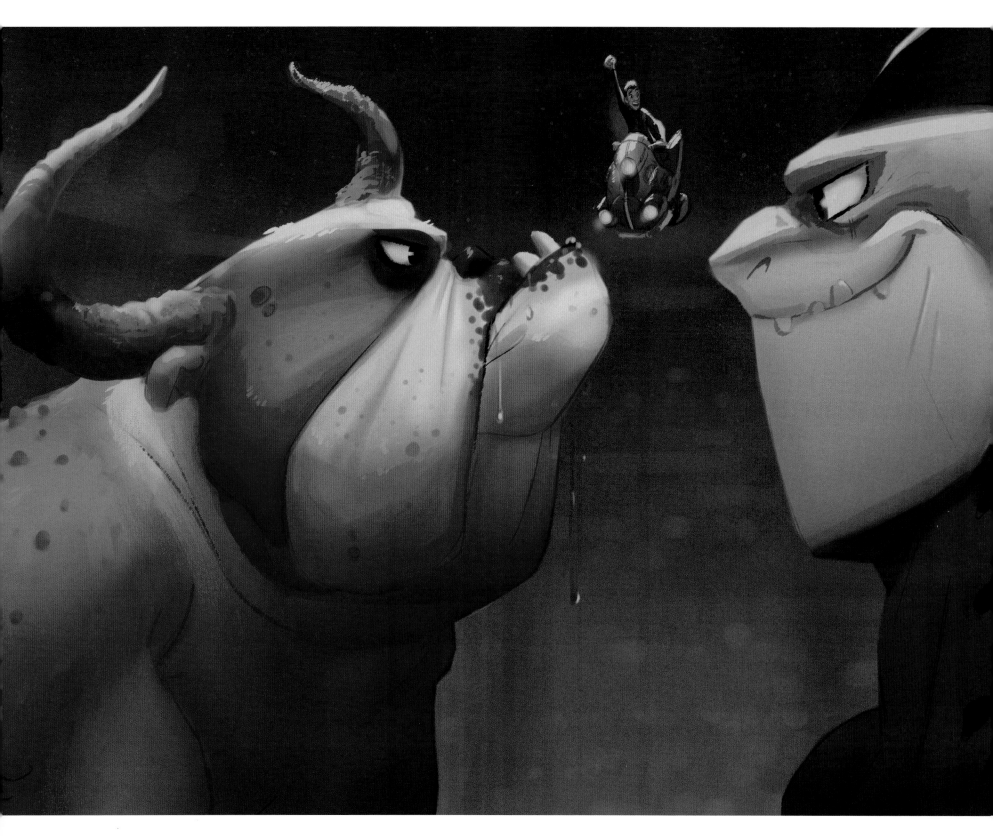

"We wanted to take the excitement and theatricality that we saw with the WWE and elevate it to the 'monster level,'" he adds. "Sweeping cinematic camera moves – drone photography, dynamic crane shots, and wide sweeping cable cams – are the hallmark of this sequence."

In lighting "Stokering the Fire," all the bells and whistles were pulled out to lend credence to the scene. "Because this is the first big fight and helps establish the WMW sport, our intention in lighting was to completely excite and capture the attention of the audience," says lighting supervisor Liz Hemme. "Just like you would find in WWE, the characters' entrances to the arena are where we did all the theatrics: fire, spots, and flares. The lighting is big and glamorous. It's the only fight sequence in which the audience roots for Tentacular, and the only one that doesn't incorporate Tentacular's 'evil' color, which is green."

The biggest issue of the scene, of course, was the scale of the monsters. "We were constantly trying to place scale cues into the shots in order to give the monsters the appearance of their proper size," says Seki. "Deep focus (staging with great depth of field using wide-angle lenses) became another tool that helped to show the scale of the monsters, which is a bit counterintuitive. If the focus was too shallow, the monsters began to feel like 'men in suits.' So, we had to rely more on atmosphere and depth fog to give us separation with the background. Ellipsing the monsters (inferring action rather than seeing it) also helped, but there was only so much we could rely on that technique since the action, as well as the comedy, had to be clear. This kind of film is a delicate balancing act for sure."

THIS PAGE/ Sequence painting by Naveen Selvanathan (Left). Color keys by Julia Blattman (Below).

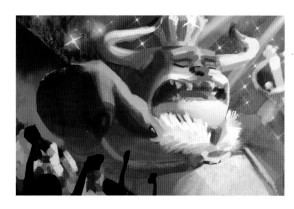

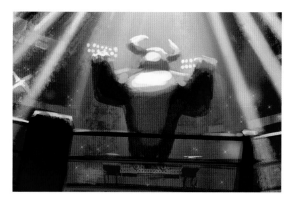

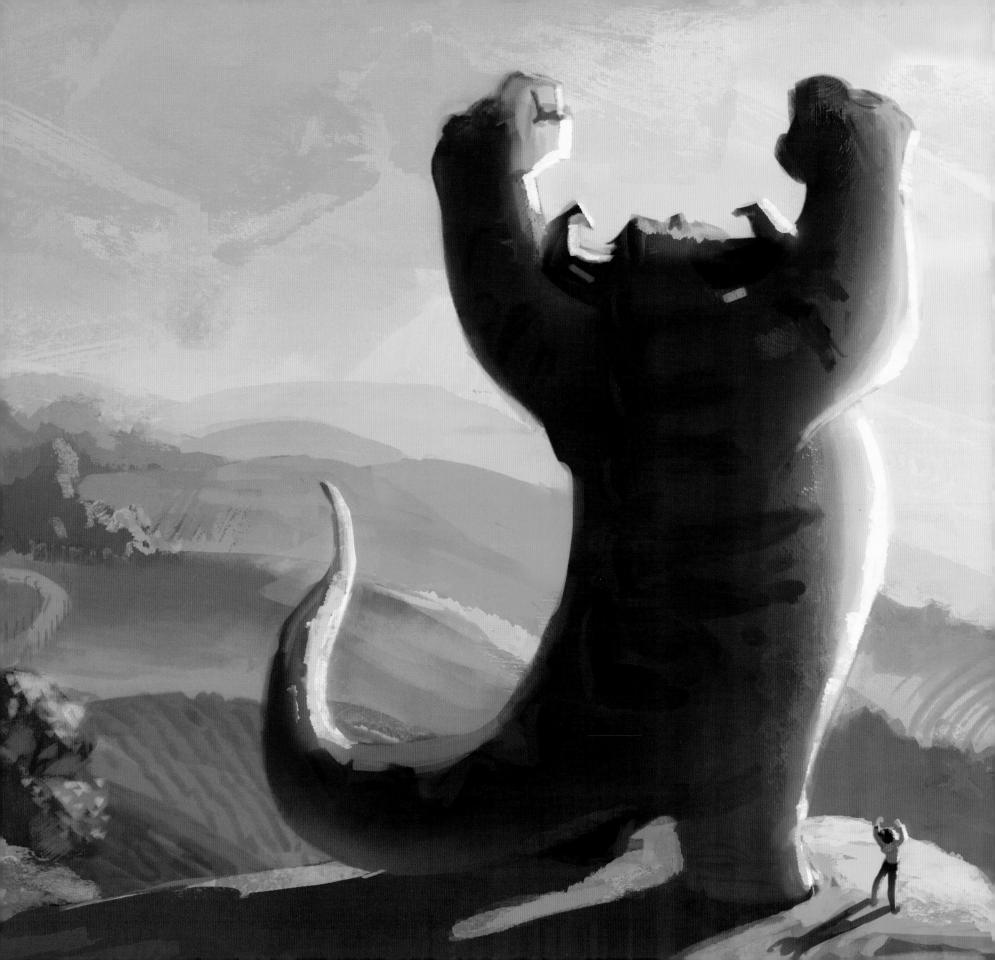

CONCLUSION

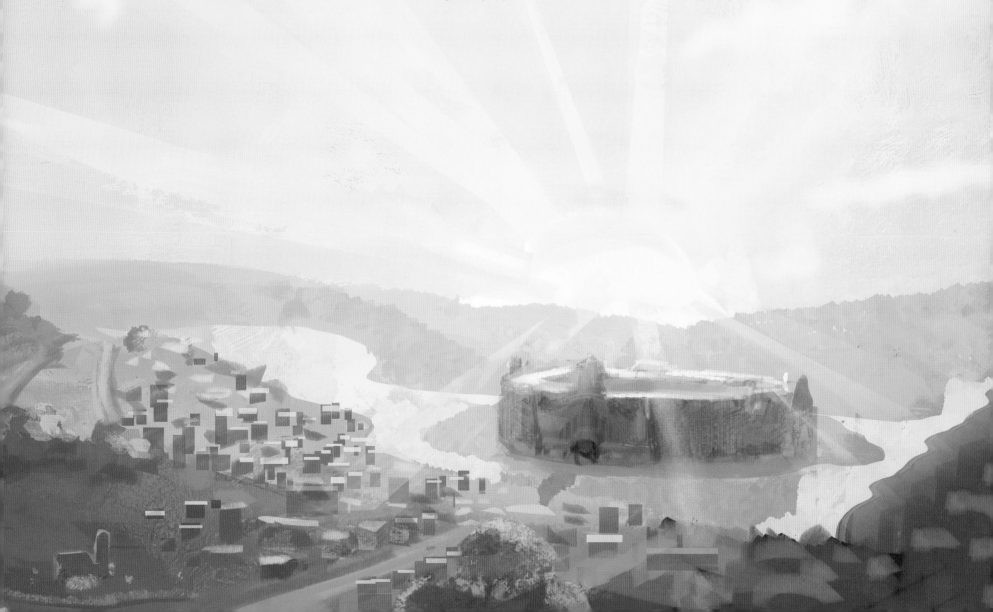

Though it emulates many a feel-good sports movie that has come before it, there hasn't been a movie quite like *Rumble*. It stands in its own right as a dynamic, engaging, and funny tale that offers audiences both a roaring good time and a subtle charge. "Winnie and Rayburn struggle with so many challenges along the way that we can all relate to," head of lighting Liz Hemme says. "In the end, I love the message to keep fighting and never give up. I have two little girls of my own and I can't wait for them to watch this film."

THIS PAGE/ Scene painting by Julia Blattman.

ACKNOWLEDGMENTS

Writing a book such as this is a team effort and I would like to thank the busy filmmakers for their contributions, particularly director Hamish Grieve, art director Fred Warter and production designer Christophe Lautrette; Kyrsti Schwarz and Sabi Lofgren at Paramount, for fielding my numerous questions during the writing process; Natasha MacKenzie at Titan, for her creativity in designing the book; and Eleanor Stores and Jo Boylett at Titan, for their guidance and for giving me the opportunity to write *Rumble – The Art and Making of the Movie.*

This book is dedicated to all the young artists in my family who are hard at work making their creative aspirations become reality. – N.H.